DIGITAL
WEDDING PHOTOGRAPHER'S
P·L·A·N·N·E·R

KENNY KIM

WILEY

Wiley Publishing, Inc.

Digital Wedding Photographer's Planner

Published by
Wiley Publishing, Inc.
10475 Crosspoint Boulevard
Indianapolis, IN 46256
www.wiley.com

Published simultaneously in Canada

ISBN: 978-0-470-57093-7
Manufactured in the United States of America

10 9 8 7 6 5 4 3 2

Limit of Liability/Disclaimer of Warranty: The publisher and the author make no representations or warranties with respect to the accuracy or completeness of the contents of this work and specifically disclaim all warranties, including without limitation warranties of fitness for a particular purpose. No warranty may be created or extended by sales or promotional materials. The advice and strategies contained herein may not be suitable for every situation. This work is sold with the understanding that the publisher is not engaged in rendering legal, accounting, or other professional services. If professional assistance is required, the services of a competent professional person should be sought. Neither the publisher nor the author shall be liable for damages arising herefrom. The fact that an organization or Web site is referred to in this work as a citation and/or a potential source of further information does not mean that the author or the publisher endorses the information the organization or Web site may provide or recommendations it may make. Further, readers should be aware that Internet Web sites listed in this work may have changed or disappeared between when this work was written and when it is read.

For general information on our other products and services or to obtain technical support, please contact our Customer Care Department within the U.S. at (877) 762-2974, outside the U.S. at (317) 572-3993 or fax (317) 572-4002.

Wiley also publishes its books in a variety of electronic formats. Some content that appears in print may not be available in electronic books.

Library of Congress Control Number: 2010923548

Trademarks: Wiley and the Wiley Publishing logo are trademarks or registered trademarks of John Wiley and Sons, Inc. and/or its affiliates. All other trademarks are the property of their respective owners. Wiley Publishing, Inc. is not associated with any product or vendor mentioned in this book.

ABOUT **THE AUTHOR**

© Kenny Nakai

Kenny Kim has always been fascinated by the visual arts, especially the connection between art and photography. This passion led him to study graphic design at the University of Illinois where he also became a skilled Web designer. In 2003, Kenny opened his own design studio, and it was during this time he realized that the greatest outlet for his artistic expression and technical skills would be through his passion for photography.

Incorporating his own vision into the technical elements of photography, Kenny's goal with each photo is to present each moment he captures with a subtle artistry that enhances the feel of the moment. With the launch of Kenny Kim Photography in 2006, his vision instantly resonated with his audience, and Kenny Kim Photography very quickly grew into a nationally recognized studio. Kenny has shot over 100 weddings in locations throughout the United States, Mexico, the Caribbean and in Italy. His clients include various local and national celebrities such as Yul Kwon (winner of Survivor, a popular CBS TV Series) and Salma Hayek (commissioned as the second shooter for international celebrity photographer, Bob Davis). He has also been contracted to photograph the University of Illinois sporting team events and various celebrity events featuring David Foster, Andrea Bocelli, John Legend, Three Doors Down, Chris Tomlin and Michael W. Smith.

Kenny's work has been featured in numerous publications including *Destination Weddings & Honeymoon, The Knot, The KoreAm Journal, WIND Magazine* and more. He is a platinum list member in highly acclaimed *Grace Ormonde Wedding Style Magazine*. He is also an active member of WPPI (Wedding & Portrait Photographers International) and has recently received special honors in the WPPI 2010 Awards of Excellence 16x20 International Print Competition. He was voted by *The Knot Magazine* in 2010 as the Best of Weddings: Photography.

Kenny currently resides in Chicago but loves to travel and explore new culture. He is thankful everyday for the privilege to call his passion in life his profession as well.

CREDITS

Acquisitions Editor
Courtney Allen

Project Editor
Mimi Brodt

Editorial Consultant
Alan Hess

Technical Editor
Heather Harris

Copy Editor
Mimi Brodt

Editorial Director
Robyn Siesky

Designer
Erik Powers

Business Manager
Amy Knies

Senior Marketing Manager
Sandy Smith

Vice President and Executive Group Publisher
Richard Swadley

Vice President and Executive Publisher
Barry Pruett

ACKNOWLEDGMENTS

There are too many people I need to thank, both directly and indirectly for making this book possible. First I would like to thank my family for always providing me with love and support despite my crazy dreams and ideas. To my dad who is looking down from above, we miss you.

My friend and older "hyung" John Hong, for recognizing the potential I had and pushing me into the deep waters. I still remember the night when you yelled at me to quit my day job and get into photography. Thank you for your sound advice and friendship throughout the years.

There are many photographer friends who have invested their time and resources unconditionally to me. I'd especially like to thank Mike Colón, David Jay, [b]ecker, Skip Cohen and Ray Santana for their support and friendship. Also Bob and Dawn Davis for allowing me to unofficially coin them as my photography mentors and for providing great advice and many opportunities. Thank you all for leading by example.

To the wonderful staff at Wiley Publishing, thank you for giving me this amazing opportunity. Barry Pruett, Courtney Allen and Sandy Smith — it has been a wonderful experience working on this project with you. And my sincerest gratitude to Alan Hess for his tremendous help in developing the content for this book.

To all my past and future clients — thank you for entrusting me to photograph the most important day of your life. It is an honor and privilege to walk into your life and to capture the essence of your special day.

To many of my wonderful friends in the industry (too many to name — you know who you are), thank you for the opportunities to network, learn and grow together. In the words of Skip Cohen, "You have all taught me that the best part of this industry has little to do with photography. It's about the friendships that come out of our mutual love for the craft."

And finally, I must give all thanks to God — the original author and perfector of my faith.

To my family for giving me the freedom
and patience to pursue my dream.

TABLE OF **CONTENTS**

INTRODUCTION

If you had asked me five years ago what I would be doing now, I doubt being a wedding photographer or writing a book would have been my answer. The truth is, I really had no clue what I was going to do. I probably would have guessed working in sports management or managing a coffee shop or possibly working for a top design agency, or even better: a sports photographer. But my life took a different path to wedding photography, and for the first time in my life, I have found something I am really passionate about.

Wedding photography allows me to creatively express myself in ways I have never been able to do before. It also gives me the opportunity to do what I enjoy the most: meet people, travel, photograph and serve people. There are days when I honestly cannot believe I call this my job and get to do it everyday.

I remember a wedding I photographed in late 2006 when I was first considering this as a full time profession. The mother of the bride, at the end of the day, walked up to me, gave me a big hug and a kiss and thanked me for being an amazing photographer. She said I was the best photographer she had ever seen. At first, I was flattered; then it dawned on me that she made this statement without seeing one single image I photographed that day! It was at that moment I figured out half the formula to becoming a successful wedding photographer—make clients and their families feel special. Being technically sound is the other half, and I am always working to improve and learn new techniques.

By picking up this book, you are either considering becoming a full-time photographer or perhaps you already started and need a little direction. While there are many planning guides available for couples, this is one for designed you, the wedding photographer. The more prepared you are the more you can concentrate on taking the photographs and getting the images that will delight your clients. In this planner you will find

numerous tips and checklists from the more than 100 weddings I have photographed in the past four years, as well as some lessons I learned from other photographers. It covers everything you need to think about and plan for when it comes to photographing a wedding—from the initial meeting with the prospective clients and how to make a good first impression, through the various stages of the wedding and how you can deliver the final product to the newlyweds. Just remember that nothing here is really set in stone. The beauty of this industry is that you can study books like this and make it your own.

Welcome to wedding photography. You are in a community of people who will help and encourage to you become a better photographer. Think of this book as just a starting point—the tip of the iceberg. Use it to develop your own style and explore new ways to doing things. I hope you find this profession as rewarding and fulfilling as I have. ❊

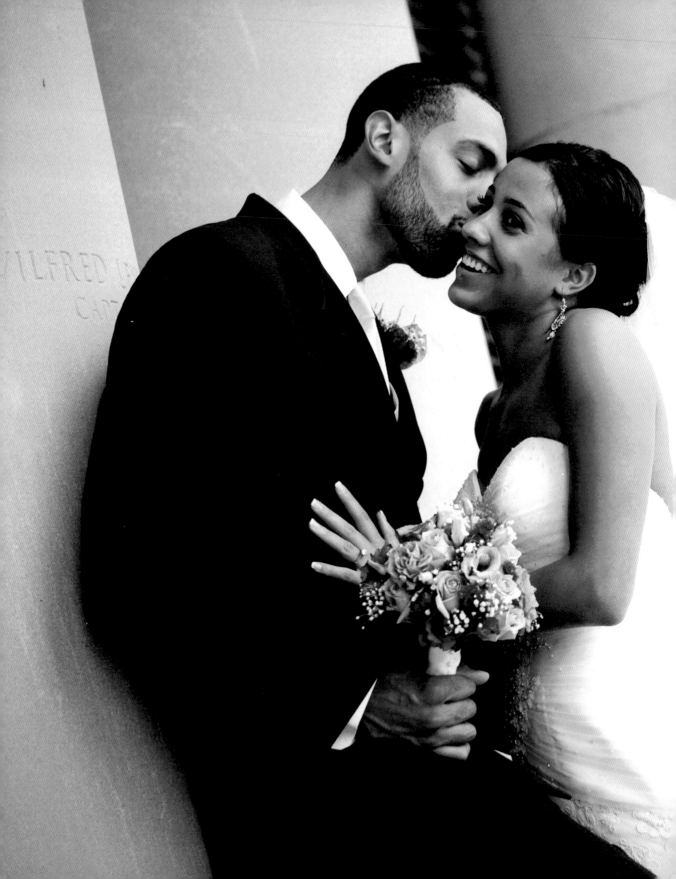

Meeting the clients

Wedding photography involves two key parties: the couple getting married and the wedding photographer(s). Many photographers approach their relationships with clients as strictly a business relationship, but part of what has made my business so successful is my ability to personalize the relationships I have with the couples with whom I work. This is important because a strong relationship establishes trust and allows the bride and groom to be themselves in front of me, but more importantly, in front of my camera. This is key to capturing the couple in their natural moments during their special occasion.

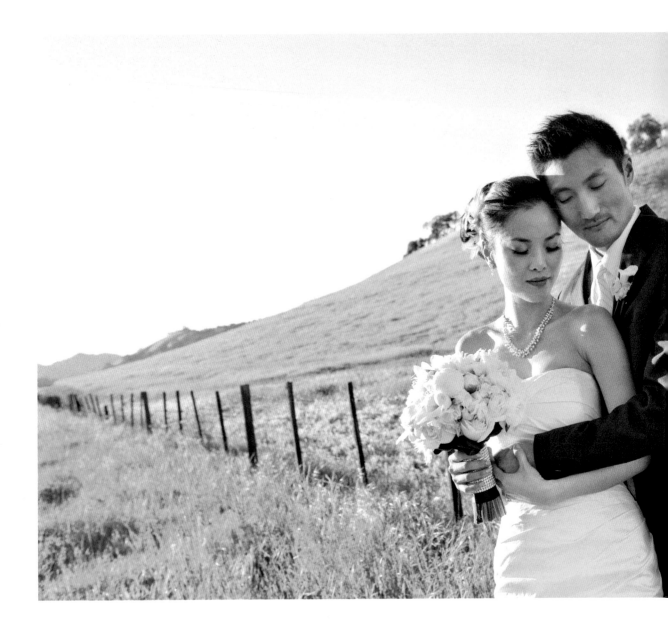

The importance of wedding photography is emphasized by the fact that most weddings seem to pass by very quickly for brides and grooms. If you ask most married couples to describe their special day, they will tell you it went by in a blink of an eye. This is the main reason wedding photography is so immensely important; it captures in sharp focus the moments of a day that requires months of planning and then so often passes by as blur for the bride and groom. ✸

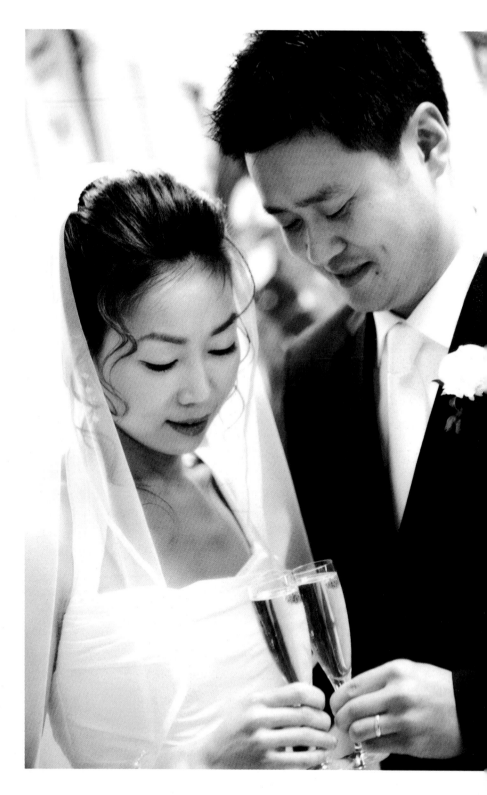

FIRST **IMPRESSION**

The Internet has changed the way people shop for everything, including wedding photographers. Most often the first impression someone receives of my work is what he or she sees on my Web site/blog. But personally, I think there is a more important impression to consider: the impression I leave with my past clients. If the newlyweds are happy with the images I captured of their special day, then they are much more likely to recommend my work to friends and family who are now looking for a photographer. When I am working at a wedding, every person who is in attendance should leave with the feeling that I did a great job and wasn't intrusive. Yet, they should recognize that I always appeared to capture each of the key moments. And most importantly, the bride and groom need to be blown away by the images when they see them.

As with most wedding photographers, the majority of my clients find me through referrals of former clients, friends or they were guests at a wedding I shot previously. This is why it is so important to always put your best foot forward and to network at every opportunity.

That is not to say that you should ignore the Internet and only rely on word of mouth. I don't. I make sure my Web site, www.kennykim.com, shows images I am proud of, are representative of my style, and I regularly update my blog and Facebook pages with images from my current projects. When prospective clients go to my Web site, I want them to be able to imagine themselves in my images. I'll cover the importance of a Web site and brand marketing further in *Appendix 3* of this book.

I have also created a promotional video available on my Web site that describes my workflow and my photographic philosophy to give prospective clients a glimpse of what they can expect before they ever meet with me. ❖

Welcome to the world of Kenny Kim Photography!

Welcome to the world of Kenny Kim Photography!

BUILDING A **RELATIONSHIP**

The most important part of wedding photography is the relationship you build with your clients. That relationship begins with the first meeting and continues to grow with each step of the wedding planning through the presentation of final photographs. In fact, great wedding photographers continue the relationship with past clients long after the couple has received their final product. I'm proud to say that many of my past clients have continued to follow my work on the blog and Facebook and often leave comments on my current postings.

You might be the best photographer and technically brilliant, but to be a great wedding photographer also requires the right kind of personality. You need to sincerely want to be friends with your clients and fully gain their trust.

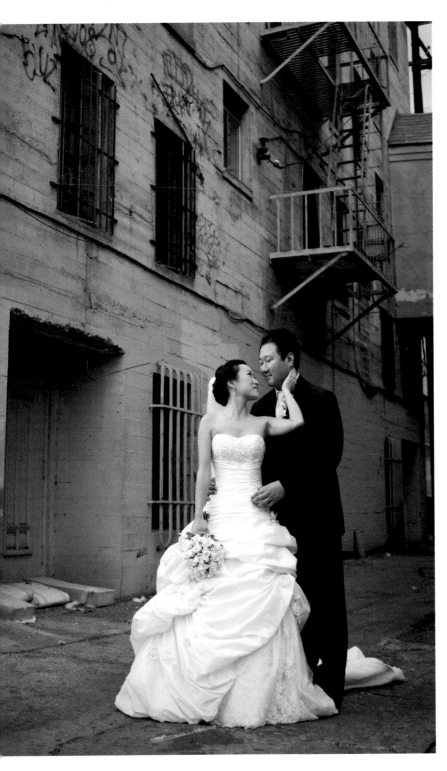

As a wedding photographer, a bride and groom will be sharing one of the most intimate days in their lives with you. You will be there as they are getting ready, when they see each other for the first time that day, when the bride walks down the aisle toward her future husband and when, as a couple, they walk back down the aisle after the ceremony. You'll be there when the couple is introduced as a married couple for the first time, when they have their first dance, and all the other noteworthy moments during the wedding day.

To best capture all of these intimate moments, you must develop a strong and trusting relationship with both the bride and groom. When I meet new clients, I begin to build this relationship from the very first time I speak with them, by focusing the meeting on their needs, not mine. ✤

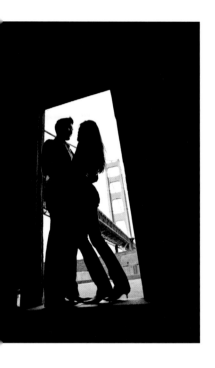

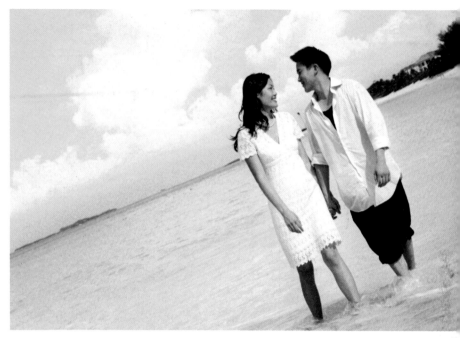

INITIAL **MEETING**

Many of my initial meetings take place on the phone since about half of my clients are from out of state and I don't actually meet them until the engagement shoot (more on this in chapter 2). When meeting by phone or email, it is really important to clearly convey your thoughts and information. Unfortunately, it's entirely too easy to have miscommunications and misunderstandings when only communicating by phone and email. To counteract this, I always try to be really specific and when in doubt, I make sure to ask questions and get clarifications.

When I do get to meet potential clients for the first time in person, I usually let them pick the location. Many people want to meet at a coffee shop and that can be a good choice, but I try to suggest one that isn't very busy so that we can talk with little interruption. Other great locations are nice hotel lobbies or even a quiet restaurant.

There are times I am invited to the client's house, which is great because it lets me get a strong sense of who they are and assess their personal style. Meeting at a

Since first impressions are so important, how you dress conveys a big message to the clients as to what kind of person you are. I usually wear a nice casual dress shirt, a good watch (if you are a guy) and jewelry, and am well groomed and presentable.

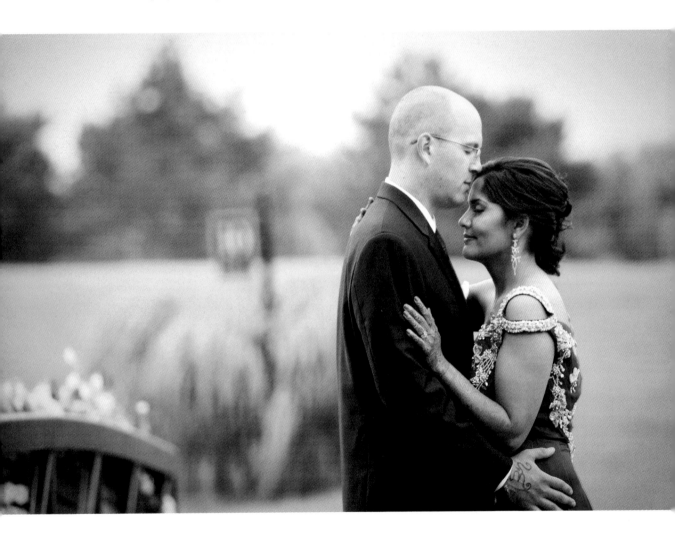

client's home also allows me to meet them where they are most comfortable and often helps me understand what direction they may be leaning in regards to their budget and style of photography. I can also learn more about their personalities and interests.

At this initial meeting, I always bring a couple of wedding albums so prospective clients can see more detailed examples of my work. It is important to let them see samples that cover the entire wedding day. For most couples, choosing a wedding photographer is a new experience. Often, they don't realize the depth of services I can provide, so this is a great opportunity to show them how I can fully capture their special day.

I also bring along a pricing sheet so we don't have to discuss or barter about price and service. I don't ask for a deposit or expect the couple to make a decision immediately. In fact, I don't usually discuss pricing unless the couple brings it up. I just leave them with the pricing guide so they can take the information home and discuss it.

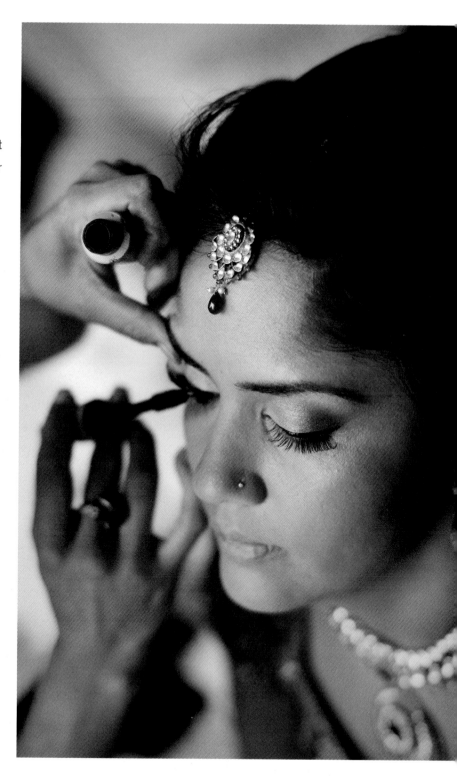

Choosing a wedding photographer is an important decision to make and there is no need to rush it or be pressured into making a decision. I want to make sure potential clients have enough information about what I do and how I do it so they can make an informed decision. I recommend they go home, discuss the meeting, look over my images, and contact me with any additional questions they might have. If they hire me, I want them to feel confident that they chose the best photographer for their special day.

The initial meeting is not just about a business negotiation, but it is a chance to get to know the couple, to see how they interact and to find out about their wedding day. Regardless of whether you are meeting the clients in person, on the phone or through email, try to get as much information about the wedding and the couple as possible. For example, the choice of wedding location and reception are usually significant choices for the couple. Perhaps they picked the historic church because they love the architecture or the museum reception location because they are lovers of art. Knowing these elements would be beneficial for you to know as the photographer and possibly incorporate in the shots.

An important aspect of this initial meeting is that it gives you a chance to educate potential clients about how you work and what they can expect from you. In my experience, while price and their budget can come into play, most people will book me because of my personality, my work, and the experience I bring to the table. The same will be true for you, so the impression you make at the initial meeting will help potential clients determine if you will be a good fit for their wedding.

Questions to ask the couple at the initial meeting

- Bride's name and contact information
- Groom's name and contact information
- Where will the wedding be held?
- Where will the reception be held?
- What is the wedding date?
- What is the wedding schedule?
- Will there be a rehearsal the night before?
- Is there a wedding coordinator? If so, need contact information.
- Why did they choose the locations and date?
- What are they looking for in a wedding photographer?
- Find out more about their families
- How do they want to handle their first meeting—before the wedding or when the bride first walks down the aisle? This will determine the wedding schedule.
- How did he or she propose?
- What is the location of the honeymoon
- Estimated number of guests at the wedding
- Names of all the people involved in the wedding (family, wedding party, main relatives, helpers)
- List of all the vendors (which you can use when you credit them in your blog and also for sending your work for publication)
- Learn more about bride's and groom's backgrounds, including how they met, what they do, and their hobbies and interests

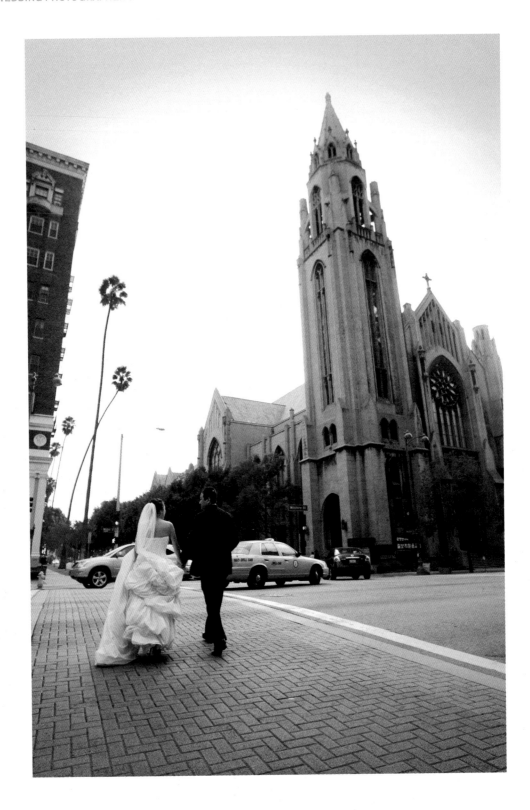

Often when I meet with clients, we talk about everything but wedding photography. We laugh, share stories, get to know each other and in the end briefly discuss the services I provide. By then, they are already comfortable with me and trust that I will provide them with the best service and photos on their wedding day. It comes down to just picking which package or services will best meet their needs.

I make a point to pay for the drinks and/or meal during that first meeting. Think of this as a goodwill gesture. The couple sitting across from you plans to invest a lot of money in you. The least you can do is show that you are genuinely interested in them and you are there to serve them. I recall a personal experience when I met with a financial advisor for breakfast. The bill was about $20, and he didn't even cover my check even though he invited me to invest my money and trust in him. He was asking me for thousands of dollars on which I'm sure he would have gotten a nice commission. Let's just say that my relationship with him did not continue. You need to invest in things like this; even though it's a small gesture, it goes a long way toward building a strong relationship with your clients. ❋

Initial Meeting Checklist

❋ Meet in person when possible

❋ Let the client choose the location

❋ Dress appropriately for the occasion

❋ Pay for your clients' coffee or drinks

❋ Take sample photo albums

❋ Take a calendar updated with all previous obligations

❋ Provide a price list for the client to take home

❋ Discuss expectations, both yours and the clients'

❋ Take a laptop or notebook for notes

❋ Don't expect or require the couple to make an immediate decision

BEING ON **THE SAME PAGE**

While it isn't usually great business practice to turn down clients, it is important to recognize when a couple may not be a good fit for your business. I consider my style to be something I call "Invisible Observation," a term coined by a friend after seeing me work at a wedding. I try to see everything and capture it all without being seen myself. If the clients are looking for a more traditional photographer who will show up with a big tripod and medium format camera to take classical portraits, then I'm not the right photographer for their wedding.

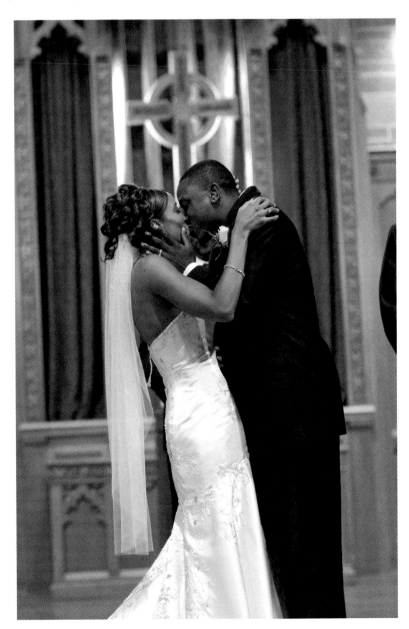

While there's an innate desire to want to book every wedding, it is not usually possible from a scheduling standpoint, and certainly not desirable. You have to select wisely, ensuring that you and the client will both be happy in the end. Chances are, if you are booking every wedding, you're not being selective enough. The case may also be that you are not pricing yourself appropriately. ❊

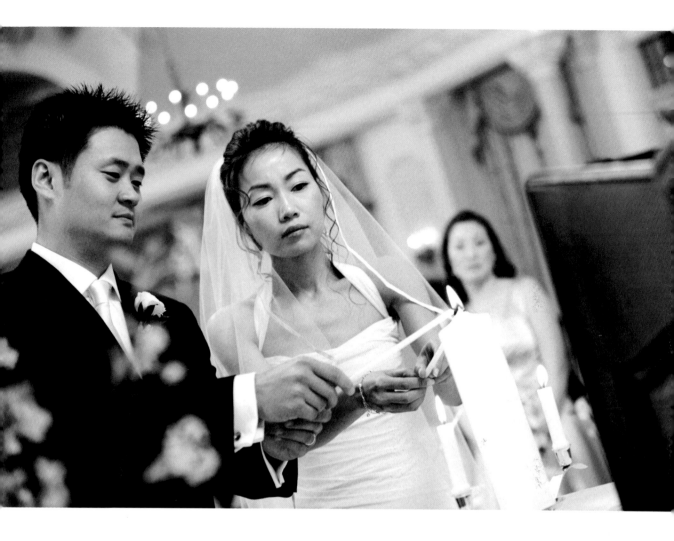

"Here's the most important thing you need to know about wedding pictures: Book the best photographer you can afford as soon as you set the date. The wedding music will fade, the flowers will die, and you won't even remember if you ate, let alone what you ate, at the reception. But the wedding pictures last forever."

Leslie Milk, *It's Her Wedding but I'll Cry If I Want To*

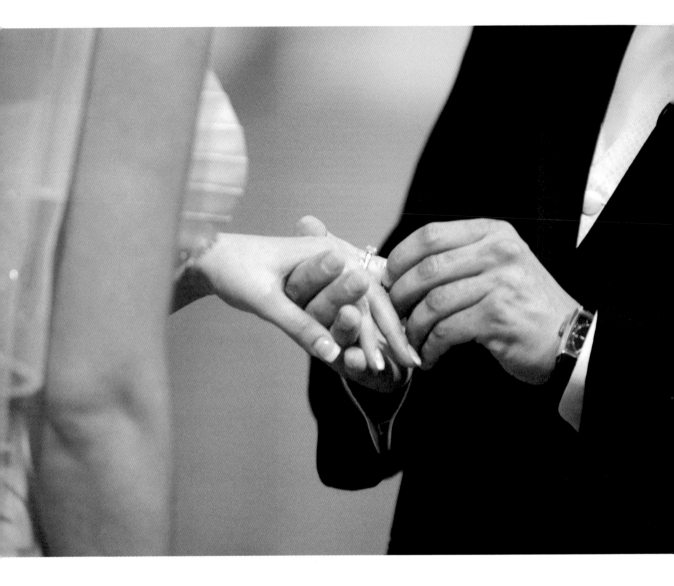

CONTRACT **NEGOTIATIONS**

Often the biggest hurdle in finalizing a deal is price. Weddings are expensive, and there are lots of unexpected costs that couples won't anticipate. But after the food has all been eaten, the thank you notes written, the dress hung up and their life as a married couple well on the way, the photographs from the wedding will still be there to transport them back to that day, that time. Even if the couple doesn't understand how important their wedding photos will be, I do and I know how much my work is worth.

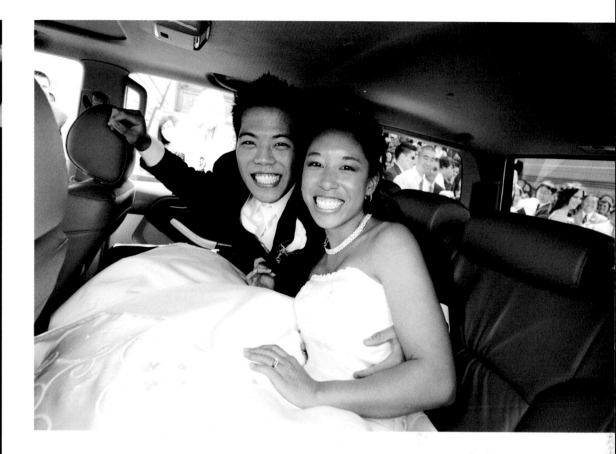

Negotiating is fine, but too often wedding photographers (photographers in general really) are tempted to lower our prices just to get the job. As photographers, we need to value the time and the investment we have made in our businesses, and when you negotiate lower prices, you are potentially losing profit in your business. If you respect yourself and your talents, clients will too. Remember that even if you do not get this client, there will be another opportunity waiting for you.

In fact, I've known a few couples who regretted their choice after deciding to work with a less expensive photographer. When they've communicated their concerns, it's already too late for me to do anything except offer them my sympathy. However, perhaps this

indicates that I didn't properly communicate the importance of photography to them from the start. If you experience this, I suggest asking them what you could have said or done before the wedding to prevail upon them the importance of choosing the right photographer for them. This may help you better communicate the importance of photography to your future potential clients.

It is important to make sure your clients understand what they will be getting in return for their money, and help them see the value in what you will provide. When a couple wants to hire me, I send them a contract, which details the services I will provide so there are no surprises later on. I include an advance fee due to reserve the date and lock me in as their photographer. I do not use the term "deposit" because legally a deposit can be refunded. Make sure they are clear that this fee is non-refundable because you are setting this date aside for them alone, and cannot take on any other jobs that day. It is not acceptable for them to cancel when you may have turned down other potential clients. �֍

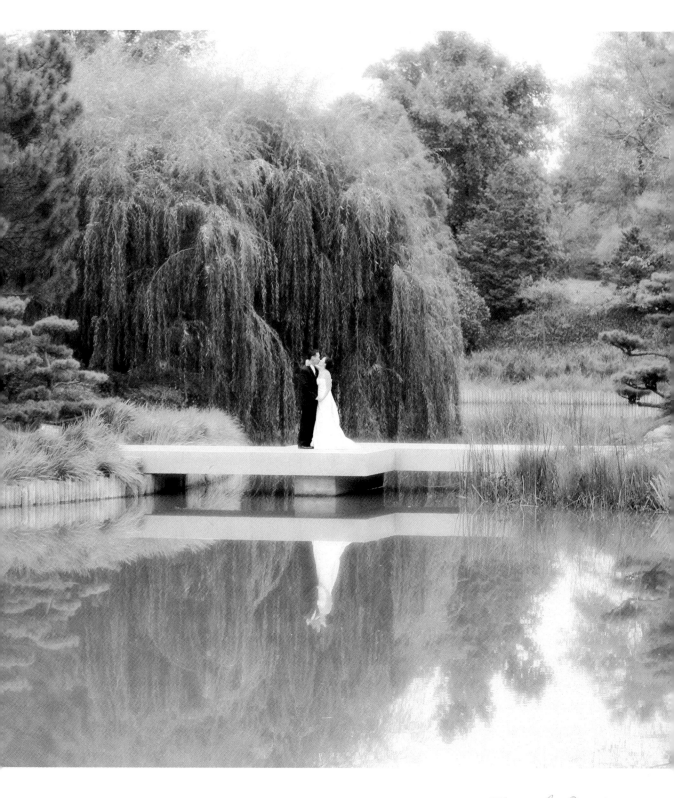

Some of the important information covered in my contract includes:

❀ Client contact information

❀ Venue location

❀ Event date

❀ The amount of time I will be shooting on their wedding day

❀ Engagement photos

❀ Assistant costs

❀ Second shooter costs

❀ Incidentals and travel costs

❀ Album costs

❀ Prints

❀ Fee schedule, including amount due for "date-reservation"

❀ When the clients can expect to receive their final images

❀ What happens if I cannot make it due to an act of God, accident or other legal issues?

❀ What happens if they are forced to cancel or reschedule their wedding?

SUMMARY

As you begin your relationship with new clients, it is important to gain their trust and remember that while you may shoot dozens of weddings each year, this is most likely a once in a lifetime experience for them. I cringe when I hear married couples complain about their wedding photographers. But when I hear a couple express how fabulous their photographer was, I smile. Although I probably don't know who that photographer was, I want to shake his or her hand and say "well done." Imagine the positive impact you can have on the couples you photograph. Let them know you understand the significance of this event and want to be part of their special day. They will appreciate you for rest of their lives. ❖

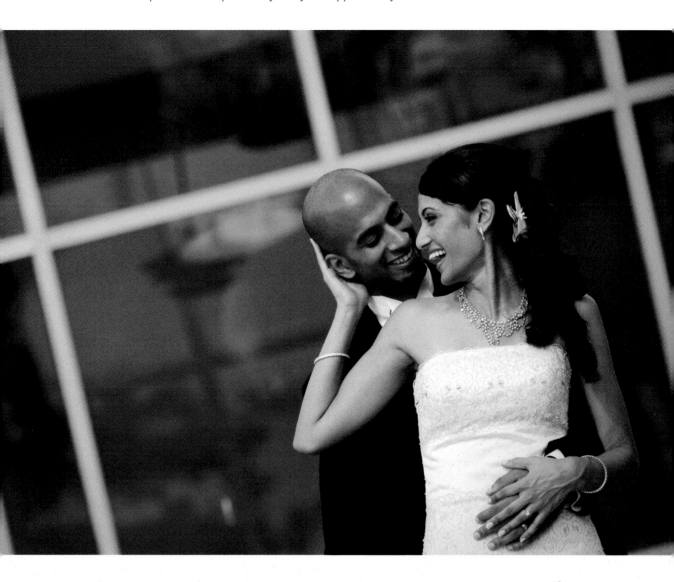

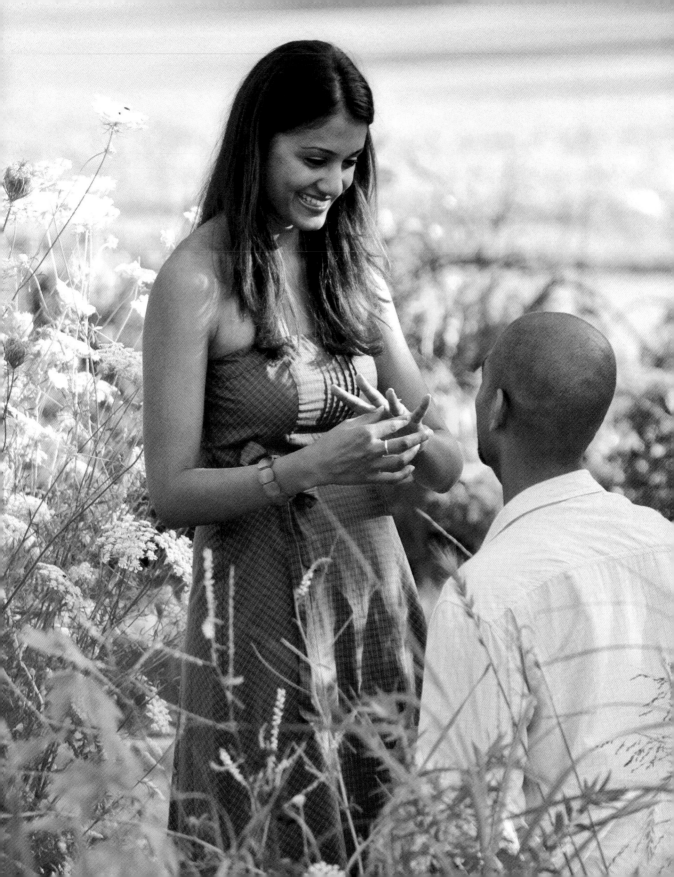

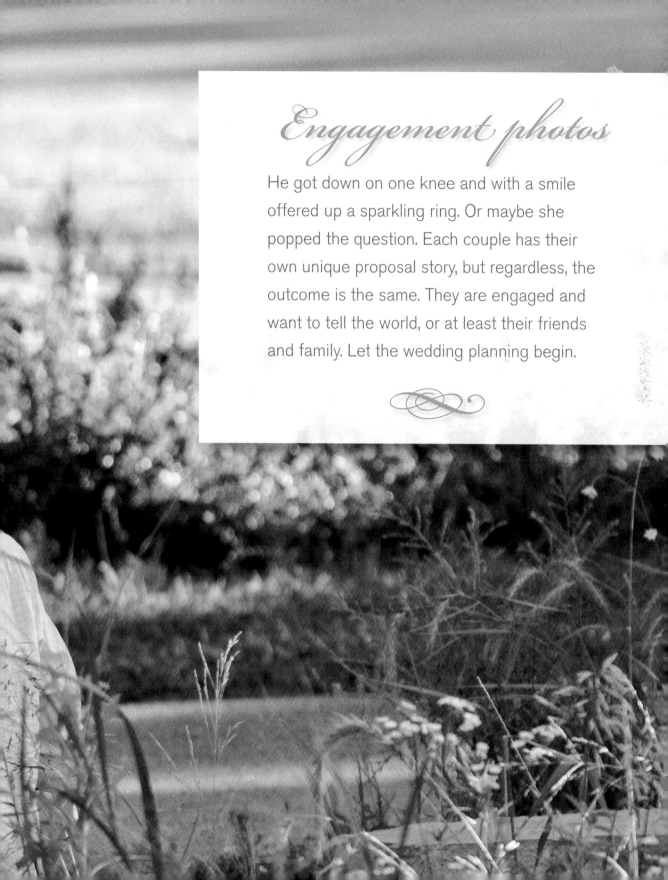

Engagement photos

He got down on one knee and with a smile offered up a sparkling ring. Or maybe she popped the question. Each couple has their own unique proposal story, but regardless, the outcome is the same. They are engaged and want to tell the world, or at least their friends and family. Let the wedding planning begin.

WHY ENGAGEMENT PHOTOS **ARE IMPORTANT**

While not part of the wedding day celebrations, engagement photos can and should be an integral part of your wedding photography services. For the couple, an engagement photo is the perfect memory of the time they decided to get married. It traditionally accompanies the engagement announcement, and as a great portrait of the couple, often finds a special place in their home for years to come. For photographers, planning and shooting engagement photos supports one of the tenets of my wedding photography philosophy; the personal relationship and trust you build with your clients allows you to get the best images possible on their wedding day. Spending more time with clients before the wedding and getting to know them increases their comfort level with you.

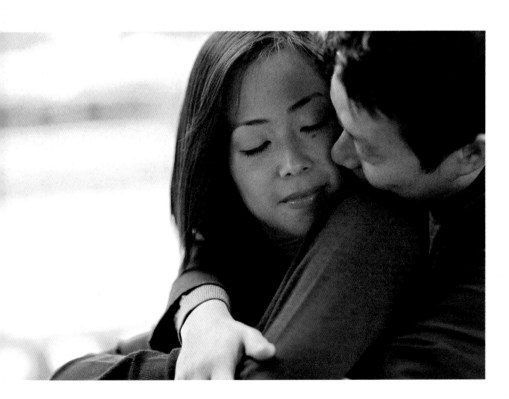

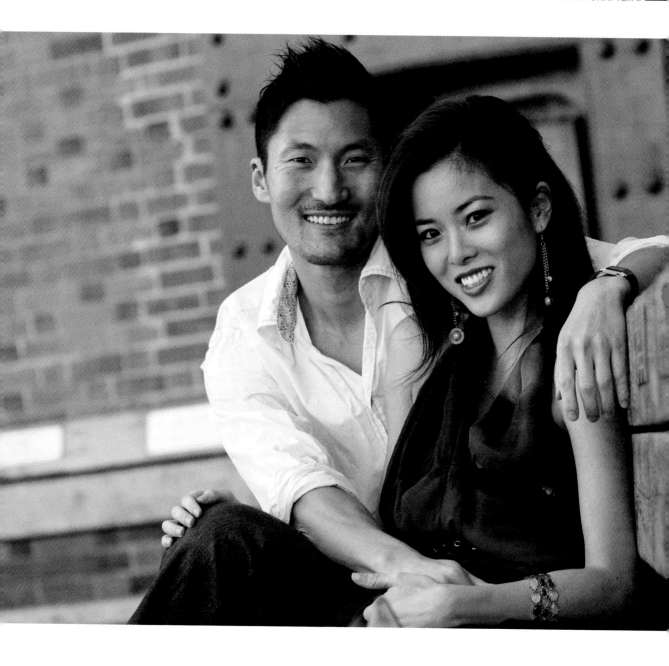

Even when I shoot destination weddings for couples who live in other parts of the country, I usually travel to the couple's hometown for an engagement shoot. We often have worked together by telephone and email to plan the wedding day photography. Unfortunately, this back and forth long-distance communication doesn't remotely compare to a face-to-face meeting. The engagement shoot lets me to get to know my clients in person.

One often-overlooked advantage to taking engagement photographs is the free marketing the photographer receives from shared engagement photos. These are the best photographs the couple has ever had taken and their first photographs on their official journey toward marriage. They will use them in the engagement announcement, on their wedding Web site, and most likely on their Facebook, MySpace, and other social networking sites. Some couples even play slideshows on their wedding day, and they may include the images you photographed at their engagement shoot. They will also likely purchase prints for themselves and their parents or other family members. In fact, by the time the guests arrive at the wedding, many of them will have already seen and been impressed by your work, making them more likely to order prints and recommend you to their friends. Think of the goodwill you will have earned by the time the wedding comes around if the couple and many of their friends and family have been admiring your work since the engagement shoot. Every time they look at the photo they will think how great their photographer is and will be much more likely to trust you to deliver the goods on the wedding day. ❧

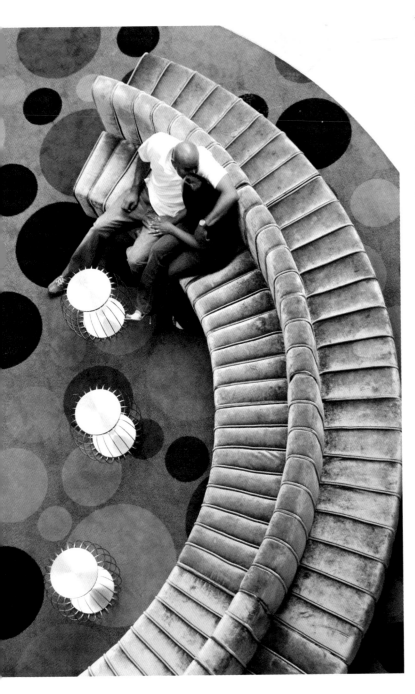

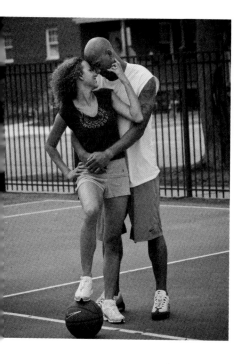

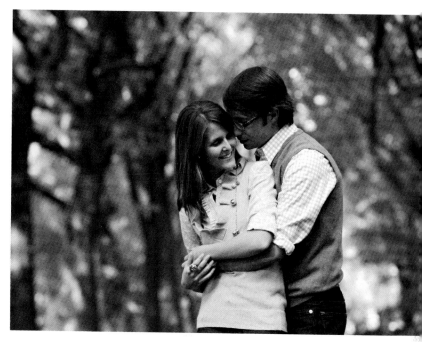

Uses for engagement photos:

* ❀ Accompany wedding announcements
* ❀ Posting on wedding Web site, Facebook, MySpace, and other networking sites
* ❀ Portraits for couple's home
* ❀ Gifts for couple's parents and other relatives
* ❀ Wedding day slideshow
* ❀ Wedding program
* ❀ Wedding favor
* ❀ Save-the-date products

THEME AND **FEEL**

As each couple is unique, each engagement shoot should create unique images that are both stunning and truly representative of the couple's style and personality. If this isn't the case with your engagement shoots, then you're not doing your job as a photographer. The theme and feel of the engagement shoot can go a long way toward giving a couple their dream photos, and many factors contribute to creating the theme and feel. Variations in location, what the couple is wearing, and how they pose will determine if the images are casual and relaxed or more staged and formal. What feeling is portrayed in the photo will depend on the personality of the couple and their comfort level with you as their photographer. ❧

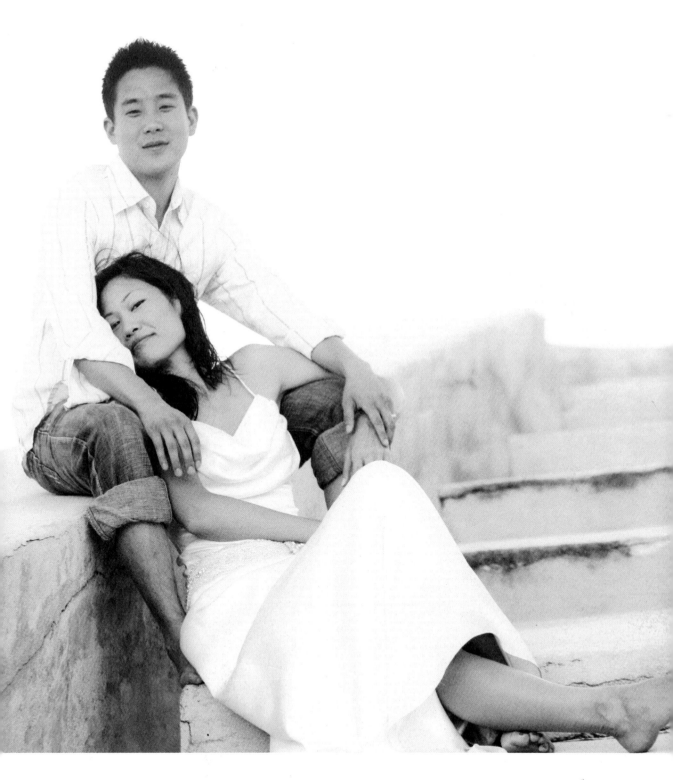

LOCATION

With engagement photos, you are not limited with the location as you are when it comes to the wedding. In fact, the engagement photos can be taken anywhere and the location should be picked with care. Consider a location that means something special to the couple, such as where they first met, went on their first date or where the proposal took place. The location might also be a place that reflects their personality. If the couple loves the outdoors, then a city landscape is a poor choice. Likewise, if they both love the hustle and bustle of the big city, then a serene park setting just won't cut it. Selecting a meaningful location for the engagement shoot can turn an ordinary portrait into an extraordinary collection of images that the couple will love and cherish forever.

Some couples have a difficult time choosing a location, so it is up to you to be prepared with suggestions as well as questions regarding their personal preferences. This will not only ensure the photos will have special meaning, but also help you learn more about the couple and in doing so,

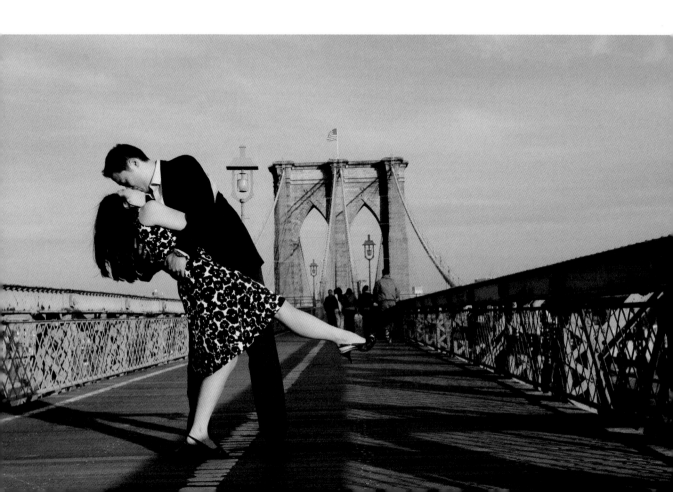

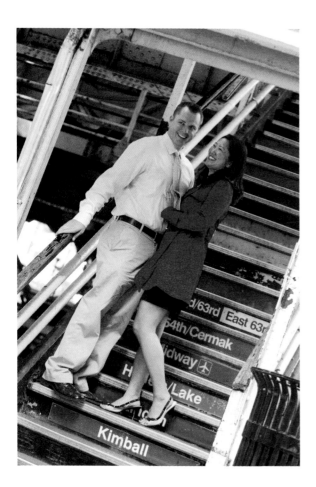

Engagement shoot location list:

❋ Wedding ceremony site

❋ Reception site

❋ Fancy hotel

❋ Local park

❋ Engagement site

❋ First date site

❋ First meeting place

❋ The beach

❋ The lake

❋ Botanical gardens

❋ Their home

❋ Downtown

❋ Scenic neighborhood

❋ Industrial area

❋ Local store (e.g. record store for music lovers)

❋ Vineyard

❋ Local landmark

❋ School campus

❋ Museum grounds

grow that rapport that is so important. Another consideration when making recommendations is the opportunity a location offers you as a photographer. I like to pick places I haven't shot before; places that can offer me something new as well as provide a great background for the couple. When I shoot in areas I am not familiar with, I ask local photographers for suggestions. ❋

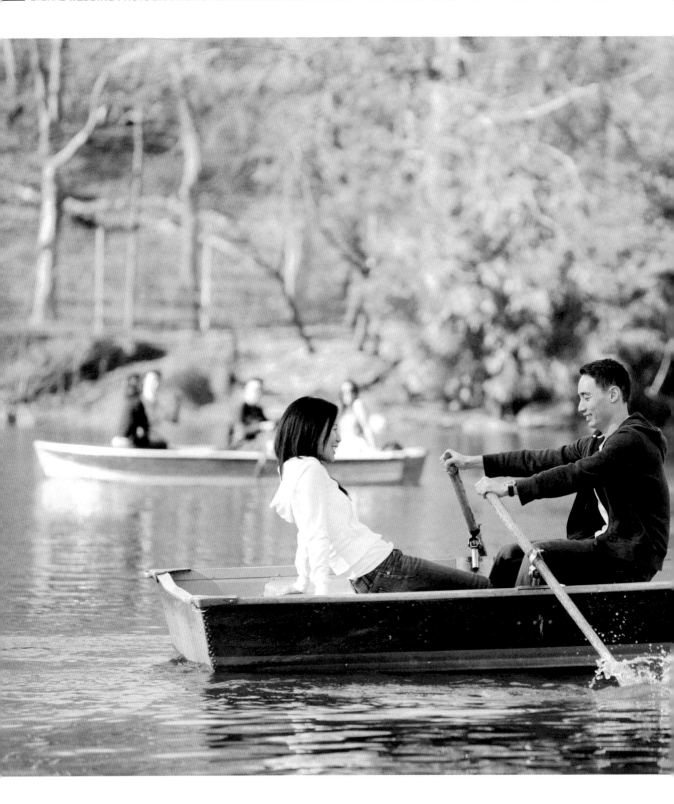

Tips for Selecting Locations

Peruse travel magazines to get ideas for your next photo shoot. They offer a variety of locations and fun facts about those places that allow you to choose a location that fits the style of your couple.

Stay connected with other photographers. They can be a wealth of knowledge about locations you have never been to before. Using online social tools such as Twitter and Facebook allows you to ask questions to photographers you are connected to, especially when you need questions answered immediately.

CLOTHING

When shooting the wedding, the apparel is set by the event. Usually a bride wears a stunning white dress and her groom looks dapper in a tuxedo. When it comes to the engagement shoot, however, the outfits can be varied and should reflect the couple's true taste. I often suggest couples bring a few choices of attire to a shoot, allowing them to change during the session. A change in clothes can create an entirely different look and feel between sets of images. Keep in mind that very light colored or very dark clothing can cause the camera's built in light meter to give faulty exposure values, and solid colors are more pleasing than busy prints. ❊

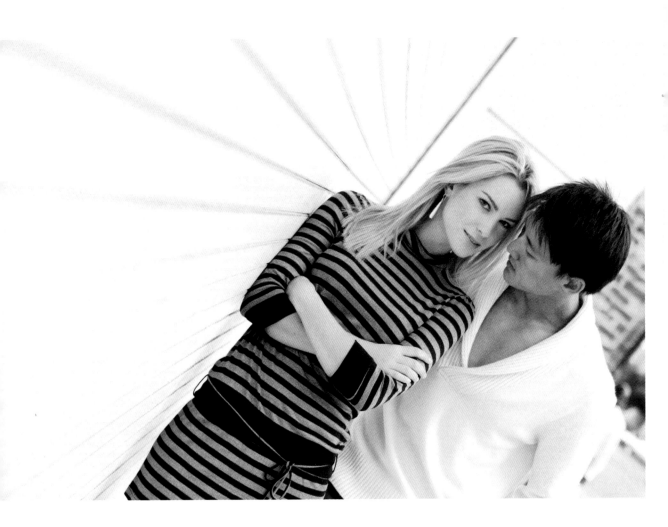

Clothing suggestions:

❈ Dress clothes - for a more formal look to their images

❈ Casual clothes - the standard black top with jeans or light shirt with Khakis

❈ Favorite clothes or item of clothing — if he always wears shorts or she is known for the wild shoes

❈ Military dress — If the military is a big part of their lives, he or she will want to be in their dress blues

❈ Favorite sports team apparel — Do they both love the same team? Or maybe they enjoy a little rivalry

POSING

For many couples, the engagement shoot is the first time they will have posed in front of a professional photographer. This is a great opportunity for you to coach the couple on how to stand and pose in front of the camera, and get them used to being the center of a photographer's attention. This really helps when it comes to the wedding day. They will likely be more comfortable in front of the lens and taking direction from you, which will result in capturing the best possible images on the wedding day.

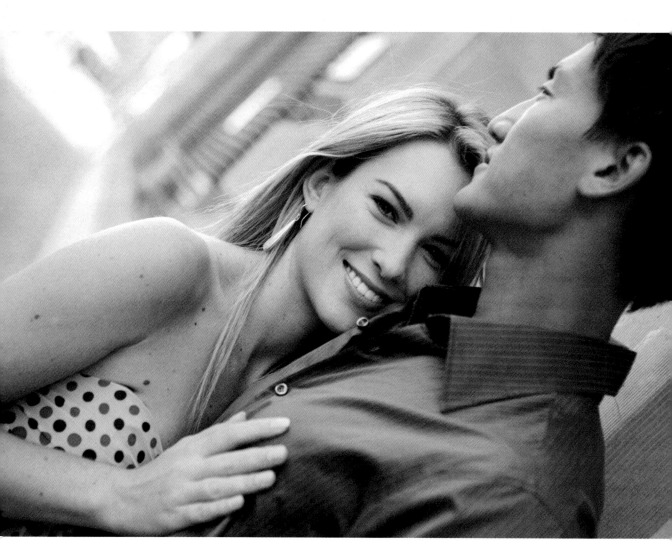

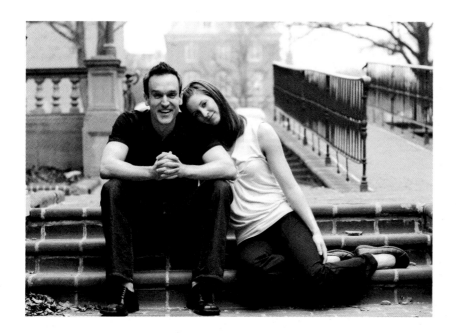

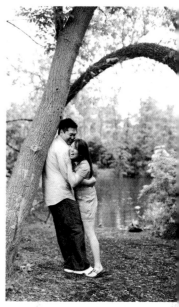

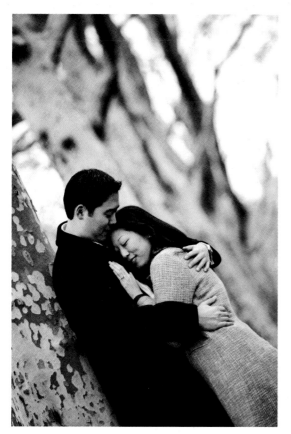

Pose suggestions:

✤ Looking at each other

✤ Holding hands

✤ On bended knee

✤ Stagger the couple

✤ Couple really laughing

✤ Back to back

✤ Sitting with bride-to-be in front of groom-to-be

✤ Kissing

In the beginning these poses are necessary to help them "warm up" to your coaching and instruction. While these poses may help the couples look nice, eventually your goal should be to allow them to be themselves. You will soon notice that as the session goes on, your couples will naturally laugh, smile, hug and do not feel as shy about public displays of affection. These are the moments you want to capture, so think of these poses as a safe set of shots and a stepping stone to getting the real natural moments. ✻

I often watch romantic movies or browse through fashion magazines to get ideas for new poses. They are full of different styles, the latest trends and are often full of actors and models who are good at posing naturally. Movies also help me see things from different perspectives, and they have a way of connecting with their viewers. You can translate that to your photography.

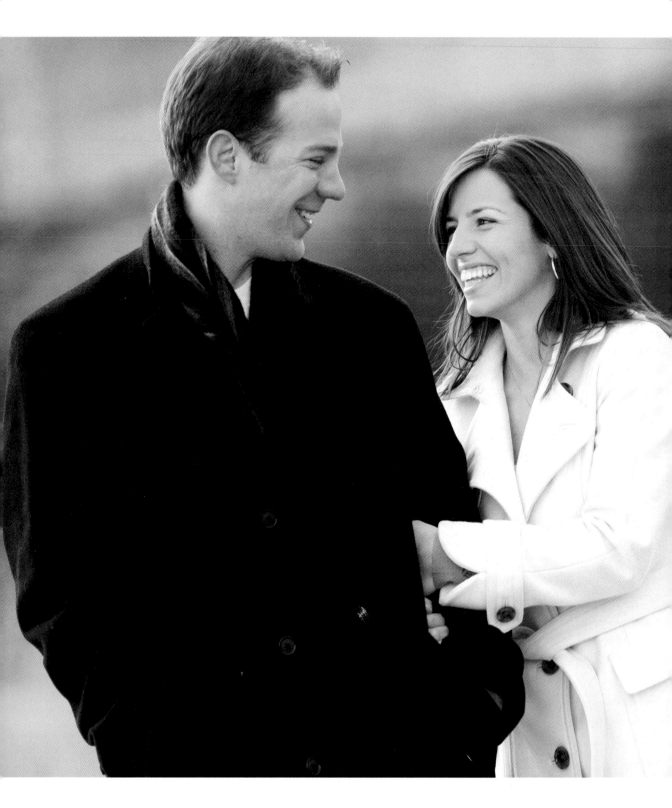

SUMMARY

Engagement photos are an important part of your wedding photography services. These images are very sentimental, allowing the couple to relive that fantastic time when they decided to get married. The shoot is also a great opportunity to impress and develop a good working relationship with your clients. Utilize engagement photo shoots to create great experiences for the couples you shoot, help them preserve once-in-a-lifetime memories and create great samples of work in interesting locations. ❄

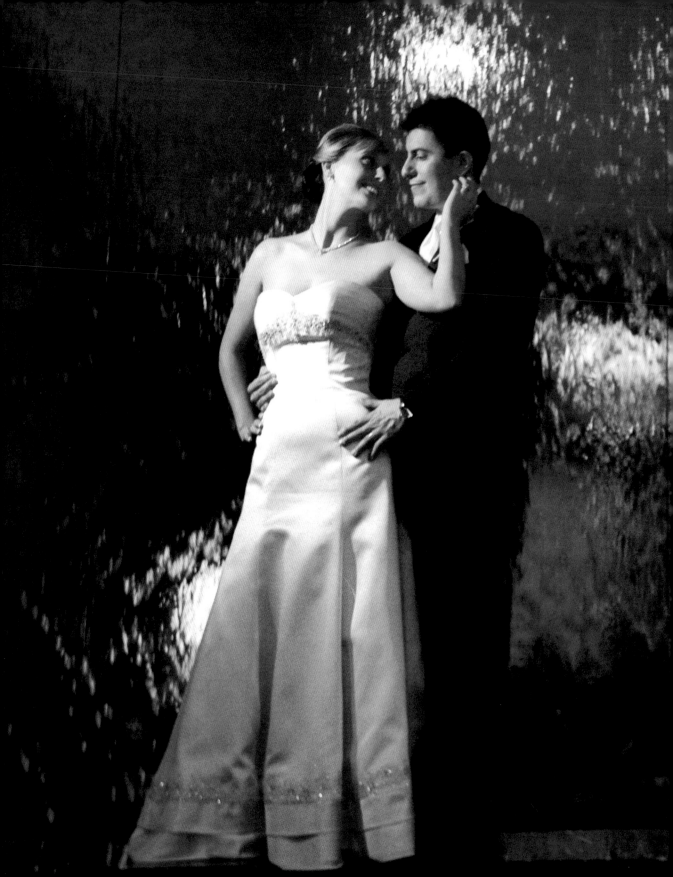

Equipment

A camera, lens, and flash are the basic tools of the trade for a photographer. Just like a painter has a set of brushes and sculptor a set of chisels, a photographer needs to have the basic equipment to capture the scene. When I think of history's great artists, the one thing they all had in common was they knew how to use the tools of their trade.

USE THE **BEST**

There are types of photography where using the best gear is not necessary; wedding photography is not one of them. I use the top-of-the-line Canon cameras, lenses and flashes. Many professional photographers use comparable equipment from Nikon. Regardless of the manufacturer you prefer, I recommend investing in the best camera body and lenses you can afford—ideally, the top-of-the-line.

It is important to use the best camera body and the best lenses available for a variety of reasons. Let's start with the least obvious. When you pick up a great top-of-the-line professional camera and lens, you just feel better about everything. It's like when you put on a great suit or great pair of shoes. It gives you a feeling of confidence, makes you look more professional and gives you more credibility.

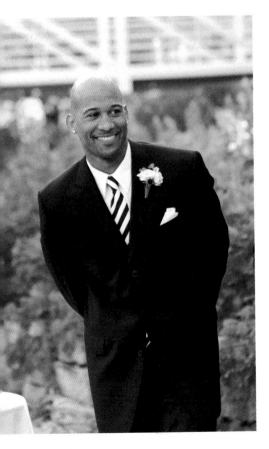
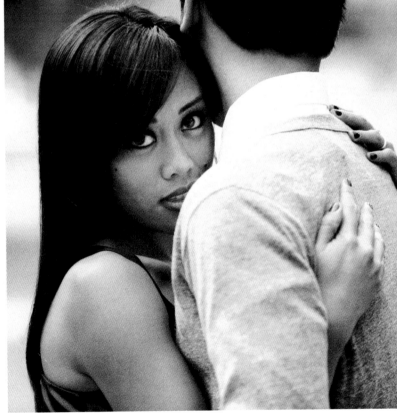

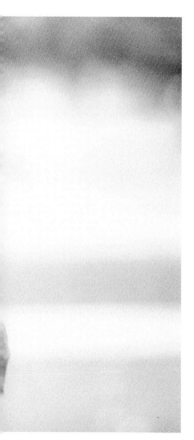

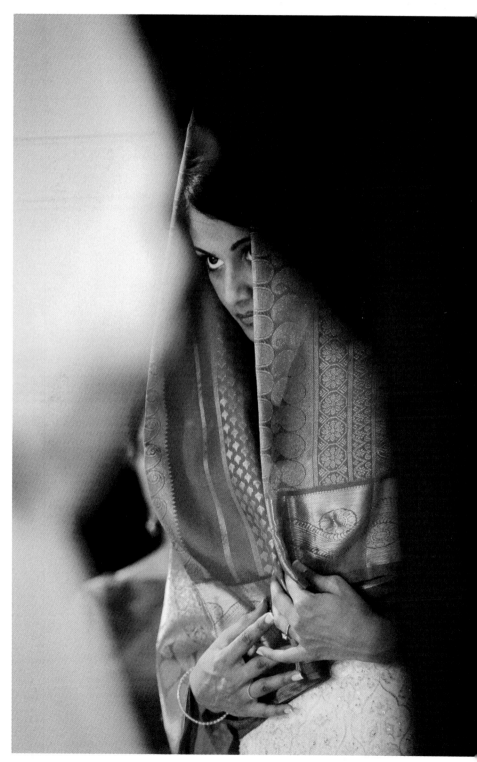

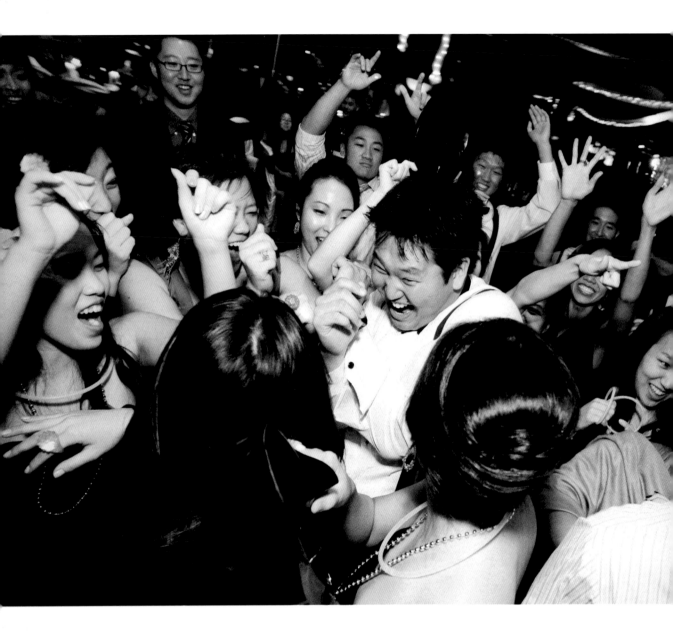

Using the best also means your gear is built to withstand heavy use and, at times, abuse. Weddings can be fast-paced, requiring you to quickly change locations and move gear. Often, there are large numbers of guests to work around and equipment can easily get bumped. Since high-end camera gear is designed for professionals, the manufacturers strive to produce durable tools that can withstand the rigors of the job.

Top-of-the-line equipment will also result in higher quality images. Camera manufacturers know their best advertising comes from people seeing what images the professionals produce using their equipment. The newest top-of-the-line cameras usually have more features, better controls and improved image processing. For example, the new direction is for camera manufacturers to increase the ability to shoot great photos in low light, which really helps wedding photographers who regularly deal with low light situations.

In essence, there is also a lot of truth to the saying "you get what you pay for." This certainly holds true when it comes to camera equipment. ❊

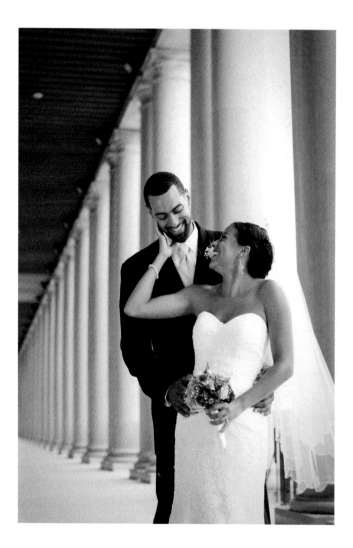

THE **CAMERA**

Canon Mark 1D IV or the Nikon D3s

Canon 5D Mark II with BG-E4 battery grips
or the Nikon D700 with MB-D10 battery grips

One of the main features to look for when selecting a camera is reliability. At weddings, there are no second chances, so it is important to make sure you have good working gear. I doubt the bride and groom would be very happy if you asked them to stop and "re-do" their first kiss as husband and wife because your equipment malfunctioned and you missed the moment.

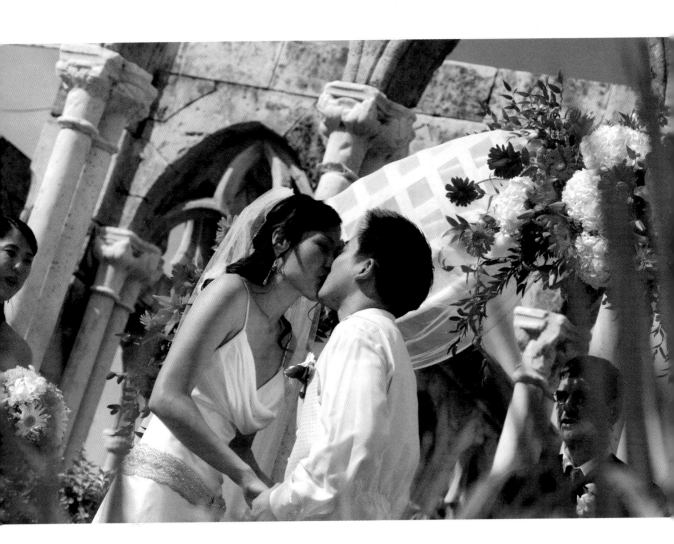

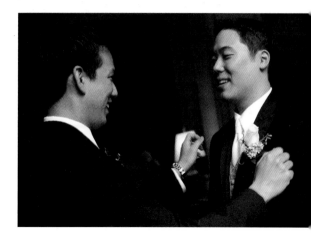

Having good working gear is a must. That said, even knowing my main camera should never fail doesn't mean I rely solely on it. I keep a second camera body in my camera bag and a backup third camera body in my car or somewhere close. That way I am covered if something goes wrong, twice over. ❈

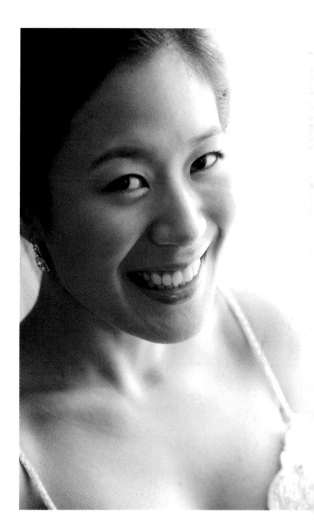

Camera Feature Checklist:

- ❈ Rugged construction
- ❈ High ISO quality
- ❈ High resolution
- ❈ Strong image quality
- ❈ AutoFocus capability
- ❈ Frames per seconds
- ❈ Vertical grip
- ❈ Extra battery pack
- ❈ Full frame vs. Cropped Sensor

THE **LENSES**

A good lens will last a lifetime, and it really pays to get the best "glass" possible. I use the L series lenses from Canon. The L stands for luxury, and these lenses are truly built with the professional in mind. Even though they cost more than other lenses, they let me create the best images possible.

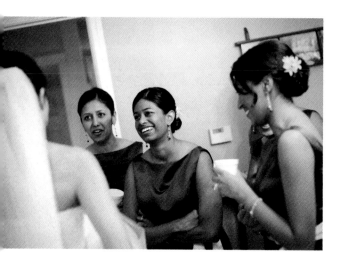 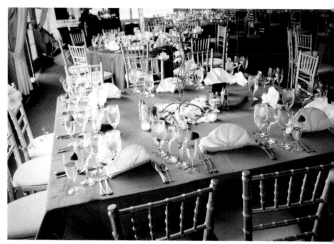

Nikon has the same lenses, but they do not have an easy way of identifying them. When it comes to Nikon, look for the following:

• AF-S means the lens has a silent wave autofocus motor built-in

• DX means the lens is designed for a cropped sensor only

• IF means the lens has internal focusing and doesn't change size

• ED is the good glass

• VR is vibration reduction technology

With Nikon lenses, the best bet is to look for lenses that fit your focal length needs and have the widest aperture possible. The easiest way to find these are by price, they are much more expensive than the other lenses. Again, whether you choose Canon, Nikon or another manufacturer, when it comes to SLR cameras, having the best lens is the best investment you can make.

Canon 24-70mm f/2.8 L USM lens

My favorite and main work lens is the Canon 24-70mm f/2.8 L USM lens. This lens from Canon is the best zoom lens in these focal lengths and is the lens I use for the majority of my work. It lets me get the shots I want and with the f/2.8 maximum aperture, I am able to not only shoot in low light, but I also have complete control over the depth of field which allows me to decide what is in focus and what is blurred. The focal lengths covered give me great flexibility. The 24mm end allows me to go a little wide, while the middle or "normal" focal length allows me to shoot so the images give you a feeling of being in the scene. The longer focal lengths let me get in closer, all without changing lenses.

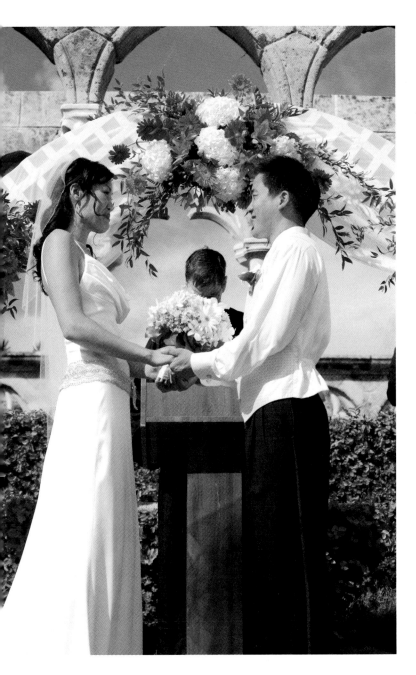

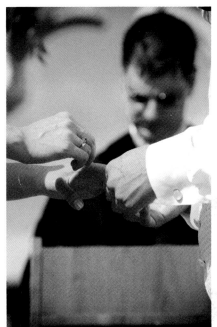

Canon L 70-200mm IS f/2.8

My second most used lens is the Canon L 70-200mm IS f/2.8 lens. Since this lens also has a maximum aperture of f/2.8, I use it in low light for more creative control by having a wide depth of field range. This is perfect for getting in close while staying out of the way.

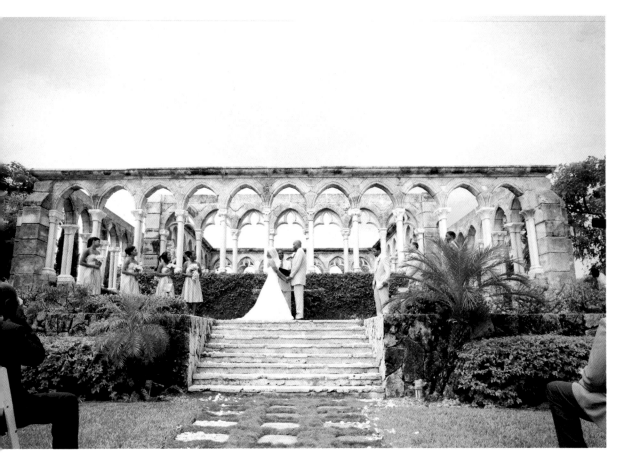

Canon L16-35mm f/2.8

The only other zoom lens I use is the Canon L16-35mm f/2.8, which allows me to get very close to my subjects. It is also useful for getting those overall wide landscape shots.

With those three lenses, I can cover a huge range of focal lengths, from 16mm all the way out to 200mm. All the other lenses I carry, which are described on the next few pages, are prime lenses and serve very specific purposes.

Canon L 35mm f/1.4

I love the versatility of this lens, but more importantly this lens is sharp and has great bokeh. The maximum f/1.4 aperture allows me to use this lens in really low light as well.

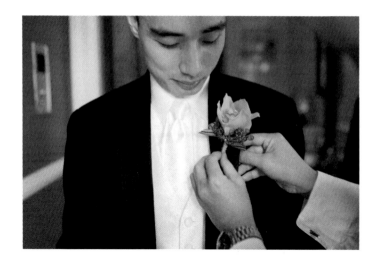

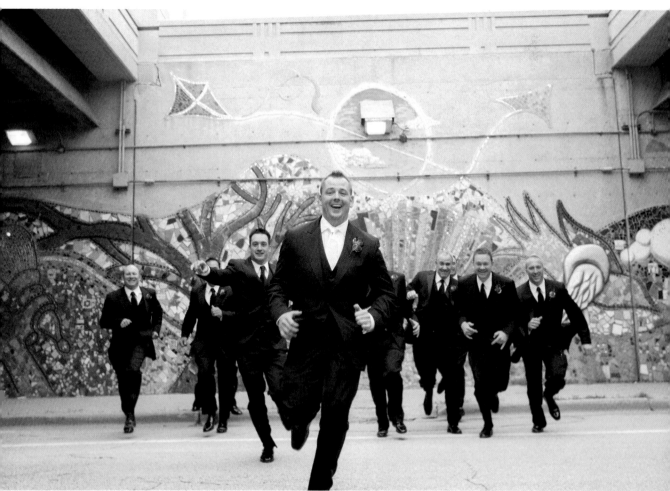

Canon L 50mm f/1.2

This is the best lens I have ever used; the quality of the image that comes out of this lens is matchless. It has an extremely wide maximum aperture, which allows me to use it in really low light situations.

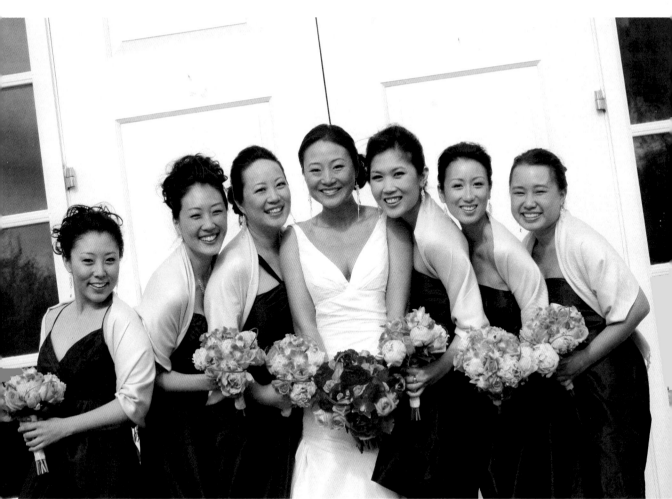

Canon L 85mm f/1.2

The 85mm lens has long been considered the best focal length for portraits, and I agree. I often use this lens for the bride and groom portraits on the wedding day. It is also a great low light lens.

Canon L 300mm f/2.8

This is a very special lens that I only use in rare circumstances when the wedding location is really huge. This lens lets me get in close from a far distance and with the f/2.8, it is good in low light situations. On the down side, it is a really big lens and can be a distraction.

Canon L 135mm f/2

I use this lens for portraits as well, but also as a lens that allows me to get close in low light situations. The 1 stop difference between f/2.8 and f/2 is huge in terms of exposure and what you can and can't do.

Specialty lenses

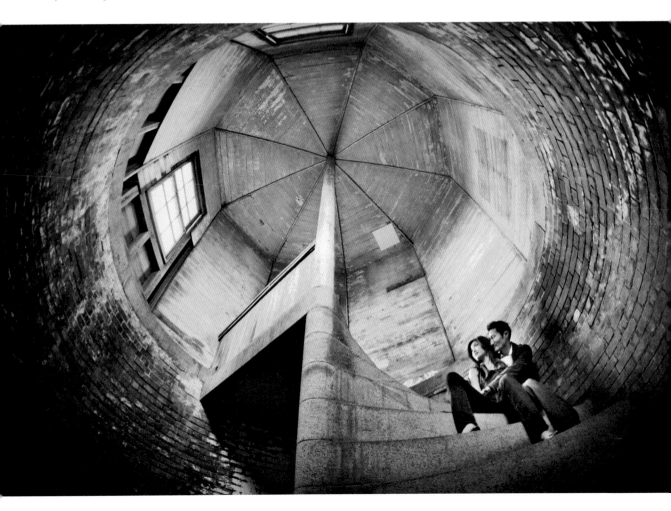

Canon 15mm fisheye f/2.8

I don't use this much for weddings, but
if used correctly it can really make some
stunning images. On the flip side, when
used incorrectly, the images tend to be
too distorted. The reception is a great
time to use this lens when guests are
dancing – as it tends to capture and
accentuate the motion more.

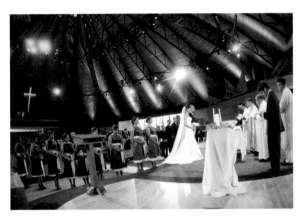

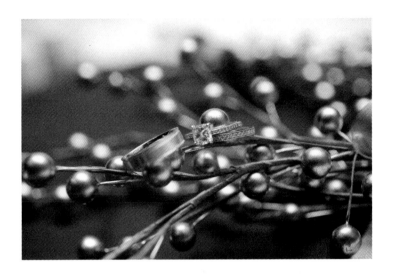

Canon Macro 50mm f/2.8
This macro lens allows me to get in really close, and I use it for the detail shots.

Lens Checklist

❉ Maximum aperture for use in low light

❉ Constant aperture lenses are useful when the maximum aperture doesn't change and the focal length does because you don't have to worry about changing the settings when zooming in or out.

❉ Variable aperture lenses, for use when the maximum aperture changes when the focal length is changed, are usually less expensive than constant aperture lenses. However, they are not as useful, especially in low light.

❉ Protective filter for the front element of your lens

❉ Focusing speed for capturing important moments. Lenses with large maximum apertures actually let the camera focus fast as they let in more light.

❉ Overall quality because the better quality of the lens will mean better image quality

❉ Rugged construction to withstand the rigors of any location

THE **FLASH**

Light is the most important part of photography and while I love to shoot using natural light, there are times when I need to add a little to the scene. That's when the Canon 580EX Speedlites come into play. I carry three of the Canon Speedlites with me, along with the Canon CP-E3 battery packs. The extra power from these battery packs improves the recycle times and increases the number of images I can take before the batteries need to be replaced.

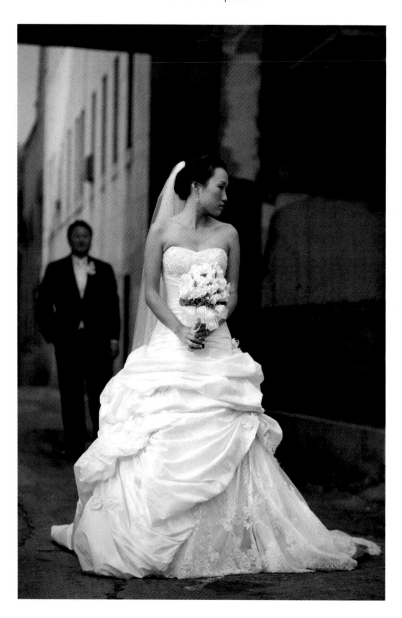

The 580EX Speedlites can be used on the camera or they can be used as slave lights on their own light stands and triggered by a master flash located on the camera. This allows me to add the light where it is needed and control how much light is added to the scene.

I use three Speedlites, two for extra fill and one on the camera for a little extra light. The flash on the camera also triggers the two external lights. The problem with Speedlites is what makes them so great for wedding work is also their biggest drawback. Because they are small and portable, they can be moved and used just about anywhere, but this also means they put up a very small hard light. There are a ton of extras that can be used to help turn the hard light from a small flash into a

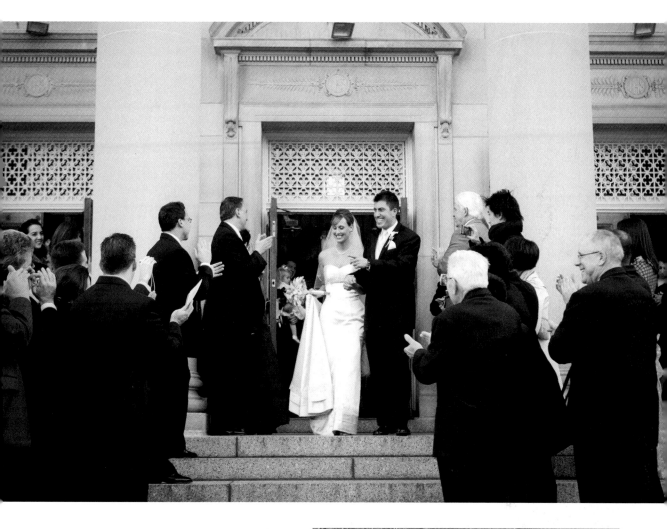

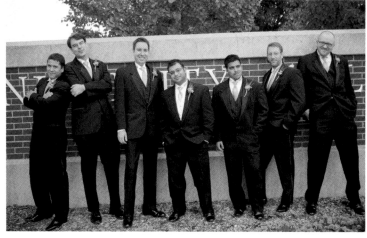

bigger, softer, more pleasing light. I use light modifiers made by Gary Fong, including the Lightsphere, the Origami and the WhaleTail to create a more pleasing light without adding much size or weight to the flash. The light modifiers can be used on the two supplementary flashes and on the main flash. Since all the flashes are the same, it is easy to switch the modifiers between the flashes as needed. To go one step further, I put on radio signal transmitting remote triggers on my flashes so they can be controlled wirelessly from my main camera. My good friend, Bob Davis has a great book about using these devices. It's called "Lights, Camera, Capture: Creative Lighting Techniques for Digital Photographers." ❈

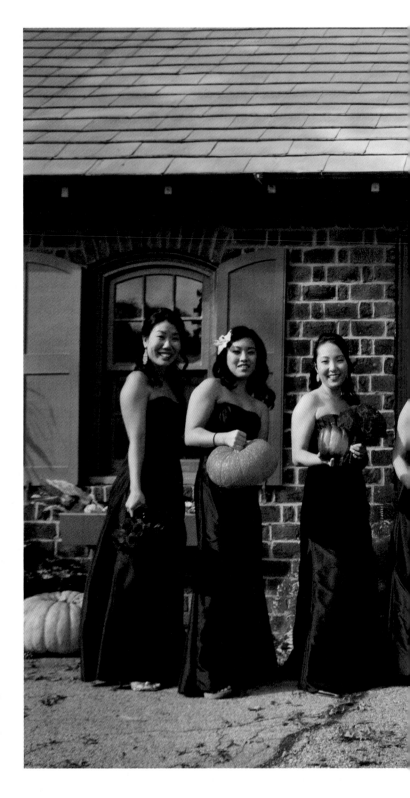

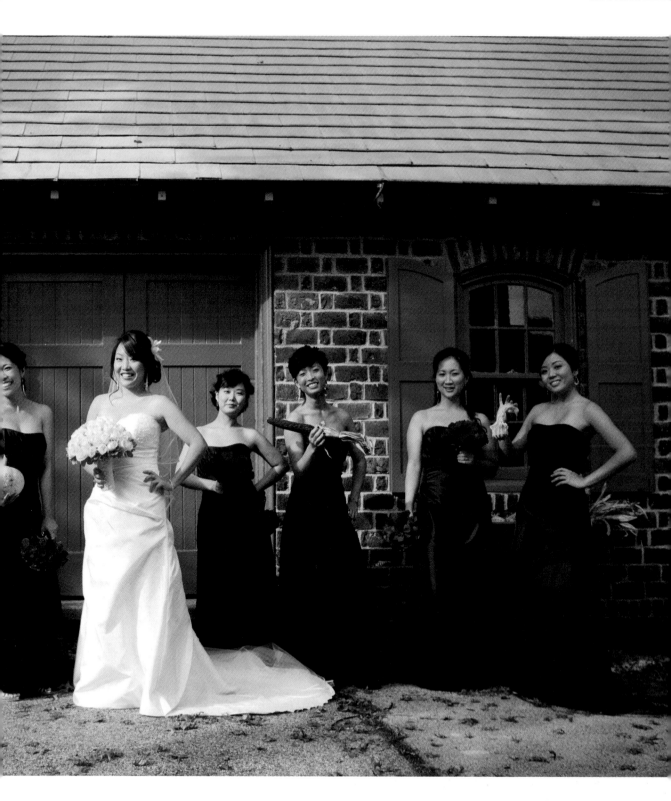

MEMORY **CARDS**

The most important thing about memory cards is to make sure you have enough of them to cover the whole wedding. I never want to take the time during the wedding to do any editing to make space on a memory card. With memory card capacities available from 4GB to 8GB to 16GB and now even 32GB, there is no reason not to have enough cards for every situation. Make sure all of them have been properly formatted and double, triple check that you have downloaded the images from your previous shoots before going to your next job. ❈

CAMERA **BAG**

A good camera bag lets you keep all your gear close and accessible so you are
not searching through the bag at the last minute when you need something
important. I use both bags made by ThinkTank (www.thinktankphoto.com) and lens
bags by Boda (www.goboda.com). These allow me to carry my gear safely and
securely in all conditions. ❊

Pre-Wedding gear checklist:

❊ Clean main camera body

❊ At least one back-up
 camera body

❊ Reset all cameras to
 initial settings

❊ Check and charge batteries

❊ Extra batteries

❊ Clean lenses
 • 24-70mm f/2.8
 • 70-200mm IS f/2.8
 • 16-35mm f/2.8
 • 35mm f/1.4
 • 50mm f/1.2
 • 85mm f/1.2
 • 135mm f/2
 • 300mm f/2.8
 • 15mm fisheye f/2.8
 • Macro 50mm f/2.8

❊ Lens cleaning cloths

❊ Lens list

❊ Formatted memory cards
 (always bring extras)

❊ Check flash units

❊ Reset flash units to
 initial settings

❊ Check and charge
 flash batteries

❊ Light stands

❊ Light modifiers

❊ Business cards

❊ Water bottle and snack bar
 for extra energy on long days

❊ One extra dress shirt, in
 case of stains

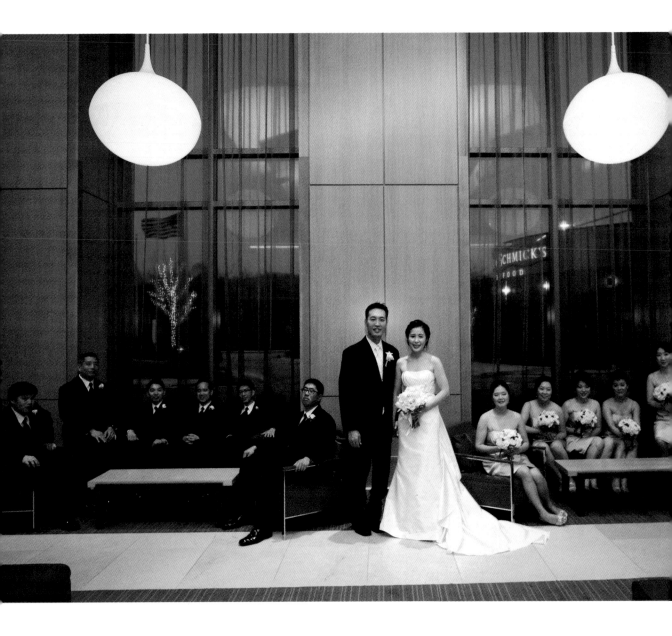

It's a good idea have backup clothes, in case of an emergency. I once ripped my pants during a shoot and had to stop by a local department store on the way to the ceremony.

SUMMARY

Investing in high quality equipment will give you the reliable tools you need to make great pictures. With a variety of camera bodies, lenses and flashes you will be prepared to shoot in any location and can be as creative as you and your clients want. Remember to check and clean equipment before each shoot, and be sure to carry back-ups in case you need them. ❉

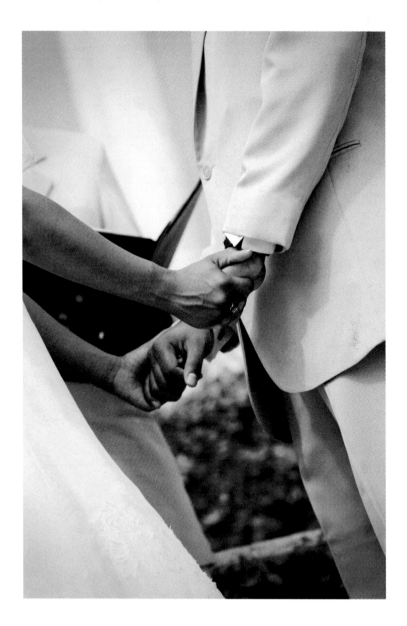

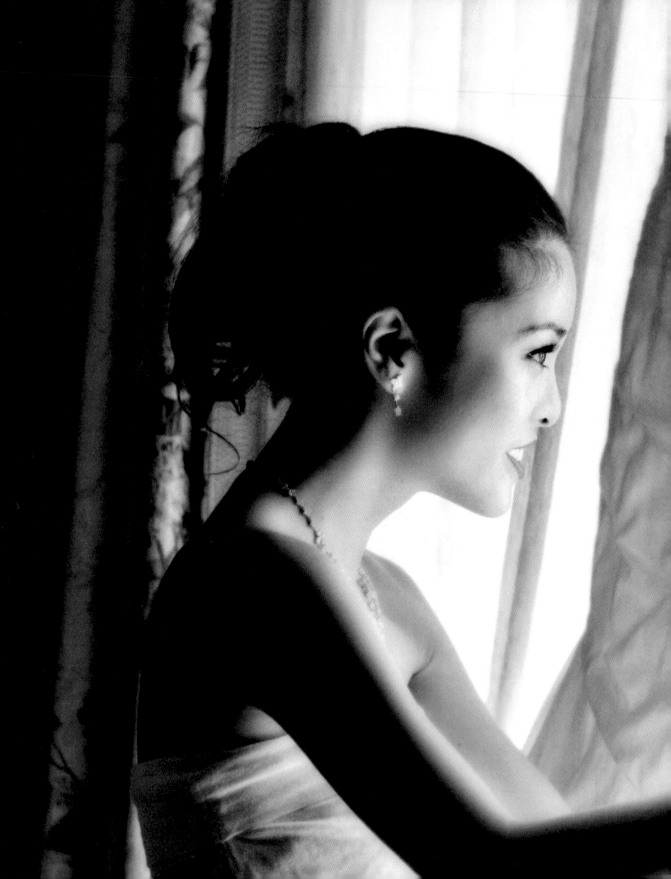

Preparation

Although nothing like what the bride and groom must do, you will also have a checklist of essential preparations to make before the wedding day. The more work you put into the event before it happens, the easier the shoot will be, and the more satisfied everyone will be with the results. Preparing for the wedding day involves understanding the couple and becoming familiar with the locations of the ceremony and the reception, as well as the wedding schedule.

LOCATION

One of the most important decisions a couple makes when planning their wedding is where to hold the ceremony and the reception. As I'm sure you know, sometimes the ceremony and reception are held at the same place. Other times they are miles apart. Obviously, being familiar with the locations is important from a technical point of view. You need to know ahead of time what type of lighting you can expect, where you can find the best back drops, and what challenges you may face. Yet, you shouldn't limit your focus on the location to identifying technical concerns alone.

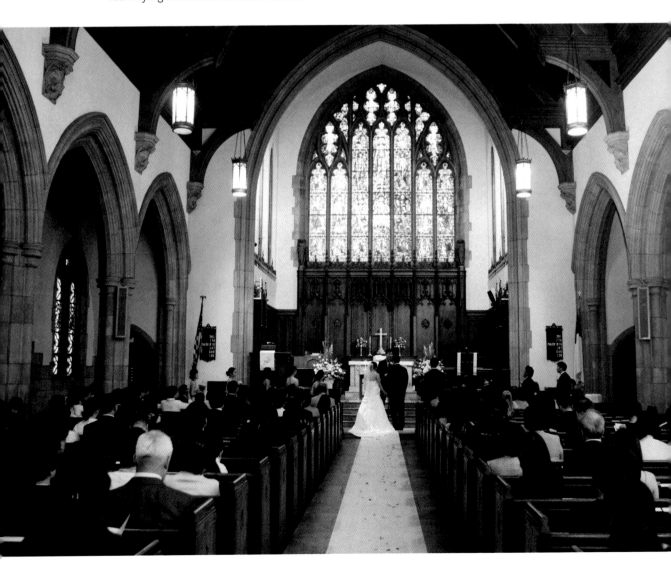

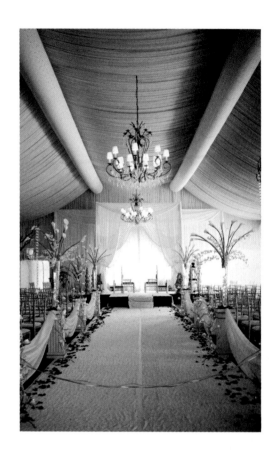

Wedding ceremonies and receptions can take place in a wide variety of places, from traditional historic churches to exotic sandy beaches. The location chosen nearly always has special meaning to the couple, and as the wedding photographer, you should be sure to ask the couple why they picked each location. Are they getting married on the beach because they love the outdoors? Or is it a big church wedding because they both have the same religious beliefs? In understanding what is special to them, you can better identify the important characteristics of the location that should be captured in your photography. Discussing their reasons for selecting their locations also shows interest in them and in the decisions they made for their wedding day, helping build important rapport between you and your client. ✿

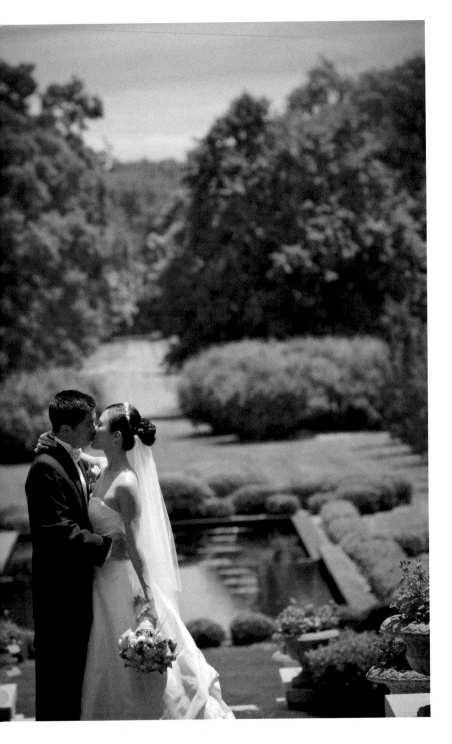

SCOUTING **AHEAD**

When it comes to wedding photography, knowing the location and layout of the wedding ceremony and reception is essential to picking the best angles, the best backgrounds, and knowing what gear you need to use. If possible, I recommend scouting out the locations of both events ahead of time. Use the shot list template at the back of this book, and make sure to study each of the areas where specific shots will take place.

Sometimes it is not possible to visit the site before the wedding. If this is the case, research the locations on the Internet to look for images you can study. You can also contact other photographers who may have shot at the locations or event coordinators at the locations to ask questions and request images. ❋

Location shot list:

* Bride dressing area
* Groom dressing area
* Relaxed pre-ceremony portrait location
* Ceremony site
* Relaxed pre-reception portrait location
* Reception area
* License signing area
* Toast location
* Cake cutting area
* Dance floor

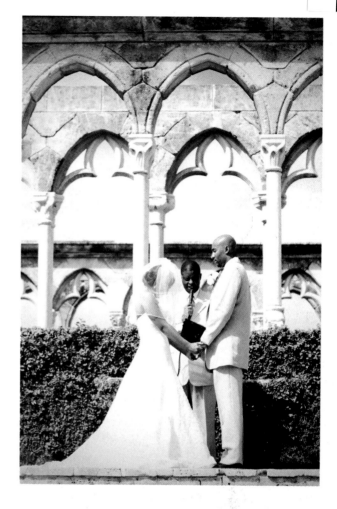

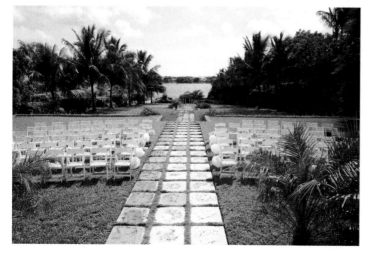

BACKGROUNDS

A good background can make an average photograph into a great one. One key to being a great wedding photographer is the ability to pick out areas that will make great backgrounds. As you scout the wedding and reception sites before the wedding, look for fun and interesting background locations.

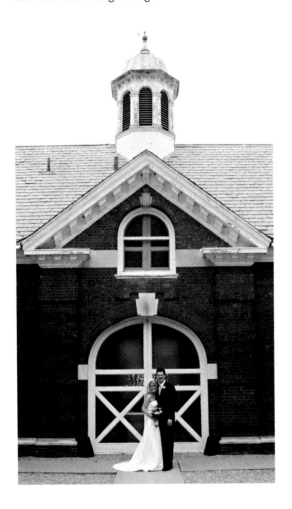
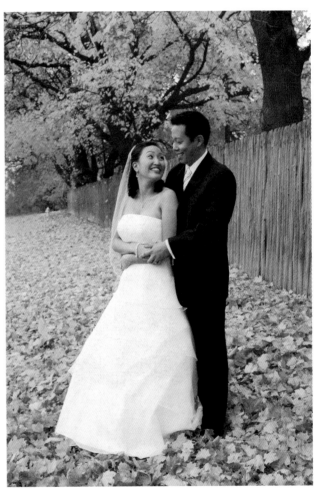

Knowing beforehand where you plan to take the photographs will really increase your chances of getting great images instead of average ones. Background is important, but I also believe sometimes you can make an ordinary background into something extraordinary with how you crop, position your client and use the angles. You may not always find the best background when working at some venues, but use that obstacle to challenge yourself to create interesting opportunities. ❧

Things to look for:

* Areas that don't compete but compliment the subjects

* Clean lines that don't distract

* Areas with uniform light

* Look for symmetry

* Repetition

* Color – look for colors that matches what the couple is wearing

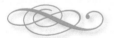

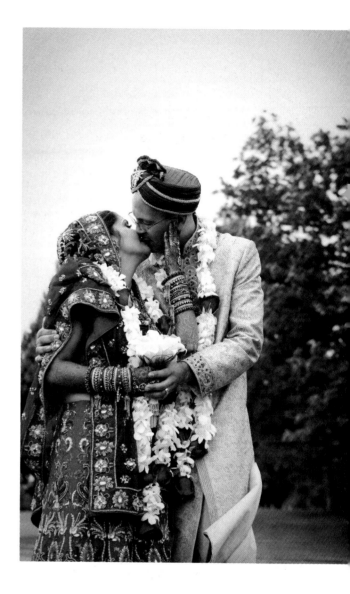

Using a shallow depth of field will help make your subject stand out against any background. Using an f-stop of f/4 or wider will make the background blur into a nearly unrecognizable blob of color.

TIME OF **DAY**

The time of day the wedding takes place will directly impact the photographs because of the position of the sun. This is true even if the wedding is held indoors since it will determine how much light will be coming in through windows and doors. For example, in churches, a bright afternoon light can make stained glass windows shine and radiate bright colors, which can cause a colorcast to be present in your photos. No bride and groom will look good with a shaft of bright red or green light falling across their faces, and while it is possible to fix these problems using Photoshop, it will take hours and could be avoided by knowing where the light falls in the first place.

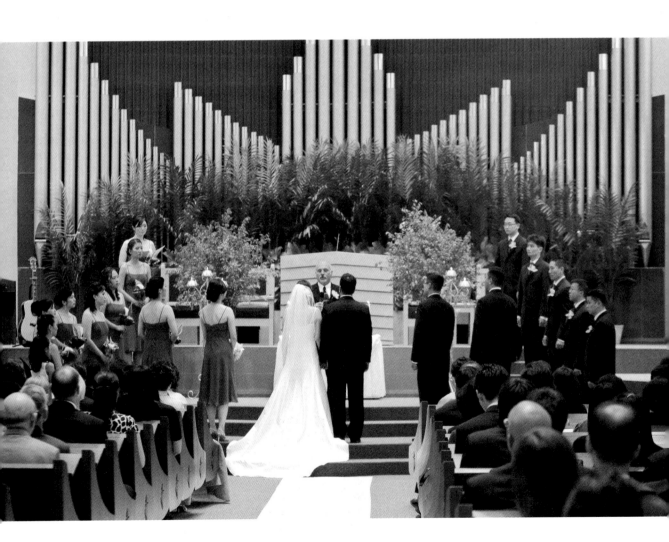

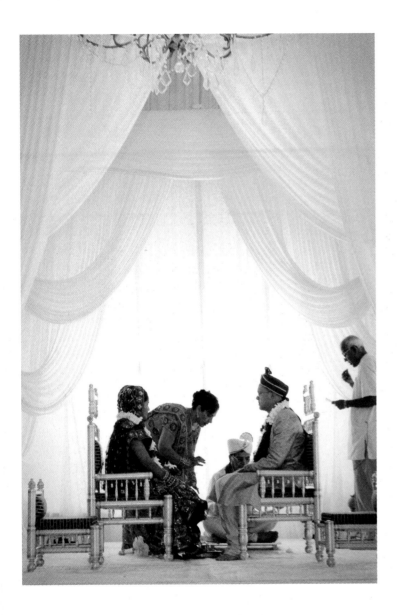

When scouting the wedding site, if possible, it's best to visit at the same time of day that the wedding will be taking place. This allows you to look for areas that are in deep shadows or bright direct sunlight that can cause problems for your images. Keep in mind that as the day progresses the natural light will keep changing. As the sun gets lower in the sky, the angles of the shadows will change and so will the quality of the light, which is diffused as it travels due to the angle of the sun. Photographers love to shoot during the "golden hour," that time right before and after the sun sets. Obviously, not all weddings are planned for this time of day, so you must see what lighting will be available and how it will impact your photography.

Light has a color and that color can influence the mood and tone of your images. The more red in the light the warmer the images will feel, while the more blue will cause your images to seem colder. While light might all look the same to our eyes, different types of light look very different to the sensors in our digital cameras, which requires proper adjustment with the white balance. The key is to understand the different light you might be shooting under and set the White Balance on your camera to match the lighting conditions. This will give you the most accurate color and help with any unwanted colorcasts. Many times, the Auto White Balance on your camera will be able to accurately render the correct colors, but if you want to understand what effect the light has on your images, consider the list of light sources on page 12 of this chapter.

In addition to an Auto White Balance setting, your camera will also allow you to pick between the following: Tungsten, Florescent, Shadow, Cloud, Daylight and you can set the actual Kelvin temperature of the light, if you know it. These settings allow you to fine tune the White Balance when photographing. It is also possible to correct the White Balance in post production using software, although it's best if you can be accurate when shooting.

When different types of lights are present in the same image, there can be a colorcast that can ruin a perfectly good image. It is up to the photographer to decide which of the light sources is the strongest in the scene and to set the white balance accordingly. ❊

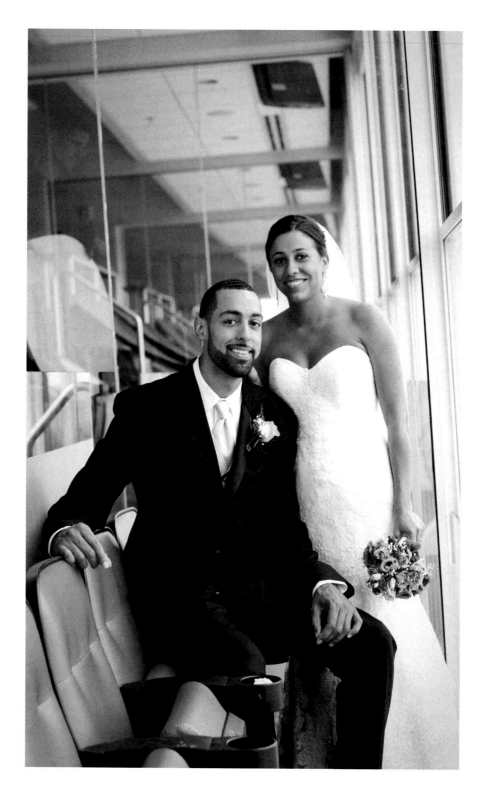

Light Sources from reddest to bluest:

❋ Candlelight

❋ Sunset / Sunrise

❋ Household Incandescent bulbs

❋ Photographic Tungsten bulbs

❋ Early morning / Late afternoon

❋ Halogen lights

❋ Fluorescent lights

❋ Mid afternoon sunlight

❋ Average noon daylight

❋ Electronic flash

❋ Overcast sky

❋ Shade

❋ Clear blue sky

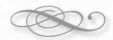

WEDDING
SCHEDULE

The wedding schedule is a formalized plan designed to keep the wedding moving. With so many different elements involved, from hair and makeup before the wedding to the getaway car whisking the bride and groom off to start their new life together, everything needs to be planned ahead of time. As the wedding photographer, you need to be involved with the creation of this timeline so you know when and how long you will have to capture each and every part of the wedding. Likewise, the wedding planner will need to know how long you need to capture the portraits before and after the ceremony. The wedding schedule can be broken into three distinct sections:

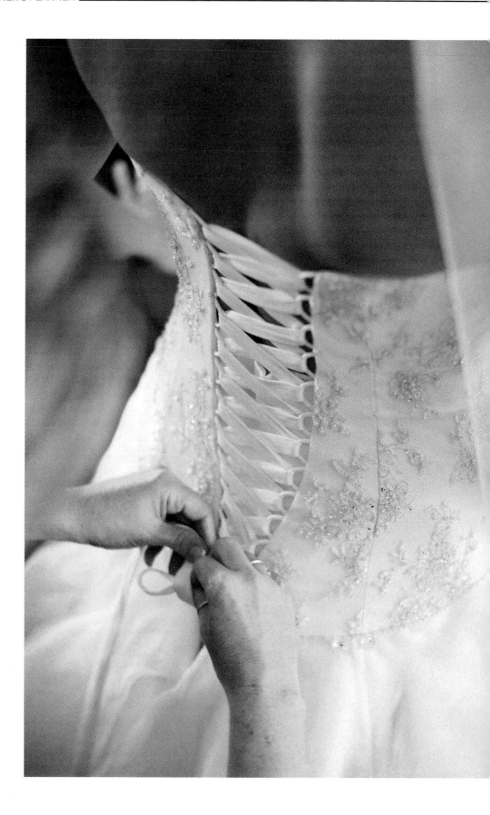

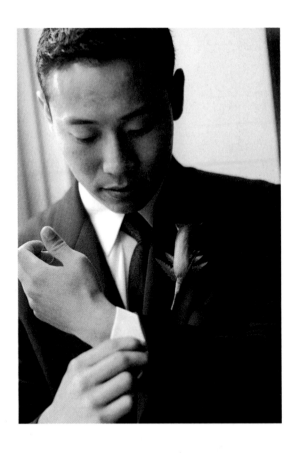

Before the ceremony:

* Bridal party arrive

* Photographer arrives

* Photograph venue
 exterior / interior

* Hair and make-up begin

* Groom and his side arrives

* Photograph dress

* Bride gets dressed

* Photograph bride
 getting ready

* Groom gets ready

* Photograph groom
 getting ready

* Photograph the rings

* Bride's and groom's
 families arrive

* Pre ceremony portraits

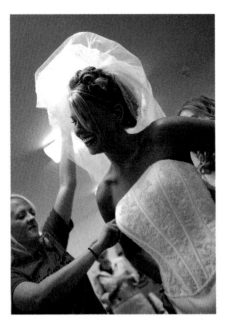

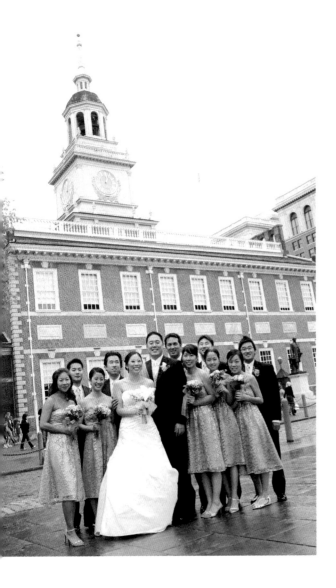

Wedding Ceremony:

❋ Guests start to arrive

❋ Photograph candids of guests

❋ Bridal party lines up for processional

❋ Processional starts

❋ Photograph processional

❋ Flower girl

❋ Bridal party

❋ Bride walks down aisle

❋ Photograph bride and groom first look

❋ Ceremony begins

❋ Special readings

❋ Vows

❋ Ring bearer

❋ Ring exchange

❋ Special ceremony moments

❋ Ceremony ends

❋ Bride and groom walk up aisle

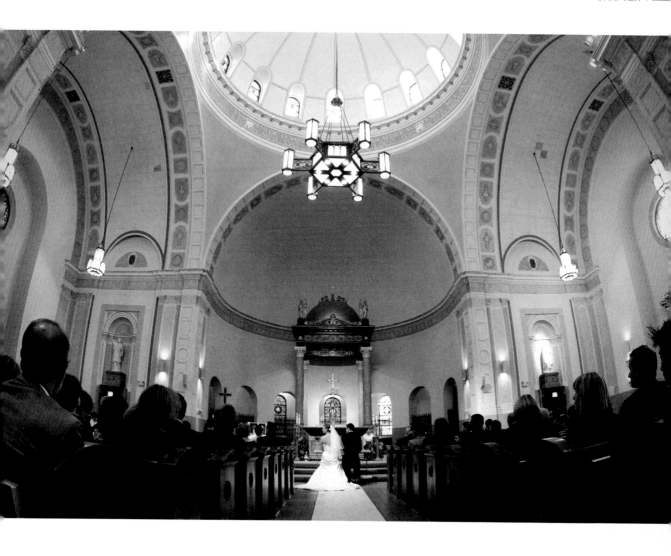

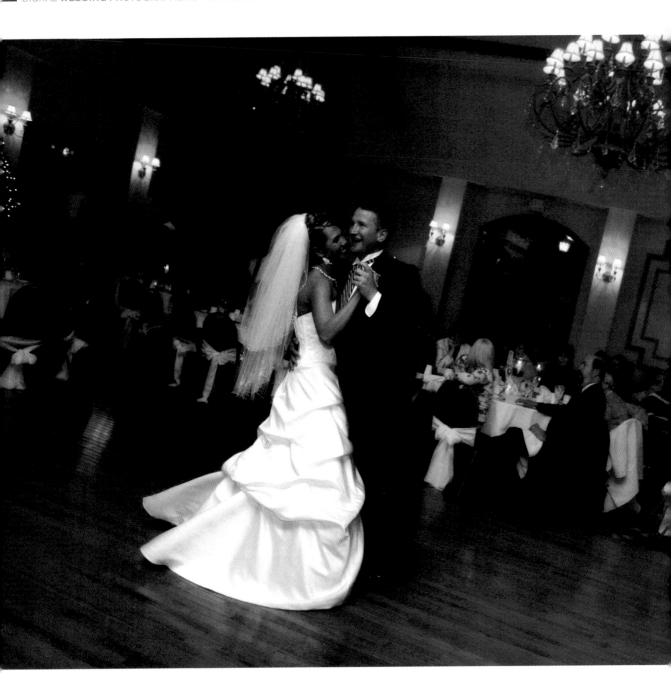

Once the schedule is set, it is up to you to get the shots you need in the allotted time. If you take too long to set up and capture the pre-ceremony portraits, then the ceremony will start late, the reception will start late and the entire schedule will be delayed. You do not want to be the one responsible for

Reception:

❋ Cocktail hour begins

❋ Pre reception portraits

❋ Bride and groom
grand entrance

❋ First dance

❋ Bride and groom are seated

❋ Dinner

❋ Best Man toast

❋ Maid of Honor toast

❋ Other toasts

❋ Groom toast

❋ Bride and groom dancing

❋ Father/Daughter dance
and Groom/Mother dance

❋ Garter toss

❋ Bouquet toss

❋ Cake cutting

❋ Bride and groom depart

guests being served cold food, so make sure if you tell them the photos will take 30 minutes, you are really done in 30 minutes. When dealing with a large crowd, it's usually a good idea to pad the amount of time required to allow for unforeseen circumstances such as when family members arrive late. ❋

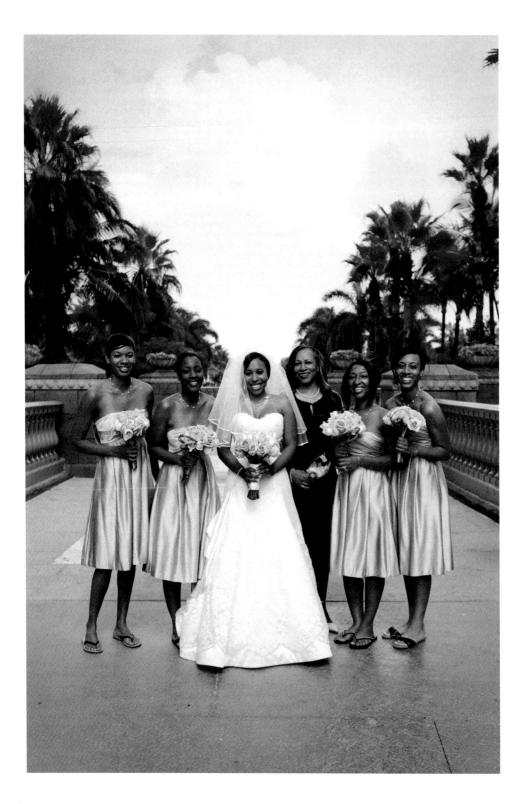

SUMMARY

Being a great wedding photographer involves much more than just showing up at the ceremony and reception with your equipment. The more you prepare for each shoot, the better images you'll capture. Understanding why the couple chose their ceremony and reception locations will help you capture images that convey the couple's unique style. If possible, scout the location before the wedding day and be sure to work with the wedding planner to create a well-planned schedule so on the day of the events, you can focus on creating a beautiful product for your clients. ❉

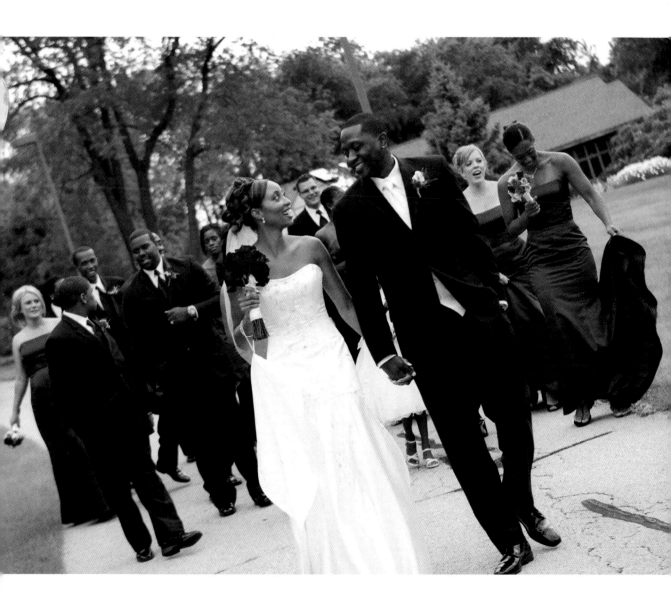

Rehearsal / rehearsal dinner

Many couples gather their entire wedding party for a rehearsal the day or evening before the wedding. This wedding rehearsal ensures everyone who plays a part in the wedding is comfortable with their responsibilities before, during and after the ceremony. Usually immediately following the wedding rehearsal, the parents of the groom host a dinner for everyone who took part in the rehearsal.

While not a very common practice, photographing the wedding rehearsal and rehearsal dinner presents some fantastic photo opportunities. Where the wedding can be a very formal event, the rehearsal usually has a much more relaxed and informal tone, allowing you to capture a set of images that can show a fun and playful side of the wedding party. Attending these events also gives you a chance to better get to know the bride, groom and wedding party before the big day.

PHOTOGRAPHER'S **PURPOSE WHEN ATTENDING**

Some photographers believe going to the rehearsal will stifle their creativity, but I believe if you can attend the rehearsal, you should. Often, the bride and groom do not think about having their wedding photographer at the rehearsal and dinner, but you should suggest it when you initially discuss your services with them. Explain that your attendance at these events can capture some very important memories as well as make the actual wedding shoot run more smoothly. ❖

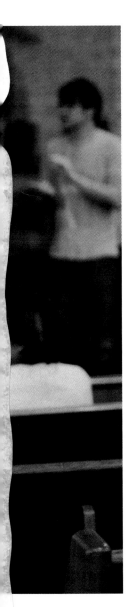

Benefits of attending and shooting the rehearsal events

❀ Familiarize yourself with the locations before the wedding day

❀ Eliminate surprises about where the bride, groom, officiate and the wedding party will be when the actual ceremony takes place

❀ Get to know and build rapport with the bride, groom and wedding party

❀ Capture relaxed, informal images

❀ Network with the wedding party and other guests as potential new clients

SOME REHEARSAL TIPS

Wedding parties range in size. Sometimes couples only have two people, a maid or matron of honor and best man, stand up with them. Other couples have many bridesmaids and groomsmen. Either way, it is helpful to know who is who before the big day, and the best way to put names with faces is to ask the couple to supply a list of names and photographs of the wedding party before the wedding. Then if you go to the rehearsal events, you can greet each person in the wedding party by name and talk to him or her for a minute or two. This really helps when it comes to shooting the wedding because the wedding party feels they already know you, making it a lot easier to position them for the portraits and group photographs.

When shooting destination weddings, I am usually on site when the rehearsal and rehearsal dinner are taking place. Even if I was not hired to shoot the rehearsals, I usually go and shoot some photos anyway. It helps the bride and groom, wedding party, and other guests become more comfortable having me around taking photos, and helps build a network of potential new clients when members of the wedding party and other guests see me with a camera as much as possible. Remember to carry business cards with you, in case someone asks.

Rehearsal shot list

- ❋ Bride and groom arriving
- ❋ Bride practicing her walk down the aisle with her father
- ❋ Wedding party in position
- ❋ Bride and groom at alter
- ❋ Officiate
- ❋ Ring bearer and flower girl
- ❋ Bride and groom practicing the vows
- ❋ Bride and groom practicing the kiss
- ❋ Organist or other musicians, and soloist
- ❋ Informal group portrait
- ❋ Bride and groom with parents
- ❋ Bride with maid or matron of honor

In many ways, shooting the rehearsal dinner is very similar to shooting the wedding reception. Start with the overall shots of the room, including details about the meal, the tables and signage welcoming the party, if applicable. Then make sure you get shots of the bride and groom, guests, and any toasts or other special moments. There are usually toasts made by the father of the groom as the host the rehearsal dinner, and the groom. Because there is no real set of rules for the reception dinner, there may be many more toasts and more relaxed toasts than at the actual wedding reception. These can all yield great emotional photos. ❈

Rehearsal dinner shot list

❈ The restaurant exterior

❈ The restaurant interior

❈ Party welcome sign

❈ The wedding party

❈ Informal groupings

❈ People chatting

❈ Tables

❈ A plate of food

❈ The buffet

❈ Father of the groom's toast

❈ Groom's toast

❈ Other toasts

SUMMARY

In reality, most of the photos taken during the rehearsal will probably not make it to the final wedding album; however, there are many benefits to shooting the wedding rehearsal and rehearsal dinner. It gives you a practice run for the wedding day and an opportunity to better get to know the wedding party, which becomes extremely helpful on the day of their wedding. For the bride and groom, having a photographer present at the rehearsal events means the whole wedding is covered. It can also result in great informal images, and capture some priceless memories. ❖

The bride

The wedding day has arrived and all the planning is about to pay off. Most people don't realize that on this special day, no one will spend more time with the bride than her wedding photographer. From getting ready hours before the ceremony to waving goodbye to her guests as she and her new husband drive away, the photographer will strive to document her day thoroughly, yet without being obtrusive.

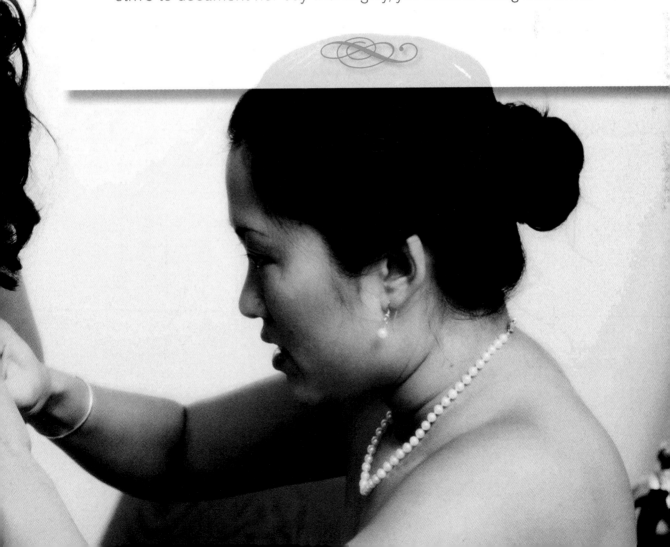

BRIDE'S **DRESSING ROOM**

Many photos for the big day will be taken in the bride's dressing room. This room can be a big suite with great natural light and plenty of space, or it can be cramped and crowded and in need of some lighting help. There are a few things you can do to make the best of any dressing room.

Clear the clutter – Remove everything that isn't necessary and will have little significance in your images. All those extra chairs, tables, and the unused lamp in the corner need to go. Empty boxes, dress bags, makeup kits, hangers and other items are also distracting and can take a great image to a bad image in 1/60 of a second. Keep in mind the old rule that if the item isn't helping the image, then it's hurting the image. At the same time, use discretion and be sure to put items back where you found them.

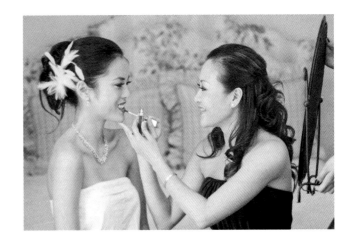

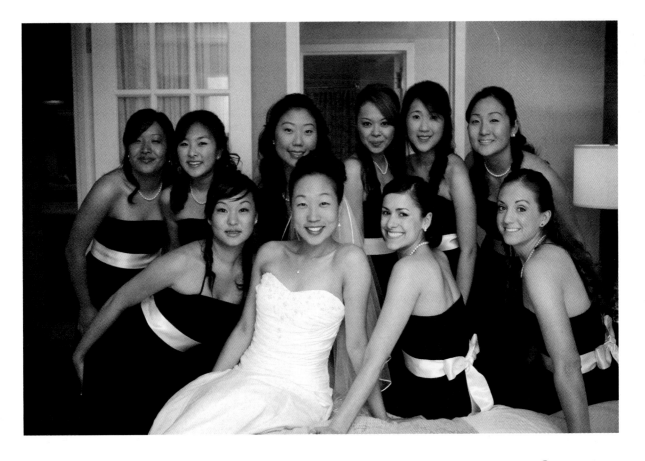

Pick the best angle – Sometimes it just isn't possible to move items. Many hotels and other venues prefer furniture not be moved. Sometimes, pieces are too large to move, or moving items can be dangerous. In these instances, shoot at the best angles to minimize background clutter and distractions.

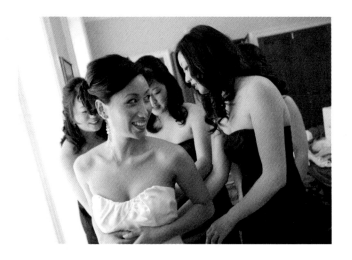

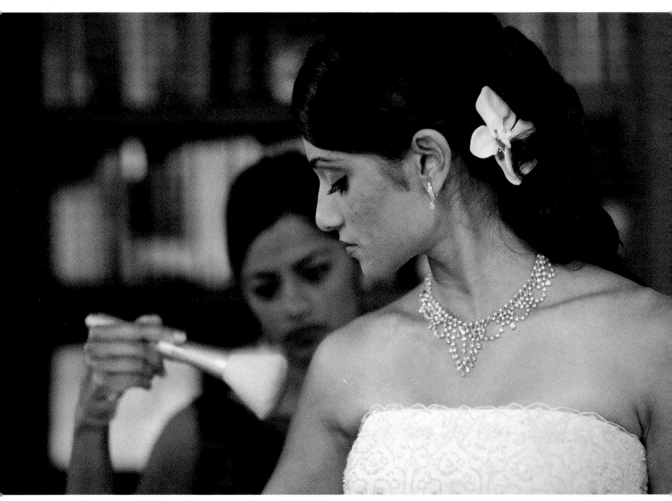

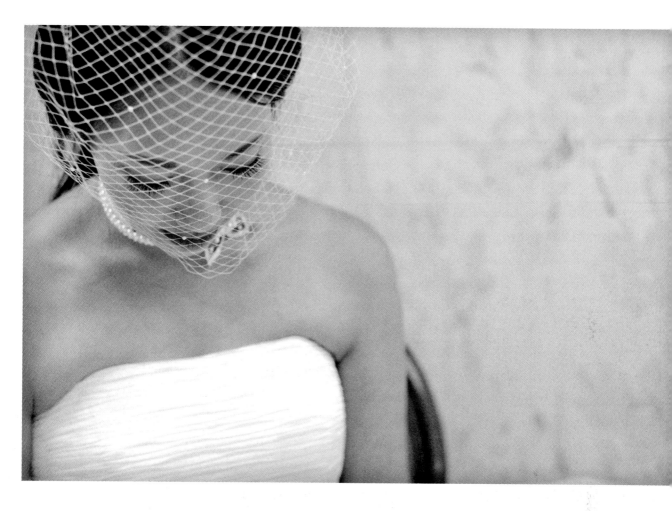

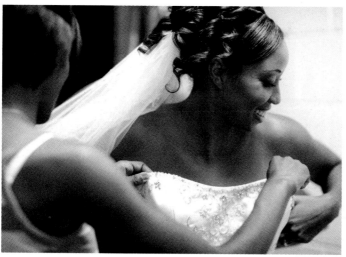

Shoot wide open – I often shoot my subjects with the lens aperture wide open, using an aperture of f/2.8 or even lower. This allows your subject to be in clear focus and the bokeh, or out-of-focus areas of the image, creates a nice blurred background.

Use a wide-angle lens – A wide-angle lens allows you to capture all the activity and commotion around the bride.

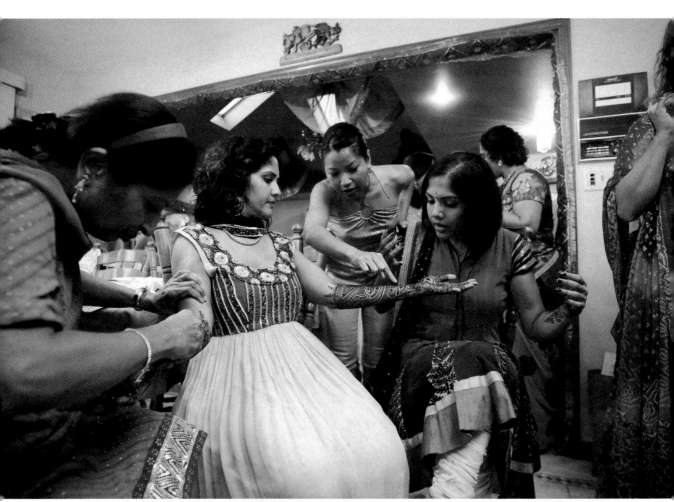

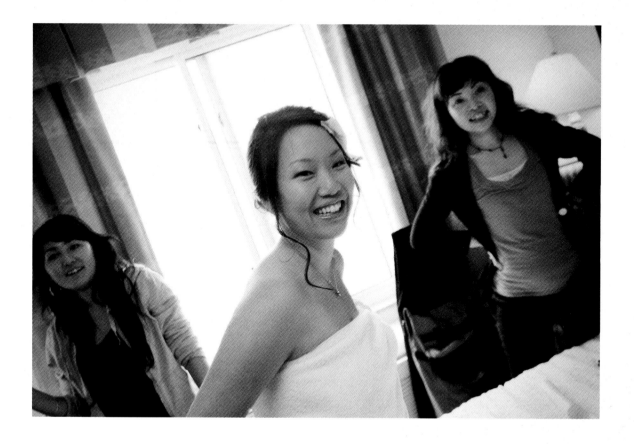

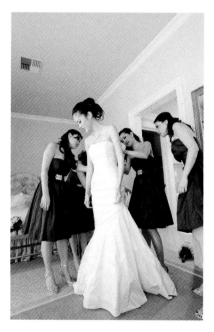

Careful with that wide-angle lens – If you use the wide-angle lens to take group shots, make sure your subjects are in the center of the frame as much as possible. Things on the edge tend to appear distorted and stretched, especially when you are using a fisheye lens or a 16-35mm lens zoomed all the way out to 16mm.

Diffuse window light – Windows and the natural light they provide can be a blessing to a bride's dressing room, as can a balcony, but remember that the very bright light from outside needs to be diffused or the tonal range in the image can be difficult to capture.

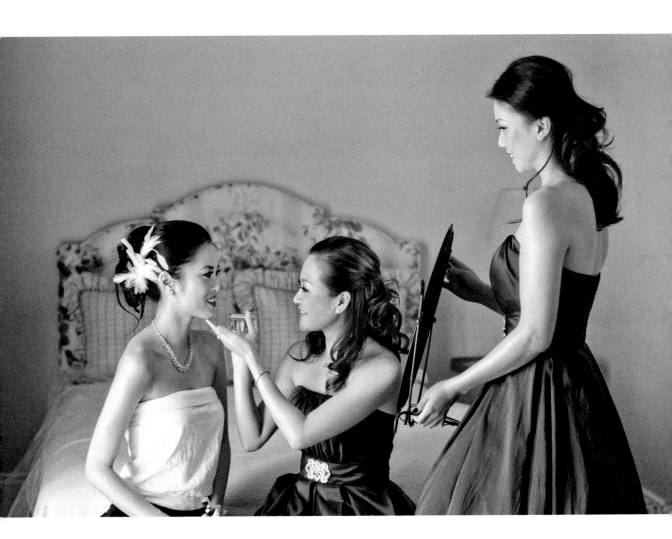

GETTING **READY**

The bride has probably been dreaming about her walk down the aisle since she was a little girl. There are a lot of raw emotions present during these last moments before the wedding. Her closest friends, family members and her wedding photographer usually surround her. Now the trust you have been building with her since the first phone call really begins to pay off. ❋

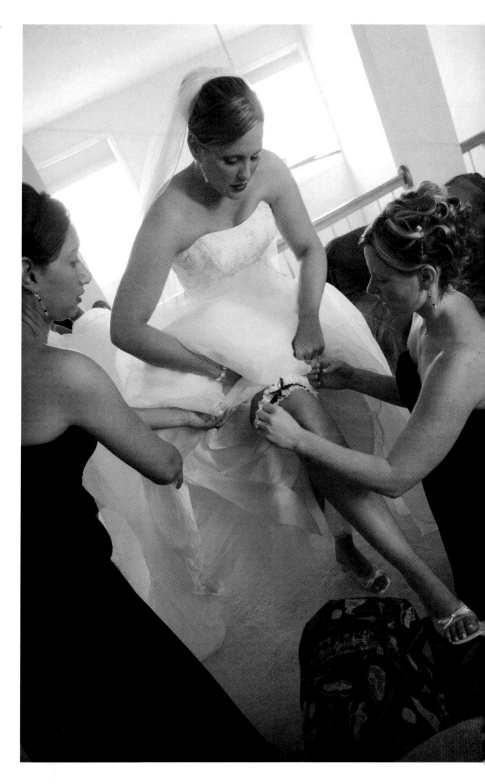

TIPS FOR SHOOTING PHOTOS OF **THE BRIDE GETTING READY:**

Hair and makeup. Capture the bride having her hair and makeup done, including before and after shots, and many in between. Also, be sure to introduce yourself to the make-up and hair artists. Often they get nervous when someone is photographing them while they are doing their work and worry about getting in the way of your shots. You need to learn to work around them and let them do their work; it is their time to make the bride look beautiful. Build a good relationship with them, and in most cases, if you ask them to reenact something you missed, they will be glad to do it. Always remember that during this time the bridesmaids and other family members are watching you work closely. Be professional, friendly and courteous.

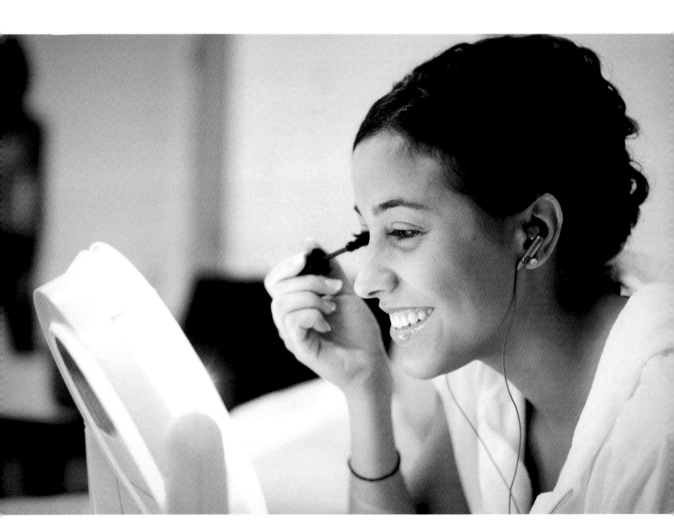

Using mirrors. Many wedding shots are of the bride reflected back in a mirror. It might seem cliché, but that doesn't mean it isn't a good shot. You can be creative and capture some really unique and fun moments when you plan the shot carefully.

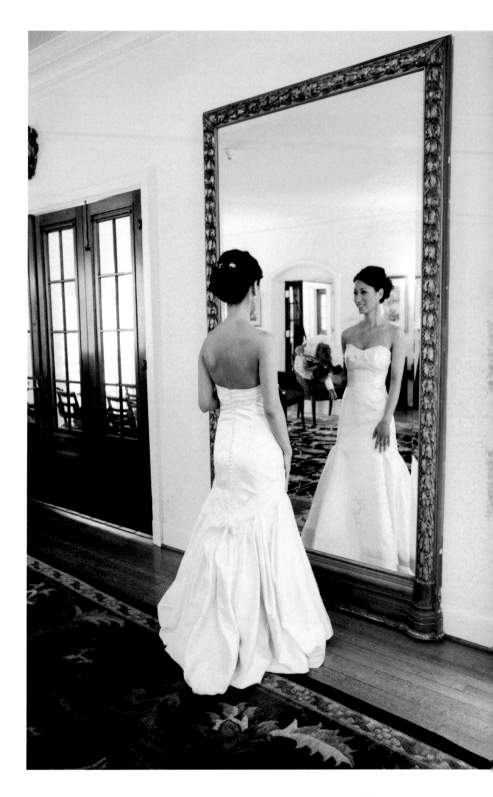

Get in close. Using a longer lens, like the 70-200mm lens, can help you get in close without actually getting in the way. Or use a 50mm or 85mm, which can create some great detail shots if the lighting in the room is not bright enough.

Fill flash. Working indoors means you have to add a little light sometimes to get the proper exposure. Use a little fill light so as not to get a harsh shadow. In your on-camera flash, there is usually a white card that can slide out. Rather than pointing the flash at the subject, try pointing it up with that white card sticking out. That card acts as a small reflector and will allow enough light to "bounce" onto to subject filling in the subject. Another way to add fill light is by using a third-party light modifier/diffuser, which diffuses light so that it emulates natural light.

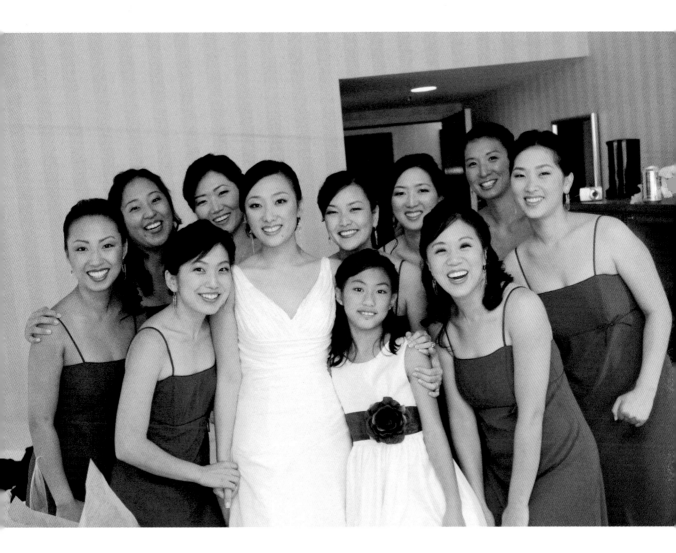

Bounce the flash. When the light is really low and you need to use the full flash, it is best to bounce it off a wall or ceiling so as not to get the harsh lighting that comes from on-camera flash. This can be easily achieved by using an on-camera flash. Instead of pointing the flash directly at the subject, which can create a harsh over exposed result, find a ceiling corner in which you can try to "bounce" the light onto the subject creating a natural light effect. Make sure to not shoot into any dark or almost black colored corners as they tend to absorb the light rather than bounce it. Anything white or off white is ideal and can be found in almost all locations.

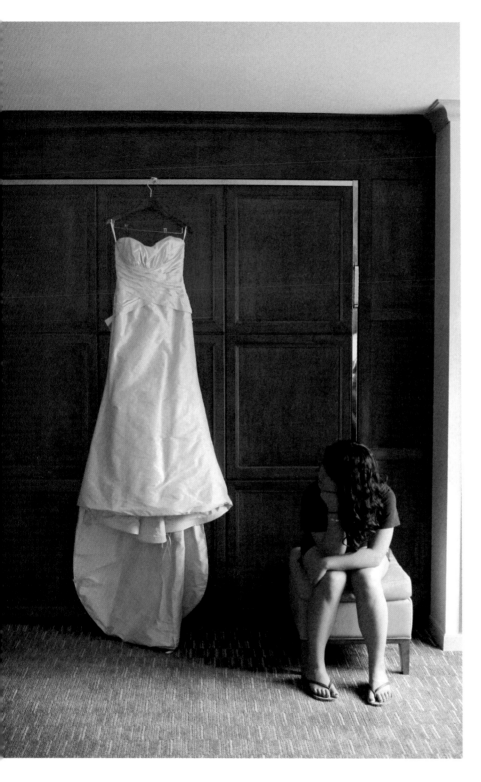

DRESS

The wedding dress is an integral part of the wedding day and it needs to be photographed. The bride likely spent many hours choosing the perfect dress to reflect her taste and style. She will appreciate an overall shot of the dress, a shot of herself looking at the dress she picked, as well as several shots capturing the details of the dress, such as intricate lace, buttons and ribbons. Speak with the bride to learn why she chose her dress and what she likes most about it.

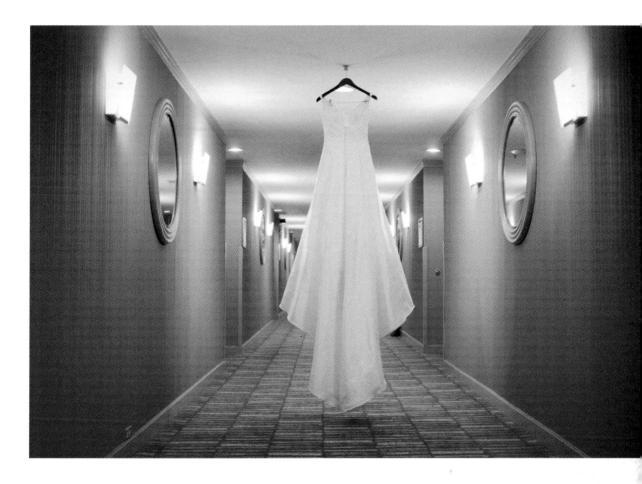

Be prepared for shooting images of the dress by bringing a good satin or wood dress hanger with you. Most dresses I've seen are hung on bad plastic hangers. If you shoot a beautiful dress and it is on a bad hanger, then it distracts from the whole photograph. Suddenly the cheap plastic hanger is more noticeable than the dress.

I look for areas in the dressing room good light so the dress can be lit naturally. Keep in mind, since the wedding dress is usually white, there is a chance your camera's built in light meter will underexpose the image. Pay attention to the exposure, and if necessary, manually overexpose the dress slightly. Don't be afraid to get creative with the dress shots either. Try back lighting the dress or shooting the mirror reflection of the dress. Use the environment to decorate the dress. Many times at a nice hotel, there are places to hang the dress to create a nice setting. Don't be afraid to experiment by trying different things; just be careful not to harm it in any way. The dress must be in perfect condition when the bride finally puts it on. ❈

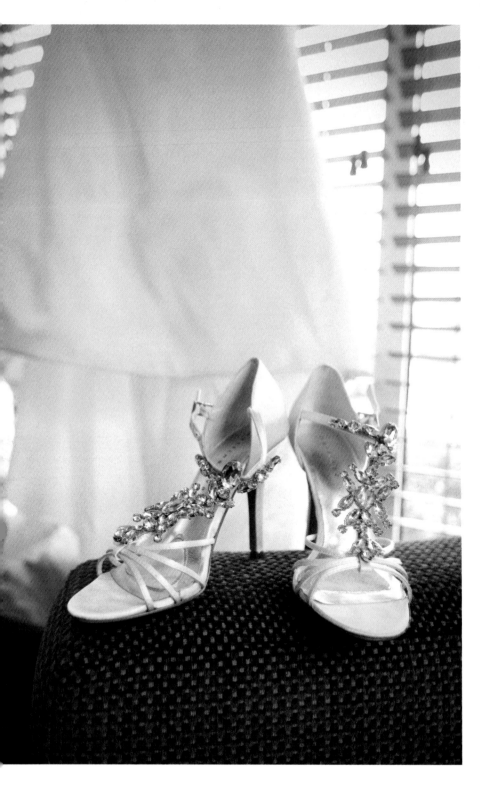

SHOES

This would a good place to make a joke about woman and their shoes, but the truth is brides spend a lot of time picking out their shoes. I try to get at least one nice detailed straight on photograph of the shoes. Once you have the straight shot, you can also get creative with the shoes. I sometimes incorporate the shoes into the dress shot, and I often look at clothing catalogs and fashion shoes catalogs to get ideas and inspiration for the shoes and the dress shots. ❈

DETAILS

When it comes to weddings and brides, it is safe to say that lots of thought went into every little detail. It might be a necklace that has been in the family for generations or an antique pair of earrings, but there is always something special. It is important to find out from the bride what is special to her so you can capture it in the best possible way. As you shoot more and more weddings, you will discover there are some things that most brides find important even if they forget to mention it up front.

I also try to be a little "nosey" and look around the room for details that will be significant to the couple. For example, when I shot a wedding in the Bahamas, I made sure to include the details that reminded them that they got married there, such as the front cover of a newspaper that shows the date, location, and some of the other events happening on their wedding day. Other details to capture can include their invitation, personal notes to each other, a family heirloom or jewelry, gifts they gave to each other on that day, or initials on the groom's cufflinks. I use the Canon Macro 50mm or 24-70mm lens to photograph many of these details because of its ability to get in really close and fill the frame with the details. One word of caution when using a macro lens; because you are usually very close to your subject, you need to closely monitor the depth of field to make sure your subject is in focus. A slight movement can cause the image to blur. �֎

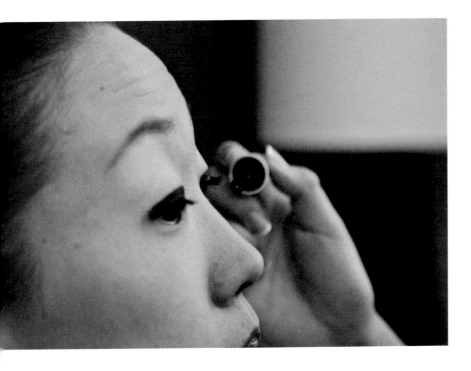

DRESSING

There is something very symbolic about a mother, sister, or best friend helping the bride get into her wedding dress—helping with the last button or zipper, straightening the veil or tucking a stray piece of hair back into place. While it is mainly symbolic and somewhat old fashioned, it still makes for a very strong and compelling image.

I always want to make sure the bride feels comfortable with me. When she is ready to change into her dress, I let her know that I will step outside and wait by the door until she feels comfortable being photographed again. When I come

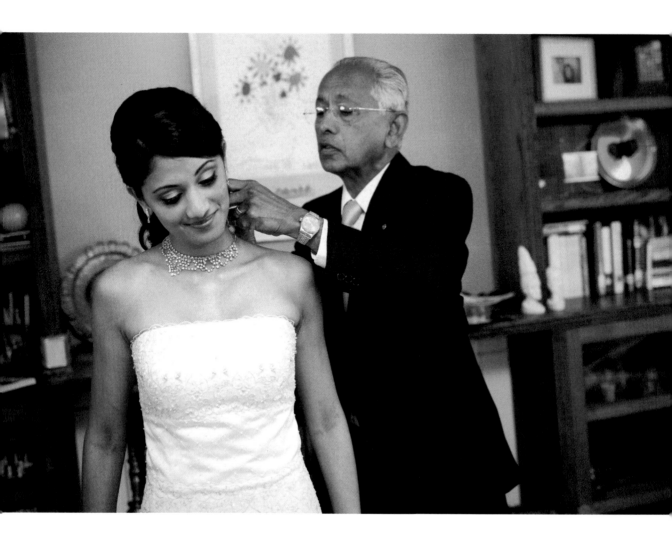

back in, if the bride already has the entire dress on, I usually ask them to reenact the detailed shots (such as zipping up or button up the back part). Even in the moment of reenacting, you can capture the emotion that is shared between close friends and family members helping the bride. This is one of the times having a female second shooter assisting me during the wedding is really useful. In those cases, if the bride is comfortable, the female shooter can stay behind and get the creative shots the brides will appreciate. ❊

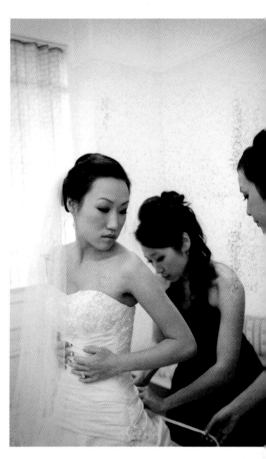

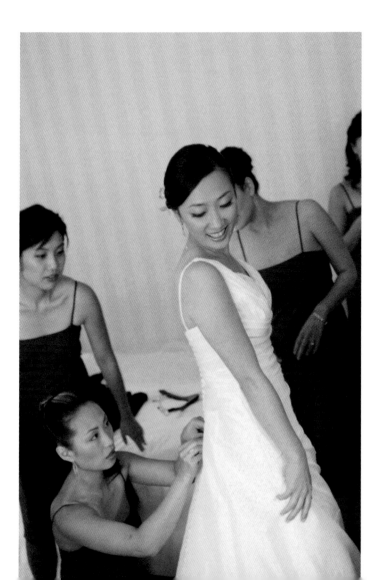

BRIDESMAIDS

The bridesmaids are the bride's best friends and closest confidants. It might be her sister, cousin, best friend or college roommate. Regardless, the one thing you can count on is that these are the important women in her life, and they need to be captured as such.

Photographing the interaction of the bride and her entourage is easier when you are considered a friend. Be sure to capture shots of individuals as well as small groups. Once again, that rapport you have developed with the bride will pay off here, and help you to blend in without being noticed until you start to pose the group. ❈

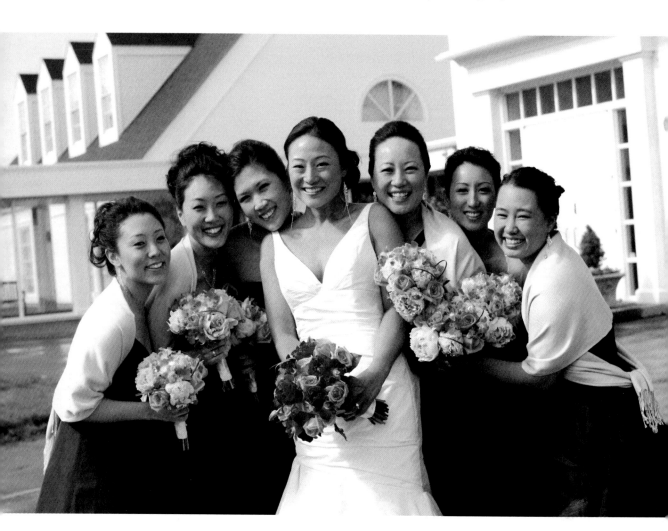

Bride Getting Ready Shot List:

- ❈ Bride getting her makeup and hair done
- ❈ Wedding dress
- ❈ Wedding dress detail (lace, buttons, bows, etc.)
- ❈ Dress shoes
- ❈ Something Old
- ❈ Something New
- ❈ Something Borrowed
- ❈ Something Blue
- ❈ Any special jewelry
- ❈ The bouquet
- ❈ Bridesmaid dresses
- ❈ Bridesmaid flowers
- ❈ Candid shots of bride getting ready

- ❈ Candid shots of bridesmaids getting ready
- ❈ Flower girls getting ready
- ❈ Mother helping the bride get ready
- ❈ Mother helping with one last detail (veil)
- ❈ Maid of honor helping bride get ready
- ❈ Bride with bridesmaids around her
- ❈ Bride with each member of her entourage
- ❈ Full length shot of bride in dress
- ❈ 3/4 Length shot of bride in dress
- ❈ Bride and bridesmaids toasting
- ❈ Bride and her family

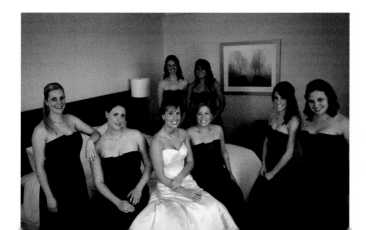

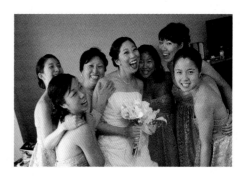

SUMMARY

Every woman has a mental picture of how she will look on her wedding day, and the "getting ready moments" will be some of her most cherished shots. Shoot all aspects of the bride and her party getting ready, from the details of what she is wearing to the intimate moments with her closest friends and family. You will capture many moments she will want to remember for the rest of her life. ❀

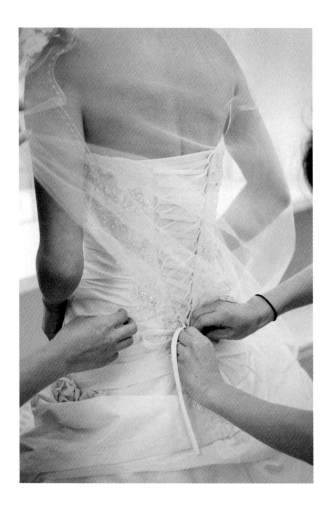

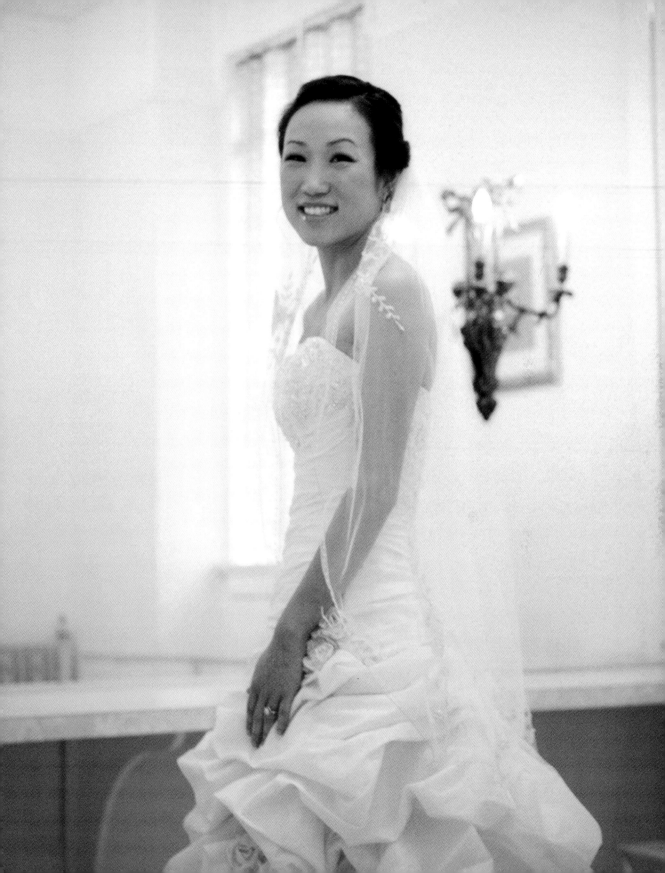

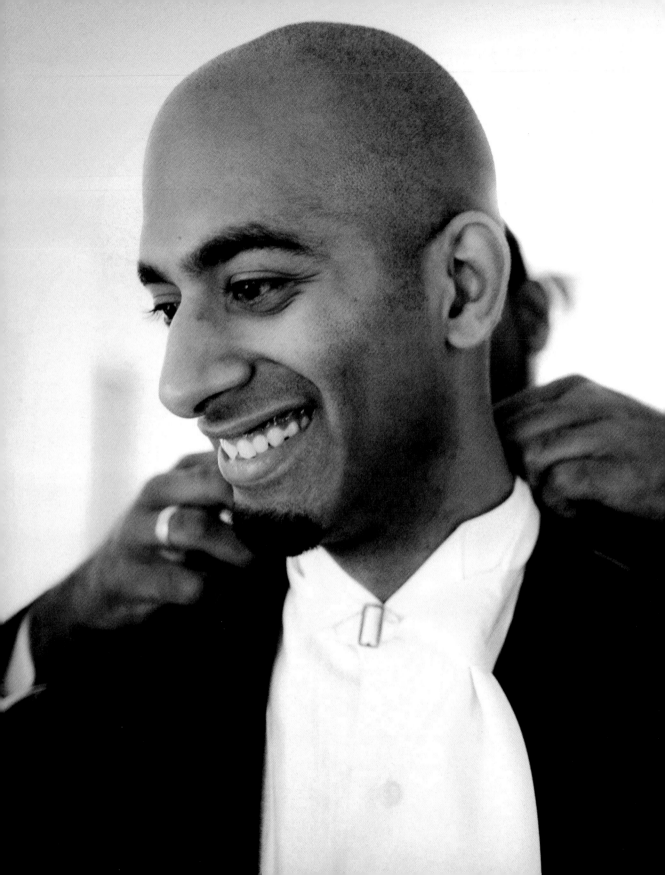

Don't forget about the groom

Many men may not think about their wedding day in the same way as their brides do, but that doesn't mean it isn't just as important to them. Even though there are inherently many more photo opportunities of the bride getting ready, knowing what to shoot can yield some great shots of the groom and his groomsmen getting ready for the ceremony.

At times I work with a second photographer who will shoot images of the groom getting ready as I am off capturing images of the bride. I carefully explain to my second shooter what images I need, and if time and location permit, it is a great idea for both photographers to cover both sides of the wedding party getting ready. Each photographer's different perspective and creativity can result in really unique photos.

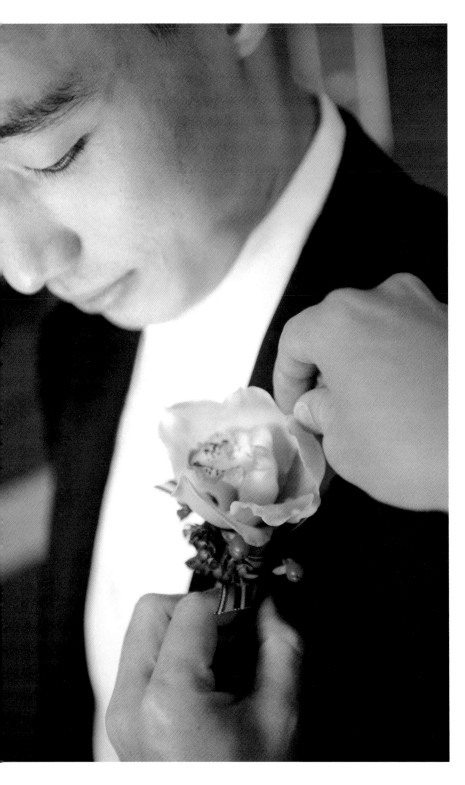

GETTING **READY**

It usually doesn't take the groom and his groomsmen as long to get ready as the bride and her bridesmaids. Most grooms don't have hair and makeup sittings and get dressed rather quickly allowing you to get the images needed in a short amount of time. I believe one of the most important shots of the groom getting ready is when his father or groomsmen help him. Look for the following opportunities or set one up to make it happen. ❀

Grooms getting ready shots opportunities to look for

❋ Putting on the tux jacket

❋ Help with the tie

❋ Help with the boutonnière

❋ Help with the cufflinks

❋ Straightening the jacket

❋ Dusting imaginary lint off the shoulder

❋ Relaxed moments when the boys are just being themselves

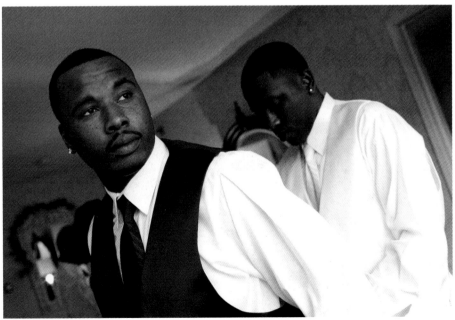

THE **TUXEDO/SUIT**

The tuxedo or suit is the traditional uniform of the groom, and it really does make every man look great. Remember, however, that when shooting a man or a group of men wearing tuxedos/suits, the light meter in your camera can overexpose the rest of the scene due to the large amounts of dark areas in the image. This happens because the camera tries to even out the tones in the image making the dark tones lighter and causing the light tones to be overexposed. This is particularly true if the groom is wearing a very dark tuxedo/suit and it is filling a lot of the frame.

When shooting men in tuxedos/suits, be sure to pay attention to the way the jacket looks and that it is flattering. Unbutton the jacket if the groomsmen are sitting down or have their arms over the shoulders of the people next to them to avoid an unflattering bunching of material. Before you take any photos of the groom, make sure the jacket hanging properly. Give the bottom edge a little tug to get it into place. This will create a much better look.

Some couples choose to go with a less formal approach and won't have tuxedos or suits for the groom or groomsmen. Or in different cultures, wearing a suit is not common. Regardless of their choice of clothes, capturing images of the groom and his groomsmen getting ready is important. After all, it's really about capturing the emotions and memories of this special time before the ceremony. �֍

THE **DETAILS**

Since the tuxedos or suits worn by the groom and his groomsmen can all look the same, pick out the small details that add individuality. This can be as obvious as the different boutonnières worn by different members of the wedding party or it can be subtle as the cufflinks handed down from father to son. Many times, you may not easily notice the differences, so be sure to ask the groom about any special items he might be wearing. ❧

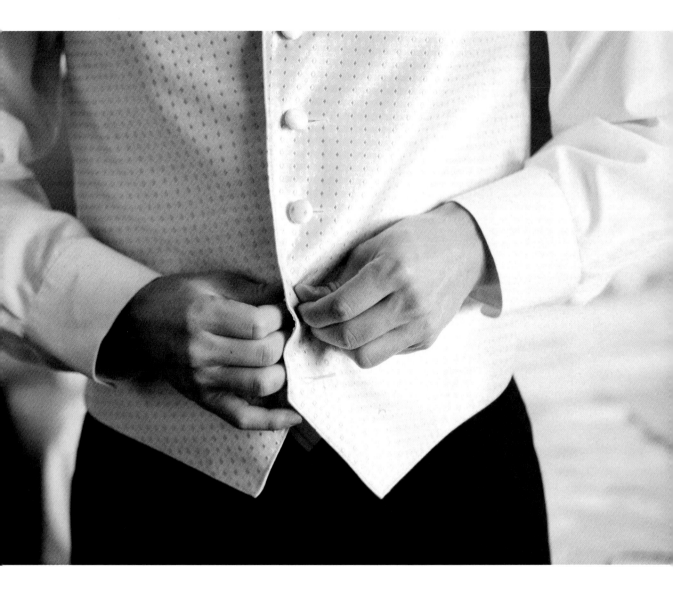

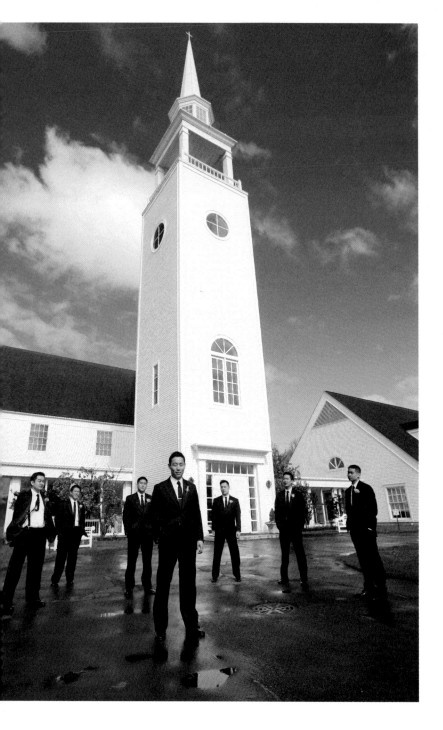

THE **GROOMSMEN**

As the bride has her bridesmaids, the groom has his groomsmen. These are the people he is closest to — family, friends and confidants. A word of caution: sometimes they can be difficult to work with, as there is a tendency for men to joke around to hide their actual feelings at weddings. Since they can get ready in much less time, there tends to be more time for playing around and a lot more pent up energy. Try to use that energy to get them into some poses, and actually this extra energy helps come up with some creative poses. Once at a wedding I shot in the Bahamas, all the groomsmen and the groom collectively agreed that it was too hot to wear suit jackets so they took them off.

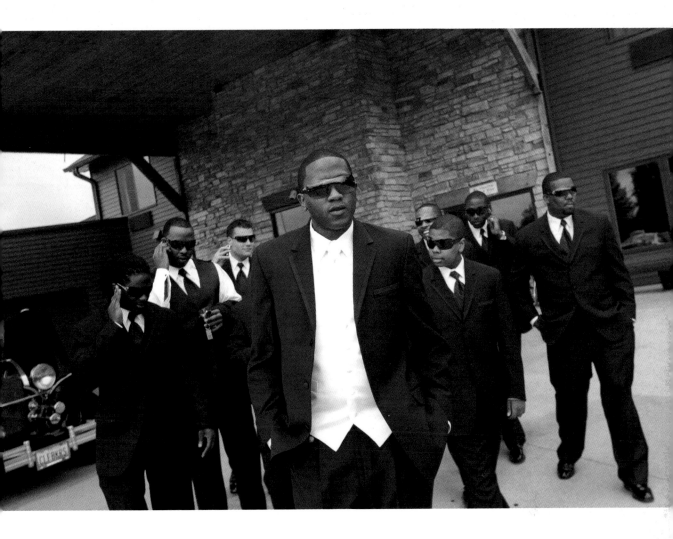

They took it a step further and while waiting outside, decided to roll up their shirtsleeves and pant legs as well. I was able to capture their contentment as they sat around laughing and having a great time. Be sure to watch the interaction between the friends between the posed shots and look for the moments when their guard is down. These candid moments can really capture the true spirit of the day, and will make great additions to the wedding gallery. ❈

THE **RINGS**

The rings are the traditional symbols of marriage, and while the ring photo might seem cliché, it needs to be done. Make sure you know who has the rings before the ceremony so you can get them both in the same place. It is difficult to get the shot if one ring is with the groom but the other is already with the bride. In that event, make a note to capture that shot after the ceremony. It can even be done during the reception when there is some idle time. You can kindly ask the newly weds for their rings for that purpose. I have never had a couple decline my request. ✳

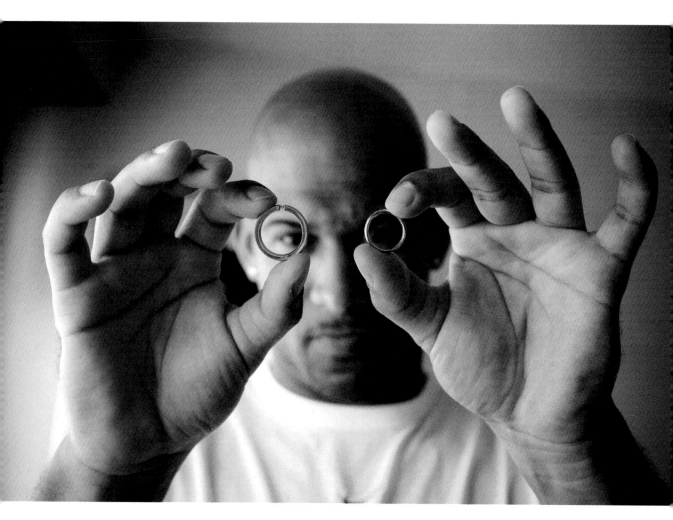

TIPS FOR **SHOOTING THE RINGS:**

Make sure they are clean. Since rings are usually highly reflective, make sure all lint, dust, grime and fingerprints are wiped off. A lens cloth or other lint-free cloth works really well.

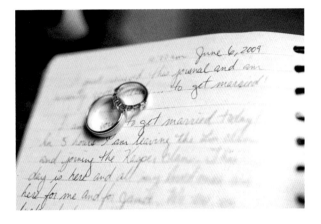

Watch for reflections. Make sure there is nothing being reflected in the rings that you do not want in the photo.

Create the scene. The ring bearer pillow was made to carry the rings and will look good as the background. You can have the ring bearer hold the ring pillow with the rings for an interesting shot. Another idea is to take an invitation with you, and shoot the rings placed on the invitation. These are just some suggestions. There are endless possible ways to photograph the rings; use the things around you to come up with some creative ideas.

Use the macro lens. Made to shoot small objects, macro lenses will let you get in close and capture all the details in the ring. Otherwise, a 24-70mm 2.8L lens works well.

Control the depth of field. Keep the rings in sharp focus and blur the foreground and background by picking the right aperture. This will depend on the lens and the distance between the front of the lens and the rings. An aperture f/3.5 is a good place to start. Then use the preview on the back of the camera to make sure the rings are in focus, and make sure to zoom in to see the critical parts.

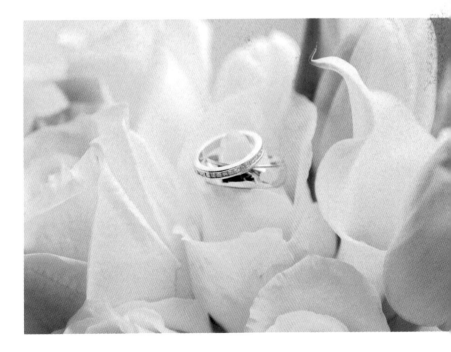

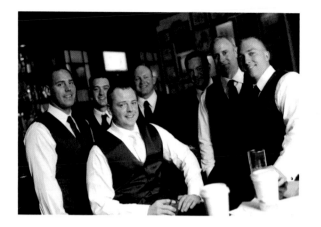

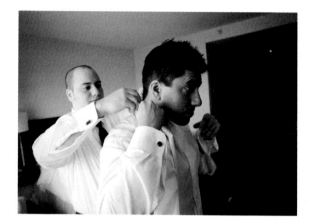

The Groom getting ready shot checklist:

❋ Putting on the tux or suit jacket

❋ Help with the tie

❋ Help with the boutonnière

❋ Help with the cufflinks

❋ Straightening the jacket

❋ Dusting imaginary lint off the shoulder

❋ Groom with parents

❋ Groom with siblings

❋ Groom with groomsmen

❋ Groom's mother helping with the boutonnière

❋ Groomsmen putting on their boutonnières

❋ Groom and groomsmen straightening their ties

❋ Groom relaxed waiting

❋ Groom with ring bearer

❋ The rings

❋ Tux or suit details

❋ Groom with his entourage

❋ Groom ready to get married

❋ Groom and groomsmen waiting for the ceremony to start

SUMMARY

Although grooms and their groomsmen get ready for the wedding much more quickly than brides and their bridal parties, there are still many outstanding photo opportunities. This is a special time for the groom to hang out with his best friends and family members. Watch carefully for moments when the real emotions shine through. ❊

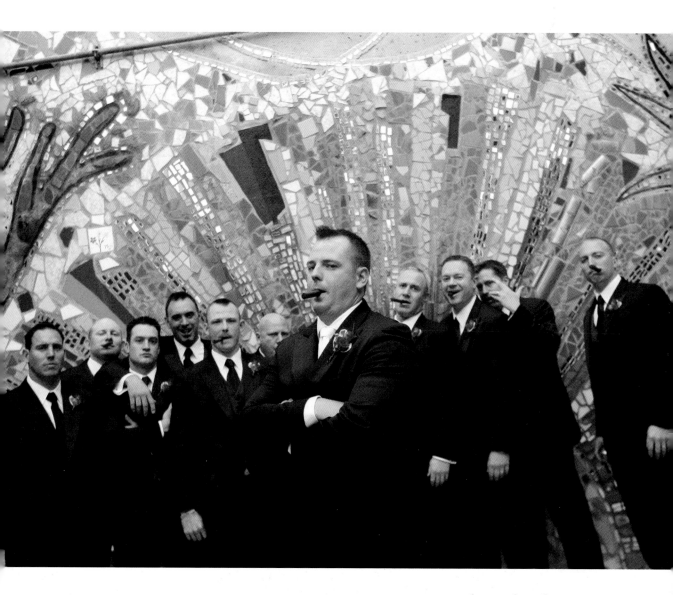

Images before the ceremony

There is a popular trend right now in wedding photography in which couples want non-posed candid photos instead of the traditional posed shots of the family members and the wedding party. Although these candids are valued and make up about 85 percent of what I photograph during the wedding day, the more traditional posed shots of the bride and groom, their family, and the wedding party continue to be an important part of the services that a wedding photographer provides. Statistically, you will find many guests, family members and friends still order these photos more than any other photos you capture that day. So it is essential to do a great job capturing these posed photos.

There are two times during the wedding day ideal for taking posed shots. The first is before the ceremony, but after the bride and groom are done getting ready. The second is after the ceremony, but before the reception. There are pros and cons to both approaches, but in the end, it is up to the couple to decide when they prefer to capture these traditional shots.

BRIDE AND GROOM **FIRST LOOK**

The big question that determines when the photographs can be taken is
whether the bride and groom want to see each other before the ceremony
or whether they prefer to wait until after the bride walks down the aisle.
When talking to the couple during the early planning stages, present the
idea of having their photos taken before the ceremony. Quite possibly,
they haven't thought about it, and you can help them decide by presenting
them with the advantages of capturing photos before the ceremony.

Fresh hair and makeup – The bride's makeup and hair has just been done and is looking its best. That is not to say she won't be radiant all day, just that the makeup and hair will be fresh.

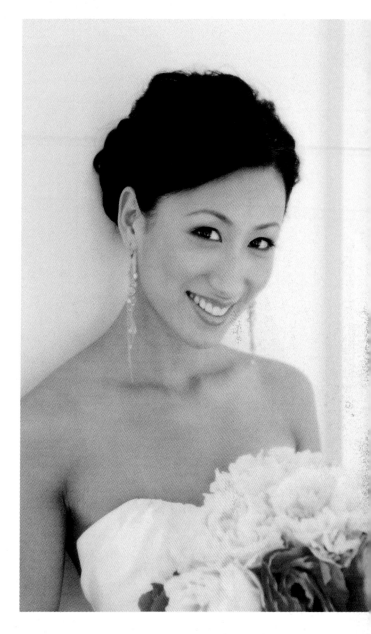

More time for photos now – You can pad the timeline when shooting before the ceremony, making sure you get the photographs you need without impacting the guests by delaying the reception. Taking photos after the ceremony delays the arrival of the newlyweds and their bridal parties at the reception.

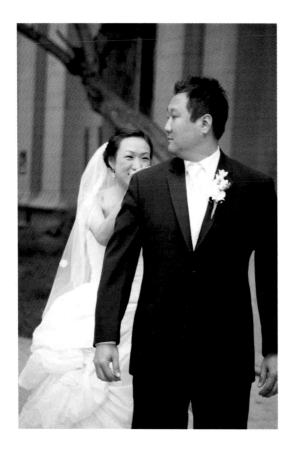

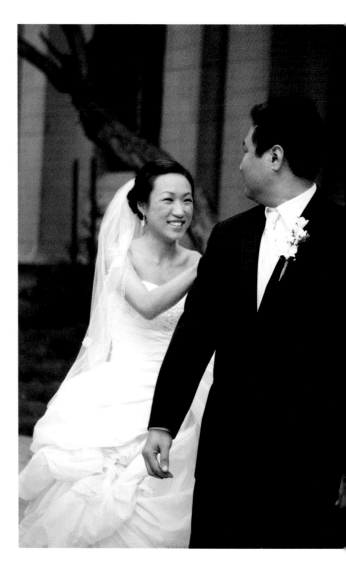

Staged first look – You can make sure you get both the bride's and groom's expressions as they see each other for the first time that day. While staging the first look may sound like it will take away the "surprise" element from seeing your bride/groom for the first time, I have captured some great reactions in past shoots. By being prepared, I can always catch those first few magical looks between the happy couple.

More time with their guests later – By shooting the bulk of the images before the ceremony there is more time for the couple to be with their guests at the reception.

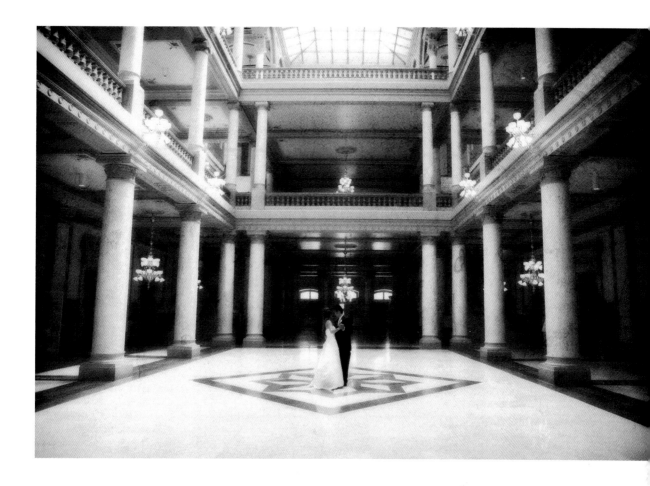

There are many great shots that can be captured before the ceremony. If the couple agrees to this format, make sure the schedule is created with this in mind. You should also make sure the bride and groom communicate to the family members who will be in the photographs where they should be and at what time. It might even be a good idea to appoint the event coordinator or even a family member who knows everyone to help coordinate the group shots and keep everyone organized.

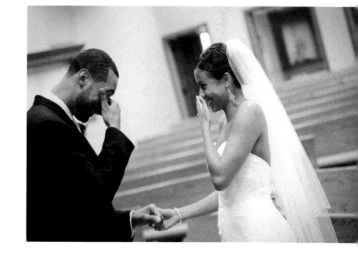

The bride and the groom can determine the location. In most cases they want these shots done in front of the altar, but they can also be done outside if the weather cooperates. One advantage to taking the photographs outside is better light. If the couple still want them to be done inside for sentimental reasons and the church is not well lit, you can easily create your own light using an on-camera flash. If more light/power is needed, you can couple the on-camera flash with two additional off-camera strobes on a light stand.

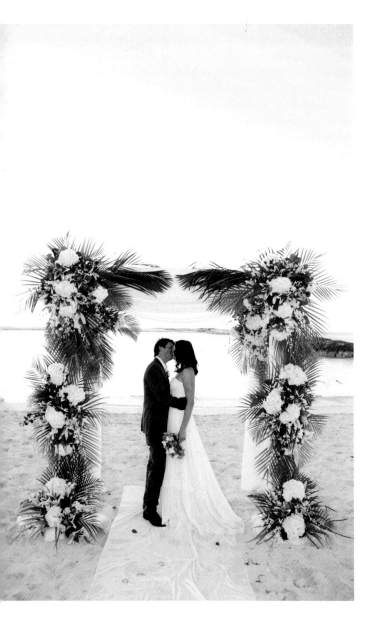

As essential as capturing these photos is, it is just as essential to be efficient. The faster you get these shots done, the better you look as a photographer. It is imperative to have a shot list and keep that list short. Explain to the couple that having a long list of different combinations of pictures may not be necessary as only a few of these poses will make it into the album. It is best to include everyone in one photo first, then start trimming them down to smaller combinations depending on the types of shots the couple requests.

This is the only time of the day where I become vocal as a
photographer. I direct the shots and keep the process moving
so everything gets done in no more than 20 minutes. No matter
what the situation, however, I am patient with everyone and smile.
Remember, the family members are an important part of the
couple's day and you do not want to treat them badly in any way. ✽

PHOTOGRAPHING **THE BRIDE AND HER FAMILY**

The wedding is important not only to the bride but to her family as well. It is the day their little girl is starting her own family, and many family members will order prints from the wedding. In some cases, family members could even become future clients when they get married.

When it comes to preparing to photograph the bride and her family, request a list of the people the bride wants in photos with her. The obvious people include the immediate family: parents, grandparents, brothers, sisters and children, but there might also be a favorite cousin, aunt or uncle she considers very important.

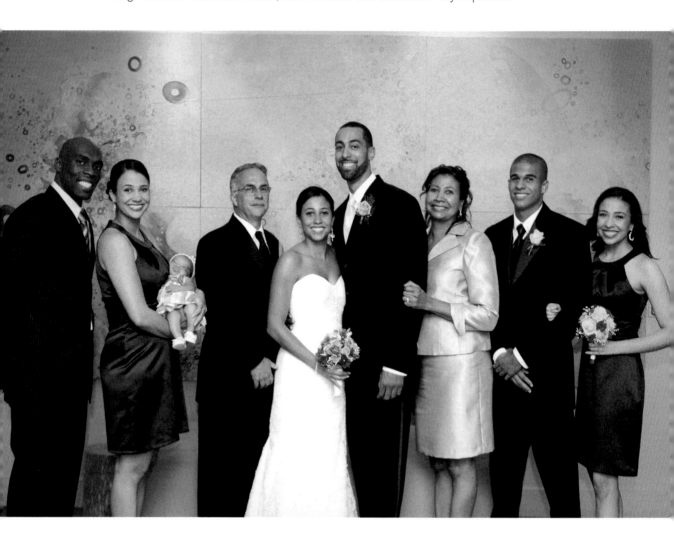

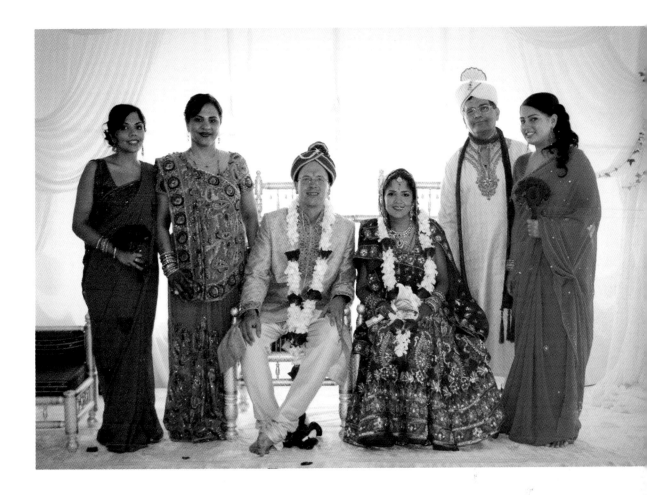

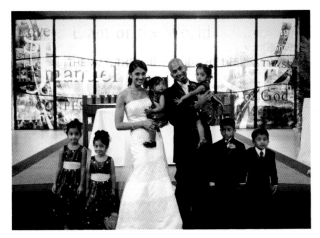

There will be an opportunity between the wedding ceremony and the reception to get photos of the extended family, so at this time, it is just about the bride and her family. If the couple has decided to have their photos taken together before the ceremony, then you can add the groom into these shots as well. If the couple does not want to see each other before the ceremony, then there will be an opportunity after the ceremony to get some family shots with both the bride and groom.

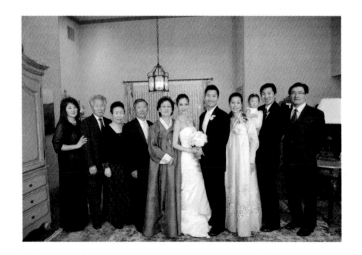

Usually, capturing the important people in the bride's life does not require a lot of different combinations of family member photos. Chances are slim that all the shots will make it into the wedding album. It's best to start with the biggest group and remove people as you go along until you are down to the bride and her parents or if she has children, her alone with them. ❉

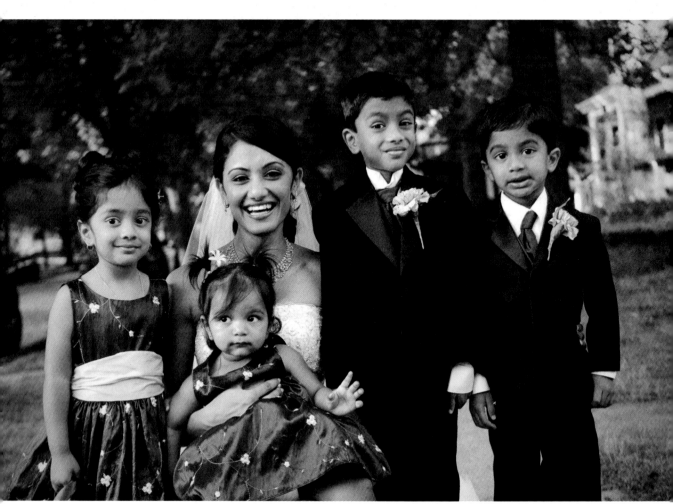

Bride Family shot list example:

The bride with...

❋ Whole family

❋ Parents, grandparents, siblings, nephews, nieces, children

❋ Parents, grandparents, siblings, nephews, nieces, children plus groom

❋ Grandmother, mother and daughter (female side of family)

❋ Grandparents and parents

❋ Grandparents and parents plus groom

❋ Grandparents

❋ Parents, siblings and children

❋ Parents and children

❋ Parents and children plus groom

❋ Parents

❋ Both sets of the parents plus the groom

❋ Parents plus groom

❋ Children

❋ Children plus groom

❋ Special relative

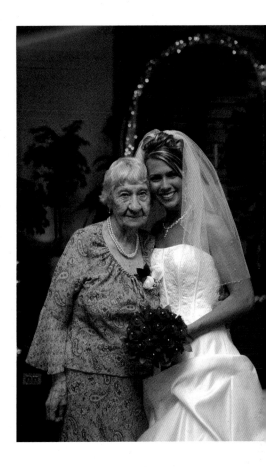

PHOTOGRAPHING THE
GROOM AND HIS FAMILY

Photographing the groom and his family is very similar to shooting the bride and her family. They will be equal partners in their life together and should be treated as such here, even if you do spend more time with the bride. In fact, the same concept applies when shooting the groom with his family. Start with the biggest group and work your way down to the groom with his parents. Remember, if the couple doesn't mind seeing each other before the ceremony, the bride can be part of these images where noted.

This list is just a suggestion. It can be shorter or longer depending on the couple. Work with the couple prior to the wedding day to create the list. This will help the shoot be more efficient. ❊

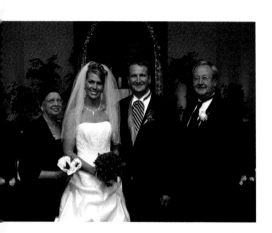

Groom Family shot list example:

The groom with...

❊ Whole family

❊ Parents, grandparents, siblings, nephews, nieces, children

❊ Parents, grandparents, siblings, nephews, nieces, children plus bride

❊ Grandmother, mother and daughter (male side of family)

❊ Grandparents and parents

❊ Grandparents and parents plus bride

❊ Grandparents

❊ Parents, siblings and children

❊ Parents and children

❊ Parents and children plus bride

❊ Parents

❊ Both sets of the parents plus the bride

❊ Parents plus bride

❊ Children

❊ Children plus bride

❊ Special relative

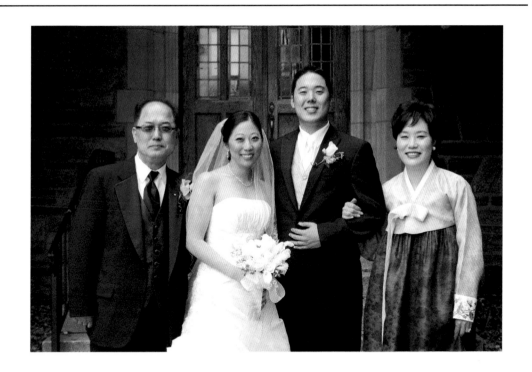

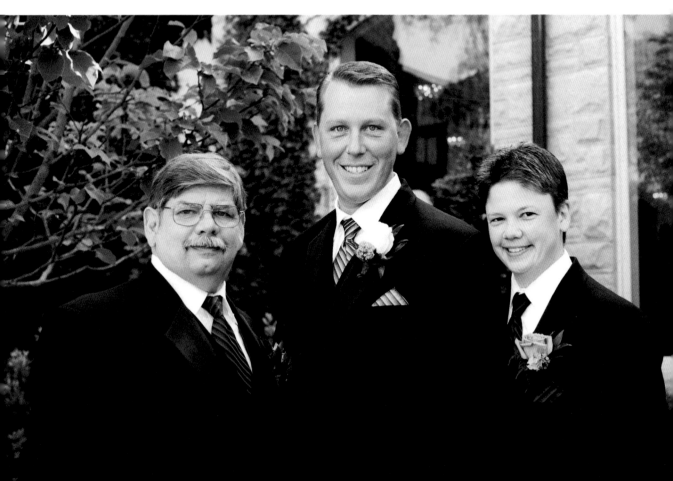

FAMILY PHOTO **CHALLENGES**

Let's face it; not every family is picture perfect. Some families face special challenges, usually caused by divorce and remarriage. Often the new stepparent wants to be in the photos, but someone else doesn't agree. Knowing about these situations before the wedding can help you diffuse the situation and make sure the family photos proceed as smoothly as possible. �֎

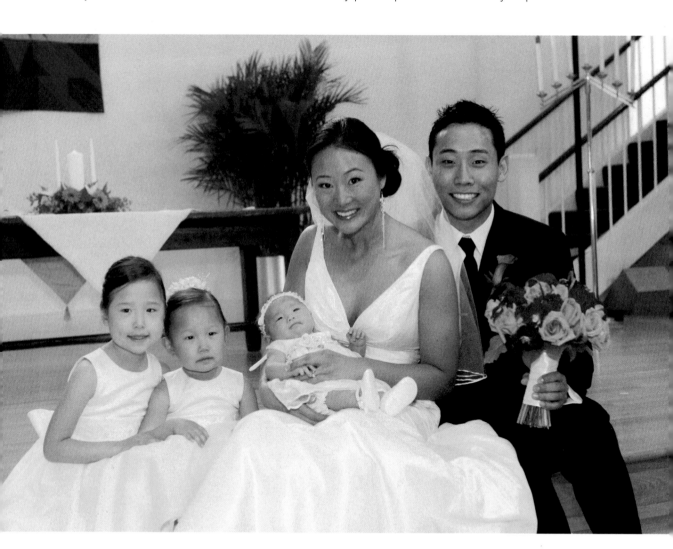

Keep the focus on the couple. Making the couple the focus of all photos keeps things moving and will not allow enough time for bad feelings to take root. If disagreements arise, remind everyone it is all about the couple.

Talk to the couple. Ask the couple about specific problems that can arise and if necessary shoot two separate sets of family images. You can do one set before the reception and one after, if necessary. At times it is the bride and groom who have a problem with the new family member. Just remind them gently that just because a photo is taken, doesn't mean they have to use it. Sometimes it's easier to take the photo and move on.

Time the photos. Have the folks who don't get along included in the photos at different times. Start with one, then have that person leave before shooting the other.

BRIDAL PARTY **PHOTOS**

You already have photos of the groom and his men and the bride and her maids, now it is time for all of them together. If the couple doesn't want to see each other before the ceremony, these shots can be taken between the ceremony and the reception. Keep in mind the bridal party includes the people who are the most important to the couple, and the shots of the full wedding party will have a special place in the wedding album and on their wall. These can be the fun shots, the time when you can be creative and step away from the plain and boring. From the way the group poses to using various props that are planned ahead, these shots can become really memorable. As you can see by the list below, there are not that many shots, but it is what you do with these that will really count. ❈

Bridal party shot list:

❈ Whole wedding party

❈ Bride and the groomsmen

❈ Groom and bridesmaids

❈ Bride and groom with flower girls and ring bearer

❈ Bride and groom with maid of honor and best man

SUMMARY

These important posed traditional shots taken of the bride, groom, their families and the wedding party will be some of the most important photos of the day. Good planning and communication goes a long way in assuring you capture all these shots without a hitch. Be creative and have fun! ❈

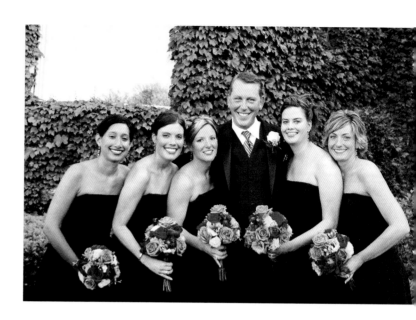

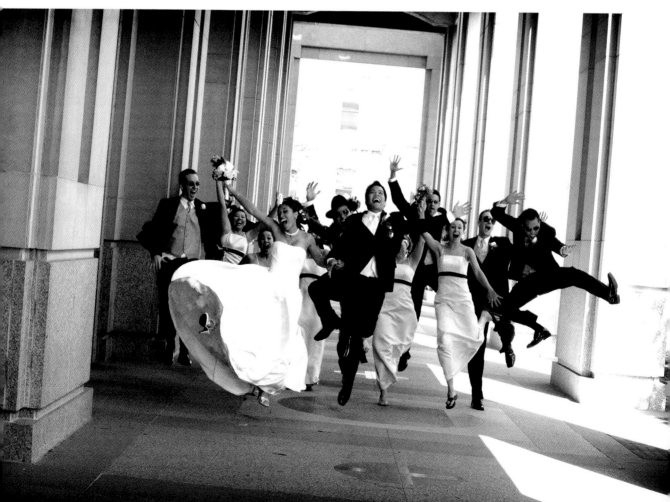

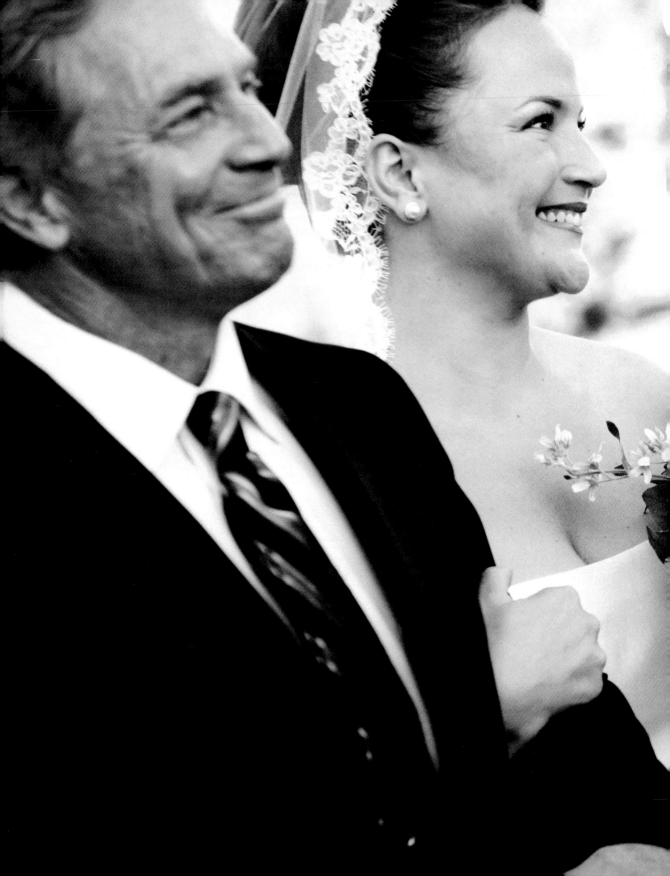

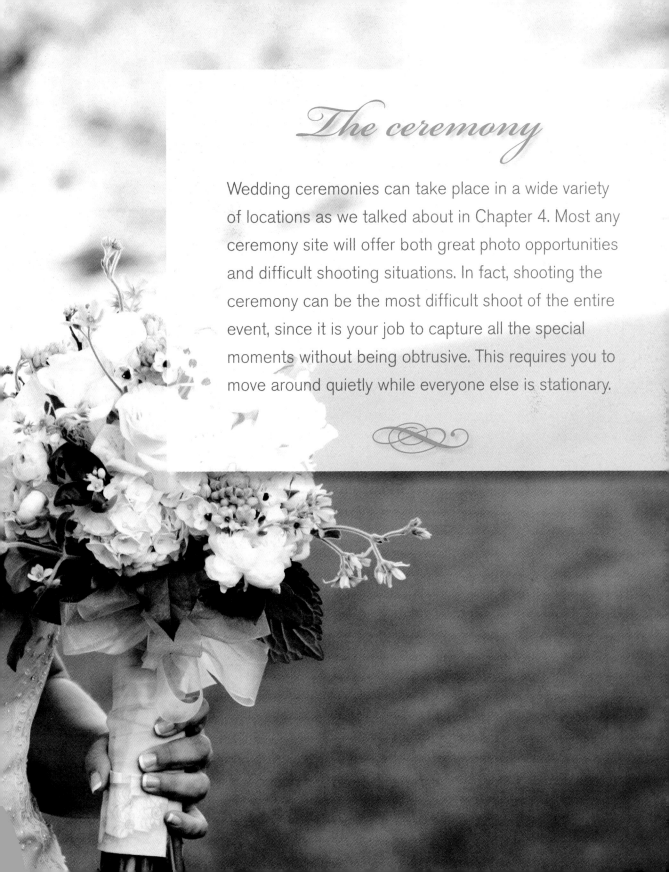

The ceremony

Wedding ceremonies can take place in a wide variety of locations as we talked about in Chapter 4. Most any ceremony site will offer both great photo opportunities and difficult shooting situations. In fact, shooting the ceremony can be the most difficult shoot of the entire event, since it is your job to capture all the special moments without being obtrusive. This requires you to move around quietly while everyone else is stationary.

CEREMONY **SCHEDULE**

Having a good understanding of the order of the ceremony will help you make sure you're in the right place at the right time. When planning with the couple be sure to ask many questions about the order of events and logistics of the ceremony. ❃

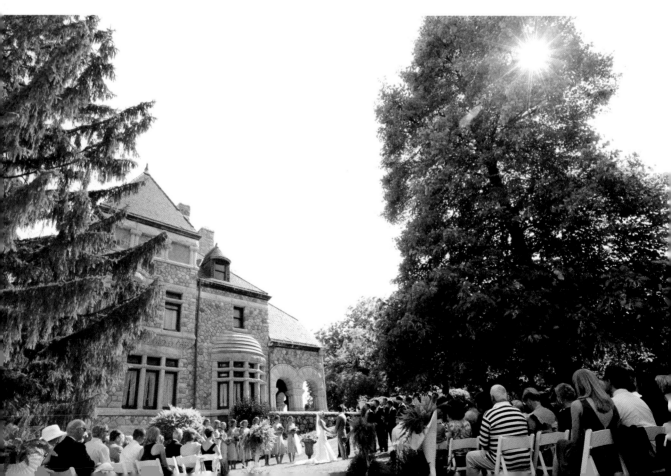

Ceremony schedule questions:

❀ What time is the ceremony supposed to start?

❀ How long is the ceremony supposed to last?

❀ Who is going to walk down the aisle and in what order?

❀ What is the path the processional will take?

❀ Where is the musician setting up?

❀ Are there any special readings?

❀ Are there any religious aspects?

❀ Are there any restrictions in the venue?

❀ Will there be personalized vows?

❀ Are there any special activities, such as a candle lighting, breaking the glass, or benedictions?

❀ Where will the wedding party be standing during the ceremony?

❀ Where is the family sitting during the ceremony?

❀ Will there be a receiving line right after the ceremony?

❀ What, if any, personal touches will there be during the ceremony?

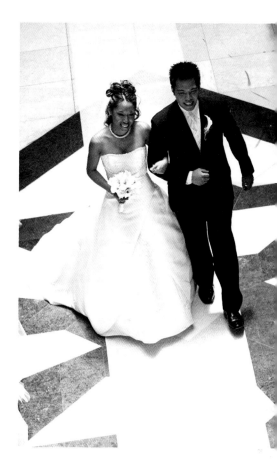

INDOOR **SHOOTING**

Many wedding ceremonies take place indoors, in buildings of worship. These buildings are usually very well taken care of and have fantastic architectural details. Make sure to get some wide angle photos showing the beautiful venue in all its glory. Of course, this means you need to build time into your schedule to do so. Consider getting to the venue early to capture these shots, especially if you won't be attending a rehearsal.

The biggest concern when shooting indoors is lack of light. To the naked eye, there may be plenty of light to see the ceremony and make out the beautiful details of the location. But often, the light is not adequate for the camera's sensor.

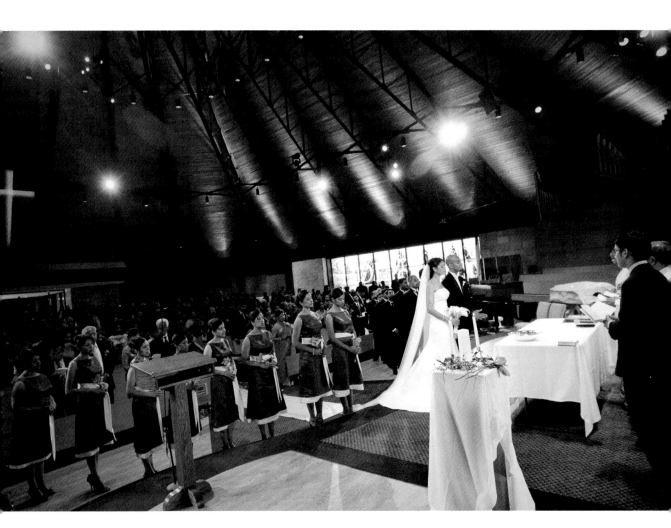

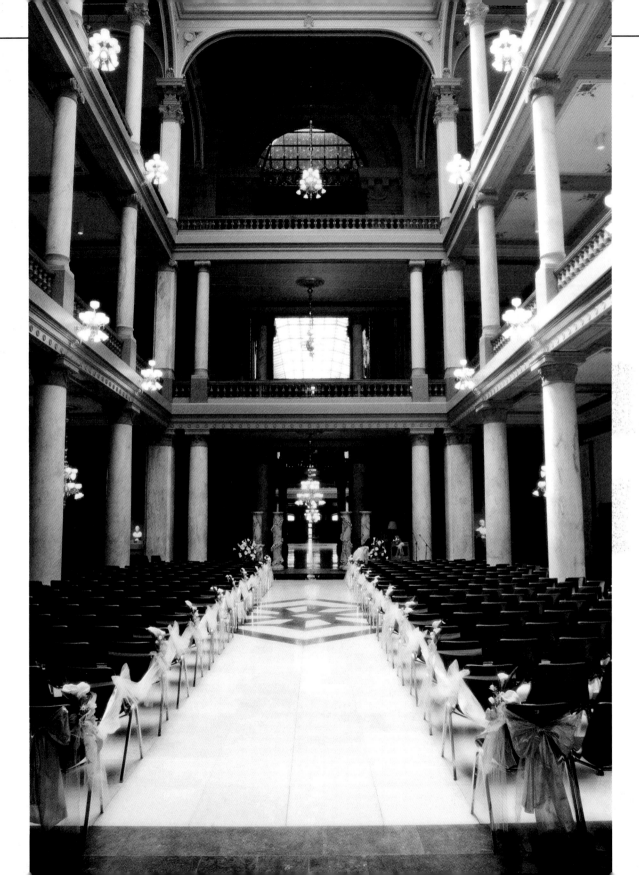

To successfully shoot in the low light situation, bring your own lights, usually in the form of a flash or two. While this works great for posed portraits and set up shots, it doesn't work for the ceremony. The flash frequently firing can be very distracting and may also be frowned upon when shooting in a religious venue. Practice using these low light shooting tips to get the correct exposure in these situations.

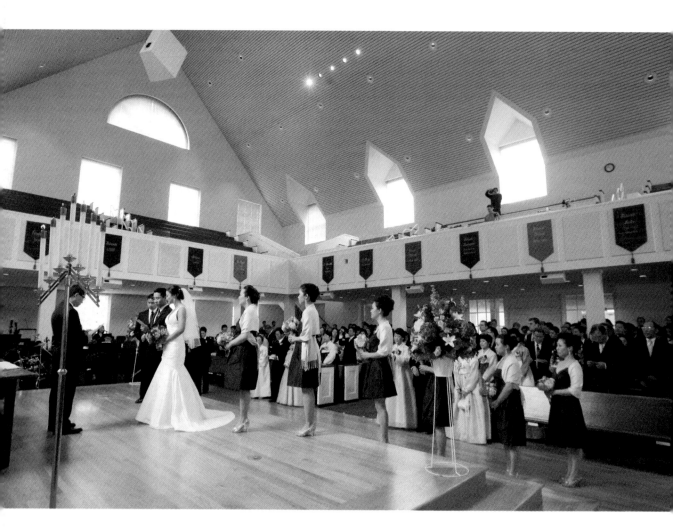

Shooting indoors may also offer some very unique angles, especially if the location has a balcony, allowing you to shoot down on the ceremony. Familiarize yourself with the location prior to the wedding so you know where you can and cannot shoot. Make sure you check with appropriate personnel before just walking around a house of worship. While it may or may not be your religion, all religions need to be shown the proper respect. Remember, you are there by invitation and should behave as such. ❊

Low light shooting tips:

❋ Know how high you can set the ISO before there is too much digital noise. You can test this by taking several shots of the same location beforehand and increase your ISO every time to see what your camera's threshold is before it starts to create significant noise in your images. You can also do research online to find out what the threshold is for your camera.

❋ Use lenses that allow more light to reach the sensor; those with maximum aperture of f/2.8 or wider

❋ Use the slowest shutter speed possible that still freezes the action

❋ Practice holding the camera steady for longer times without moving. If you are not good with this, bringing a tripod might be a good idea. You can also use the tripod to capture low-light situations during reception.

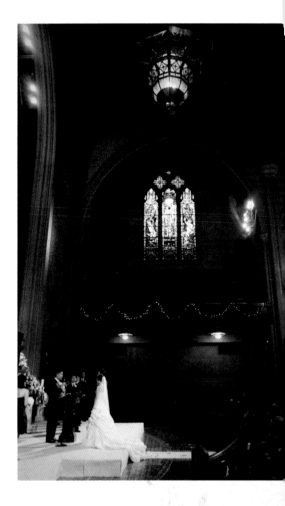

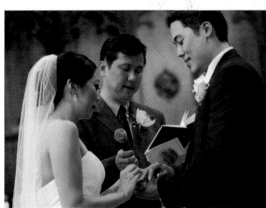

OUTDOOR **SHOOTING**

Many couples choose to get married outdoors because the natural setting is beautiful. Ocean views or majestic mountains, it doesn't matter; shooting offers amazing backdrops for your photos. Be sure to take advantage of these locations by capturing photographs encompassing not only the wedding party, but also capturing the view. Not only will it serve as a great background, but it will also remind the couple of their very special ceremony.

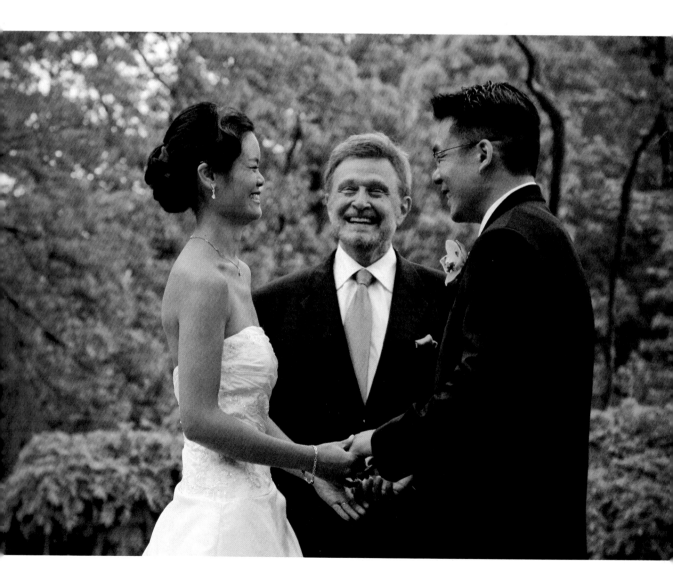

When shooting outdoors, lighting can also be problematic, but for very different reasons. The intensity of the light outside can change quickly when a cloud passes overhead. Or the amount of light can change as the sun goes down, causing areas that start out in bright sunlight to be in deep shadow by the end of the ceremony.

It's key to understand the three types of outdoor light – bright sun light, diffused cloud light, and shaded light. The light will constantly change, requiring you to continually adjust the exposure settings as the ceremony progresses. These lighting condition changes also change the temperature of your white balance. Practice in advance so you know what settings to adjust, and will be prepared to make changes on the fly. You must also be aware of lens flare as light strikes the large front element of your lens. It pays to have a lens hood for all your lenses already mounted so you can avoid this, especially when shooting outdoors.

You may encounter another challenge when shooting outdoors. Part of the scene may be in bright sunlight but the other part is in deep

ashadows. While the human eye can adjust automatically, the camera sensor is not so advanced, and the photographer must decide what to expose for. The trick is to remember what the focus of your image is and expose for that part of the scene. The other option is to move so you can recompose the scene and avoid areas of extreme highlights and shadows. During the ceremony, you don't have the option to move your subjects in and out of light to capture them with proper exposure, so you must reposition yourself to recompose the shot. For example, when you look at a bride and only half of her face is lit while the other half is dark, rather than shooting her straight on, shoot just the one side of her that is lit. ❉

PROCESSIONAL

Photographs of the bridal party making their way down the aisle are some of the "must have" photographs of the wedding ceremony. For the best view, position yourself to shoot each person as he or she starts down the aisle. Knowing the order and route of the processional lets you be in place and ready to shoot when the wedding starts and not scrambling to get into position as the first of the wedding party passes you by. In traditional Christian weddings, the processional order is as listed to the right.

Processional order:

* Ushers / Groomsmen
* Bridesmaids
* Maid of honor
* Matron of honor
* Ring bearer
* Flower girl
* Bride with escort

When I am photographing alone, I generally like to position myself halfway down the aisle so I can capture the processional as well as the reaction of the parents and family members who are closer to the front. I can also capture the groom's reaction this way. Think of yourself as the chair umpire at a professional tennis match sitting in the middle of the court. Your head will need to go back and forth from left to right to capture all the moments. If the processional aisle is narrow, I often stand at the last seat closest to the aisle, disguising myself as a guest so I'm not obtrusive. When I have a second shooter, I position myself to focus entirely on the bride, and the other photographer hangs out near the alter to capture the groom and parents.

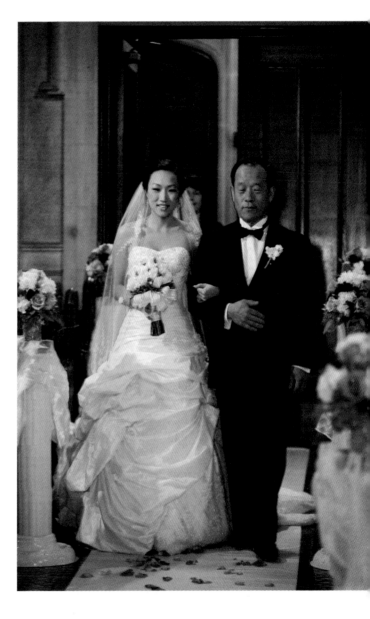

As with all aspects of the wedding, your best bet is to ask about the order of the processional so there are no surprises. The one sure thing, however, is the last person to walk down the aisle will be the bride. Make sure you are ready for her. If you have a second shooter, make sure he or she is focused on the groom, so you don't miss the opportunity to capture his response to his bride.

When shooting the processional, try to get both full-length shots and close ups to capture their expressions. This start of the wedding is very exciting and that is usually conveyed on the participant's faces. ❋

KEY **MOMENTS**

Think of the wedding ceremony as a sequence of key moments. This will help you to be prepared for what happens and when it is going to happen. Some of those key moments are as follows:

First look - The first time the groom sees his bride as she walks down the aisle is precious. Even if they posed together for images before the ceremony, there is still something very special about the moment when the bride comes into view.

Vows - The vows can be the standard set or personal messages written from groom to bride and bride back to her groom. Either way, you must capture the looks between the couple as they recite the vows.

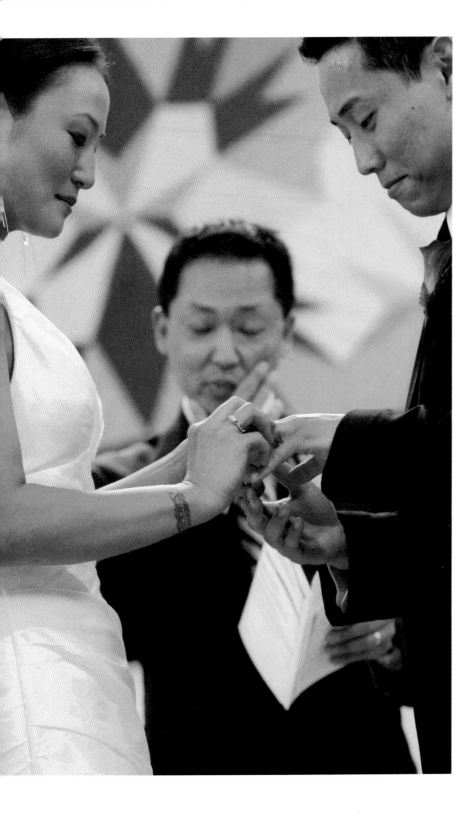

Ring exchange - All weddings have that tender moment when the groom slips the ring onto his bride's finger. This usually happens toward the end of the vows, so it helps to move in closer or use a longer lens before this moment so you are ready. Capture their expressions as they are putting the rings on each other's fingers, and use a long zoom lens like 70-200mm to narrow in on the details of their hands or to capture the tears rolling down their cheeks. I often sit or kneel in front of the first row next to the parents. They know what you are doing and will have no problem having you sit next to them for few minutes. Sometimes the wedding officiate will hold the ring up in air to explain its significance, which is a nice moment to capture. Another is when the best man hands the ring to the officiate.

The guests – The guests are the special people in the lives of the wedding couple and their reactions to the bride and groom during the key moments will help tell the story of the wedding. These reactions create great emotional images.

Wedding party – Make sure you shoot the rest of the wedding party during the ceremony. While the wedding is all about the bride and groom, they will appreciate reliving the emotions shared by their closest friends.

First kiss – It's their first kiss as husband and wife and can be one of the most emotional moments during the wedding. Even though the ceremony is practically over, the first kiss symbolizes that the rest of their lives, spent as husband and wife together, is about to begin. Sometimes, their kiss will last for less then a second, so it is good to put your camera in burst firing mode. Most high-end professional cameras have this option that allows you to shoot 3-10 multiple frames per second. Even the moment right after the kiss when they usually smile or laugh is important. If you attend the rehearsal, watch how they kiss so you can plan ahead. If you think they will not kiss for very long time, ask them to count three seconds in their heads when they kiss during the actual wedding and explain why. They'll probably get a real kick out it!

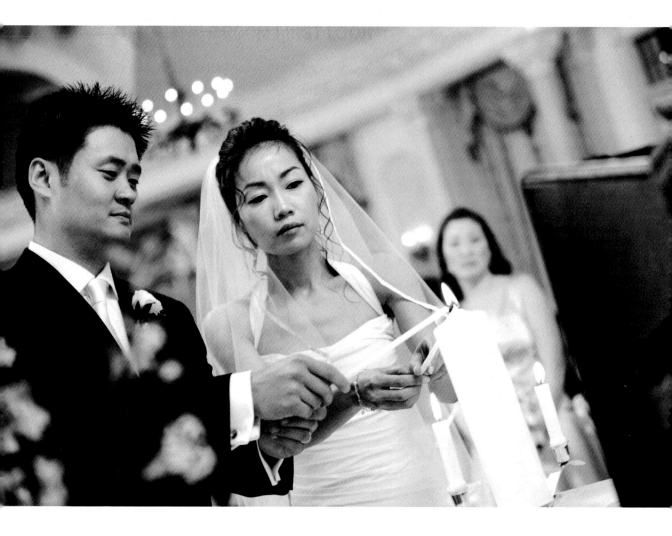

Candle lighting - Lighting a unity candle is becoming more and more popular during wedding ceremonies. The unity candle symbolizes the joining of two families into one, and is usually lit at the end of the ceremony after the couple has been pronounced husband and wife.

Glass breaking - One of the staples of the Jewish wedding is the glass breaking ritual. Not only is it an important part of the wedding, but the groom's foot coming down and crushing the glass also makes a great photo. Many modern couples will break the glass together. Either way, there is really only one way to capture the moment: from the top of the aisle looking down at the bride and groom.

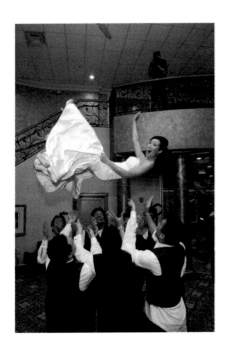

Surprises - Talk to the bride, groom and the wedding party separately before the ceremony to find out if they are planning any "surprises" that they don't want others to know about. They will be glad to share their plans with you so you can capture that moment.

Husband and wife - Capture the bride and groom walking up the aisle together as husband and wife after the ceremony. Chances are, they'll both be smiling! If possible also shoot photographs of the wedding guests as they turn to see the couple. ❄

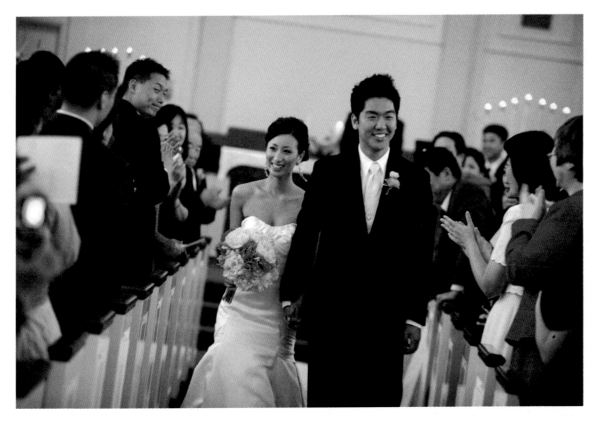

The Ceremony shot list:

* The exterior of the venue
* The interior of the venue without any people
* Guests walking into the ceremony
* Any musicians playing during the processional and wedding
* Guests being seated
* Officiate waiting
* Groom walking down the aisle with mother / parents
* Groomsmen walking family down the aisle
* Parents being seated
* Grandparents being seated
* Groom waiting for bride
* Important family members being seated
* Bridal party walking down aisle
* Maid / Matron of Honor walking down the aisle
* Ring bearer walking the aisle
* Flower girl walking down the aisle
* Bride with her escort
* Bride walking down aisle
* Bride's expression as she sees groom

* Groom's expression when he sees bride (2nd shooter?)
* Father of the bride giving her away
* Bride and groom at alter / Chupah
* Parents watching the ceremony
* View of ceremony from guest's point of view
* Close ups of the bride's and groom's faces
* Wedding party close ups during the ceremony
* Exchange of vows close up and wide angle
* Ring exchange both close up and wide angle
* The kiss
* Any blessings
* Any readings
* Any special moments like candle lighting or glass breaking
* Bride and groom walking down the aisle after ceremony
* Hugs and congratulations
* Receiving line

SUMMARY

The wedding ceremony is the crux of the day. Unlike many other times during the event, you only have one chance to capture the images you need. Be prepared; plan ahead; and if possible, work with a second shooter to make sure every angle is covered. ❊

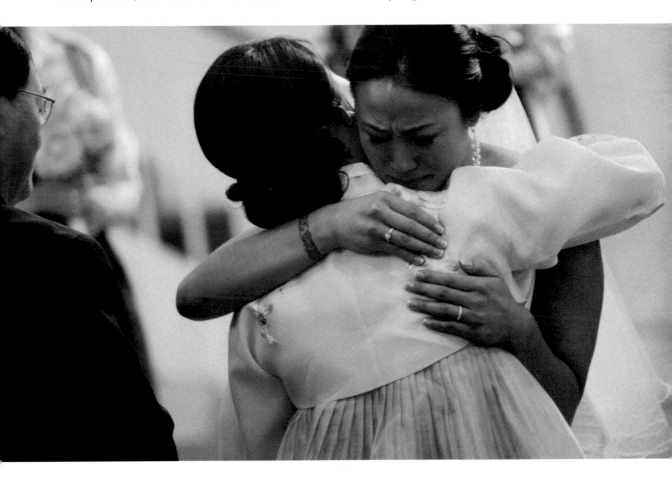

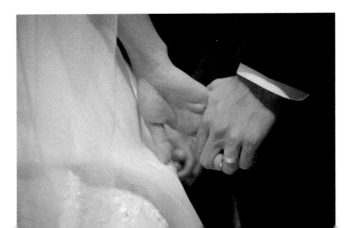

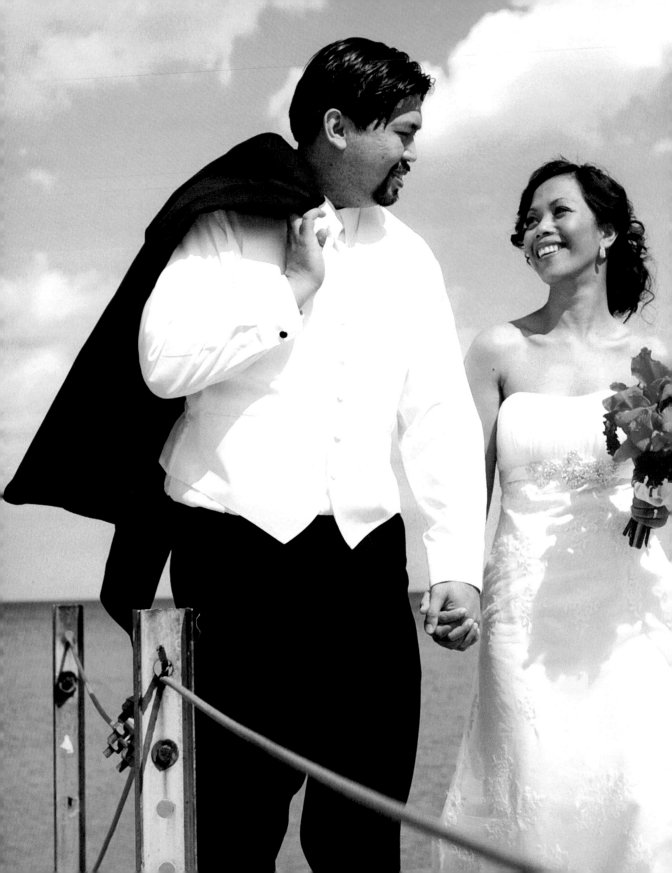

Images after the ceremony

Immediately following the ceremony, most couples and their friends and family are quite joyous. It's a time tailor-made for relaxed portraits of the newlywed couple and the family/wedding party. While there are some photographs that really should be taken after the ceremony, most couples will be anxious to get to the reception to spend time with their guests. If you and the couple plan well in advance the list of shots to be taken immediately following the ceremony, you can take as little time as possible. Be sure to make recommendations, while also listening carefully to what they want.

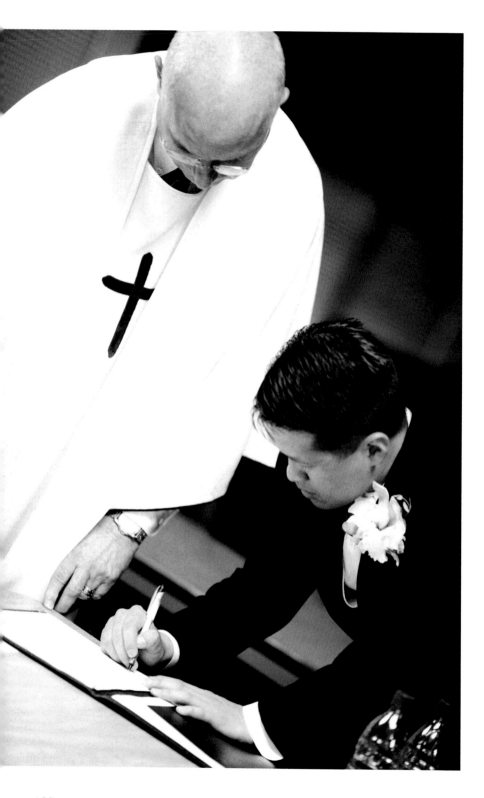

SIGNING **THE MARRIAGE LICENSE**

The official signing of the marriage license most often takes place immediately following the ceremony, and presents a great photo opportunity. A witness and the wedding officiate usually sign the license as well as the bride and groom. To quickly get the best possible photograph of the event, set up the location before the wedding. You will need the license, a nice pen, the witnesses, and the officiate along with the bride and groom in an area where there's a simple background and a nice table to sign the document. Also make sure the people involved know where and when to meet. ❈

RELAXED PORTRAITS OF
THE WEDDING PARTY

The time directly following the ceremony offers you a great opportunity to get group portraits of the whole wedding party. Even if you took a majority of these photos before the ceremony, it's a good idea to set up a quick relaxed shot before the reception. This might be the last time the whole wedding party is in the same place at the same time, all still looking neat and sharp.

If the couple did not have any photographs taken together before the ceremony, this is the time to get the images of the wedding party. When shooting the images that include the ring bearer and flower girls, keep it quick and do these first so the children don't lose interest or become distracted. Then, you can let the children be supervised by their parents while you focus on the shots of the adult wedding participants, who hopefully will have more patience than their younger counterparts.

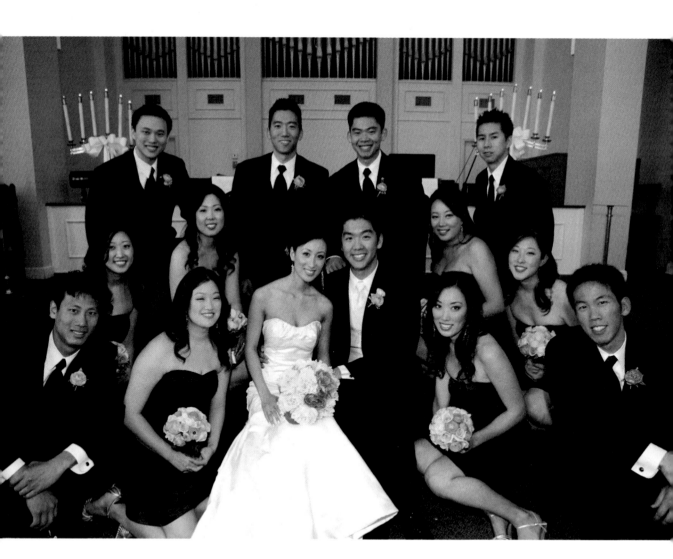

Bridal Party shot list:

�֎ Whole wedding party

�֎ Bride and groom with flower girls and ring bearer

�֎ Bride and groom with bridesmaids and groomsmen

✖ Bride and groom with bridesmaids

✖ Bride and groom with groomsmen

✖ Bride and the groomsmen

✖ Groom and bridesmaids

✖ Bride and groom with maid of honor and best man

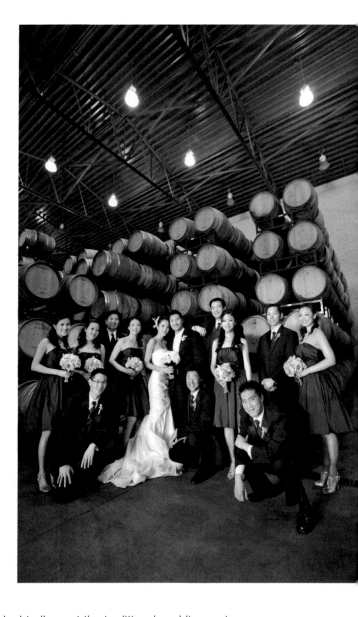

Remember, while the couple will undoubtedly want the traditional wedding party images, you should also take this opportunity to capture some fun creative pictures. The people in the wedding party are the closest people to the newlywed couple, and chances are these will some of the most treasured images. Just be sure to be mindful of the time, so the couple and wedding party can get to the reception and have time to freshen up before the celebration. ✖

RELAXED PORTAITS OF **THE FAMILY**

Before the ceremony was a great time to shoot the two separate sides of the family, but now is the time to combine the two sides and get those whole "new family" photos. This can involve a great many people, and it is best to make sure you know before hand who the bride and groom want in these photos.

The dirty little secret of wedding photography is that you don't really need hundreds of photos of every combination of family members unless the clients specifically ask for it. I have found having a big group shot and then a few of the immediate family works very well. As with all the family photos, the best policy is to ask the bride and groom before the big day. Being well-prepared beforehand cuts down on the amount of time needed to take these pictures as well as frustration.

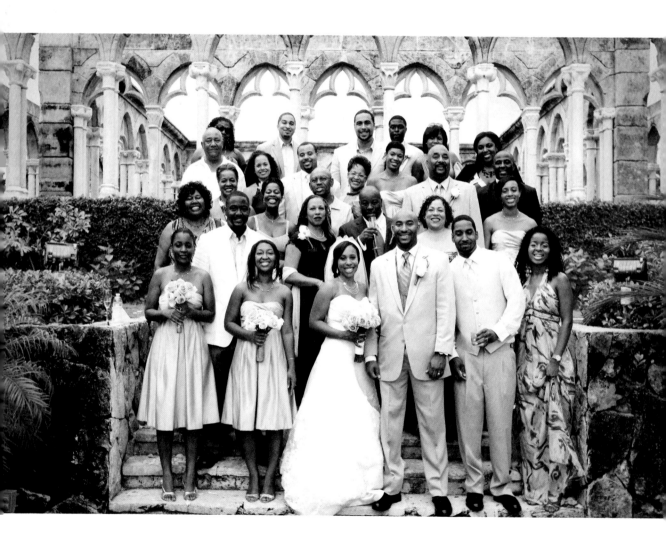

Family shot list:

* Whole family (both bride's and groom's families)
* Groom's parents, grandparents, siblings, nephews, nieces, children
* Bride's parents, grandparents, siblings, nephews, nieces, children
* Groom's grandparents and parents
* Bride's grandparents and parents
* Groom's grandparents
* Bride's grandparents
* All grandparents
* Groom's parents, siblings and children
* Bride's parents, siblings and children
* Groom's parents and children
* Bride's parents and children
* All parents and children
* Groom's parents
* Bride's parents
* All Parents
* Children
* Special relative

For these photos it is very helpful to have an assistant to help get the family members together, and then help usher them to the reception after they are done. If the bride and groom have hired a wedding planner, he or she may be able to help in the case that you don't have a second shooter. You can also ask the bride or groom if they'd like to suggest a family member who could help keep things in order. Of course, you should discuss this possibility with everyone involved before the ceremony. �֍

RELAXED PORTRAITS OF **THE BRIDE AND GROOM**

In Chapter 8 we discussed taking the portraits of the bride and groom before the ceremony if the couple didn't mind seeing each other before the traditional walk down the aisle. If your couple

made a more traditional choice to wait until after the ceremony, then immediately following the ceremony is the best time to get the bride and groom portraits. Even if you captured the main portraits of the bride and groom before the ceremony, this time frame offers you another chance to get a few relaxed shots of the bride and groom before they make their entrance at the reception. Quickly take the photos of the happy couple and let them have a few moments of alone time before they are introduced at the reception. They would much rather spend their time celebrating with their friends and family instead of taking photos. ❈

SUMMARY

To make the most of the time immediately following the ceremony, be sure to discuss with the couple ahead of time what shots will be taken. Then develop a good plan for organizing the participants and getting all the images done. Often times, the couple, the wedding party, family members and guests will evaluate how good of a photographer you are based on how you handle this situation. Plus, the couple will definitely appreciate your efficiency that allows them to get to the reception and enjoy the rest of their celebration. ❂

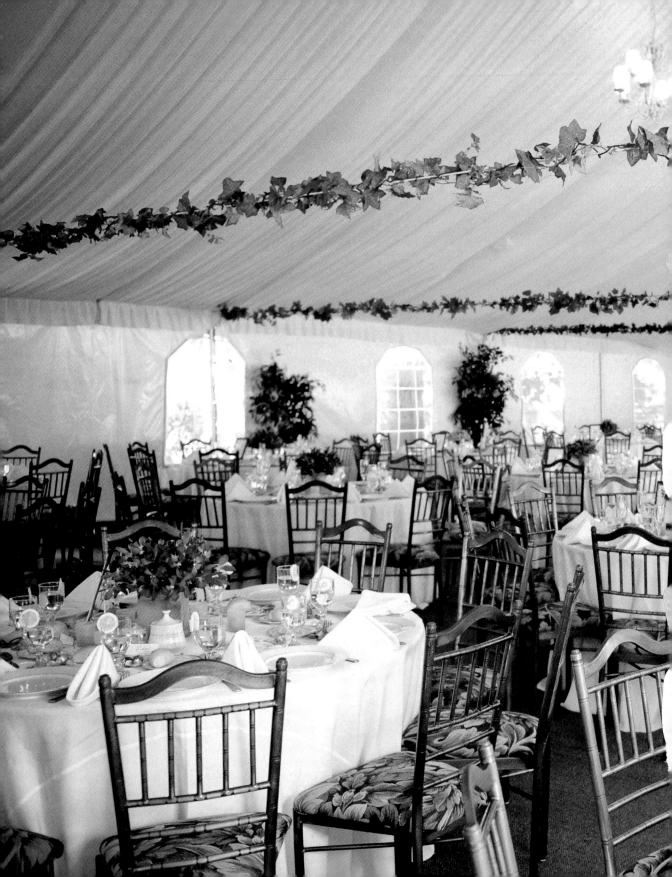

Reception

It's official! The bride and groom are now husband and wife, and it's time to cut loose and have some fun. The reception marks a joyous occasion and even formal sophisticated receptions are still, at their core, a party to celebrate the joining of two people in marriage. No more pressure; the long months of planning are over and it's time relax—unless you are the photographer.

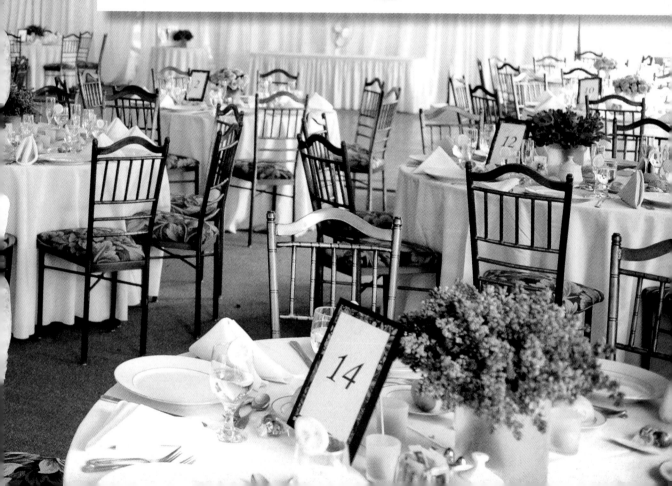

CAPTURING **THE CELEBRATION**

With so many different moments to capture at the reception, I am usually very busy from start to finish. Photographing this part of the day's events can be broken down into two distinct subjects: the still life images of reception details and the action shots of the bride, groom and guests. Because you will be shooting from a variety of locations during the reception it is imperative to keep your gear together and organized. You don't want to have to keep running back to your bag in the middle of shooting or find that you don't have an important lens during a key event. Know the schedule of events planned for the reception and have the right gear with you at the right time.

One other piece of advice—eat when you can. Weddings make for long days of shooting.

Being hungry can lead to mistakes and your attention will not be on the couple where it should be. So if there's a lull in activity, take the opportunity to briefly have something to eat. Many venues will have a place where the vendors can have their meal. Talk to the couple before the wedding to see if they can make a request that you eat your meal the same time the guests do. Usually, people do not like to be photographed while they eat, so this is a good time for you to take a break as well. I like to go step further and ask if it is possible for me to be seated in the same room where the reception is taking place so I can keep an eye out for anything that needs to be captured. This is not always possible, but usually couples are very accommodating and understanding of this request. ✼

RECEPTION **DETAILS**

Brides and grooms spend many agonizing hours picking out the right colors, the right flowers, the right everything. It's your job to capture the details, especially in the flowers and other personal touches that make this reception unique to the wedded couple. The reception will never look as good as in the moment before the guests arrive. All the place settings are clean and set properly, all the flowers are set up perfectly and still fresh, the candles are not burnt down and the place cards are in their places for the guests. This is the best time to get into the room and get the still life shots needed.

Since it is impossible for you to be in two places at one time, if you have multiple photographers, send one of them ahead to the reception site to capture the details before the guests arrive. If you are working alone, make sure to schedule your time so you will be done with all the photos at the ceremony before the cocktail hour is over. Once you arrive at the venue, immediately head to the reception hall to take some pictures before the guests enter. ❖

Details to shoot before the room fills with guests:

* ❋ Place setting
* ❋ Flowers
* ❋ Cake
* ❋ Cake table
* ❋ Cake details
* ❋ Guest book
* ❋ Seating cards
* ❋ Seating plan
* ❋ Room details
* ❋ Toast glasses
* ❋ Wedding favors
* ❋ DJ or band
* ❋ Decorations
* ❋ Table details
* ❋ Building details

Remember, when shooting anything glass or reflective to pay close attention to the actual reflection. You don't want to see yourself or any other objects in the images. This is also a great time to use both the wide angle lens to capture the whole room's ambience and your macro lens to pull great detailed shots of the smaller details at the reception site. ❋

INTRODUCTION OF **THE COUPLE**

Here they come, for the first time as a married couple. What a great photo opportunity! The keys to getting this shot are knowledge and timing. You need to know when the couple will be introduced so you can time the shot and capture the happy couple and their guests. If you are working with other shooters, it will be possible to shoot the introduction from different angles. Try shooting from behind the couple to catch the guests' reaction to the couple making their entrance. ❖

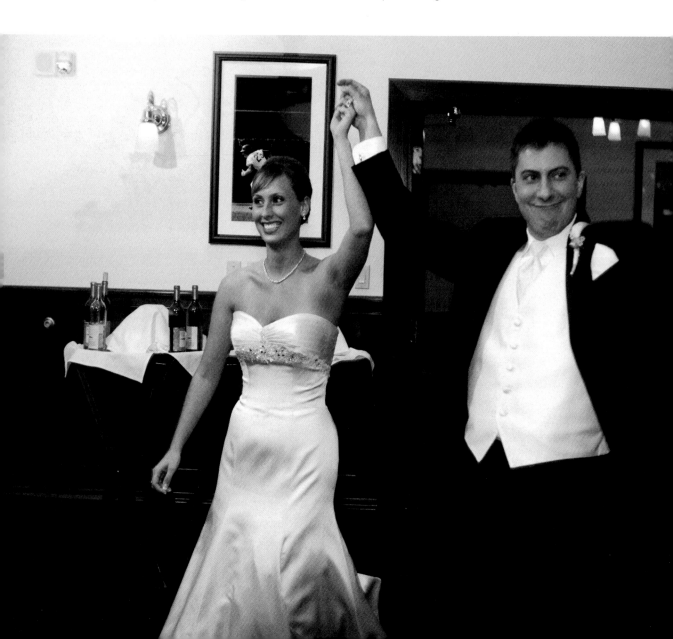

BEFRIEND **THE DISC JOCKEY**

During most receptions, the DJ or live band leader sets the pace and schedule of the events. Speak with them before anything starts, and ask them to let you know what is going to happen next. They may even be able to provide with their planned schedule of events. �ખ

FIRST **DANCE**

Many times the introduction of the couple leads directly into their first dance. When shooting this must-capture moment, you have some time to be creative. Most songs are over three minutes long, which is plenty of time to try various combinations of shutter speed and apertures. Using a longer shutter speed can add a sense of motion to the image, while shooting with a long lens, think 70-200mm or so, will allow you to get in close, yet not intrude. �

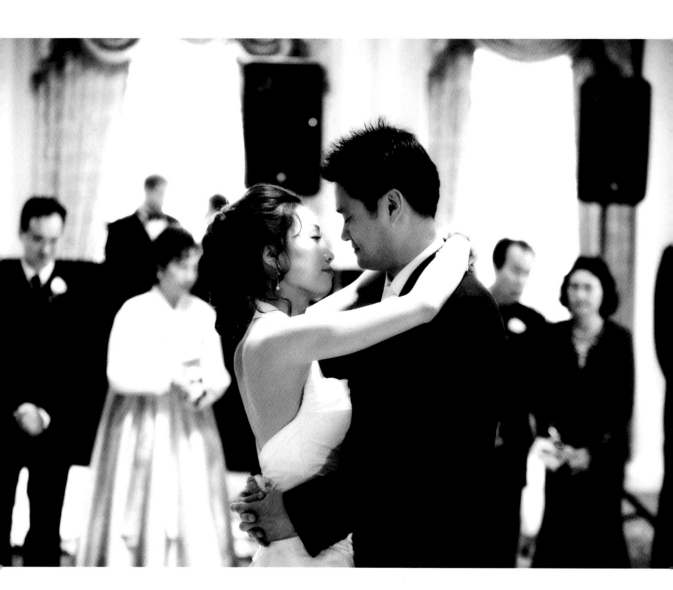

TOASTS

No wedding reception is complete without a round of toasts. Usually there are toasts by the best man and the maid of honor followed by the groom. Don't be surprised, however, if there are also toasts given by family members and other close friends. While it is important to get a good close-up of the person giving the toast, you should also get shots of the bride and groom and other guests reacting to the toasts. Many times a good toast will get a reaction out of the bride or groom—laughter, maybe a tear or two, which will usually be more interesting than the photo of the person giving the toast.

To get shots of both the person giving the toast and the bride and groom from the same vantage point takes careful positioning. If you are working with another photographer then split the shooting duties with one photographer shooting the toaster and the other focusing on the reactions. It helps to know if all the toasts will be given from the same place or if each person will be toasting from his or her seat. ❧

GARTER AND **BOUQUET TOSSES**

Shooting the garter and bouquet tosses can be some of the more technically difficult shots of the whole reception because they involve two separate subjects, the bride or groom who is doing the tossing and the group of people who are doing the catching. Often these two subjects can be quite far apart. It's ideal to have two photographers to capture these moments, but if you're shooting alone, the key is to position yourself where you can get both the toss and the catch. One trick I use to cover both angles is to ask the bride to "fake" her first toss to capture her reaction from the front. Then I position myself between the bride and the people catching the bouquet to capture the backside of the bride's "real" toss and the reaction of the guests as they try to grab the bouquet.

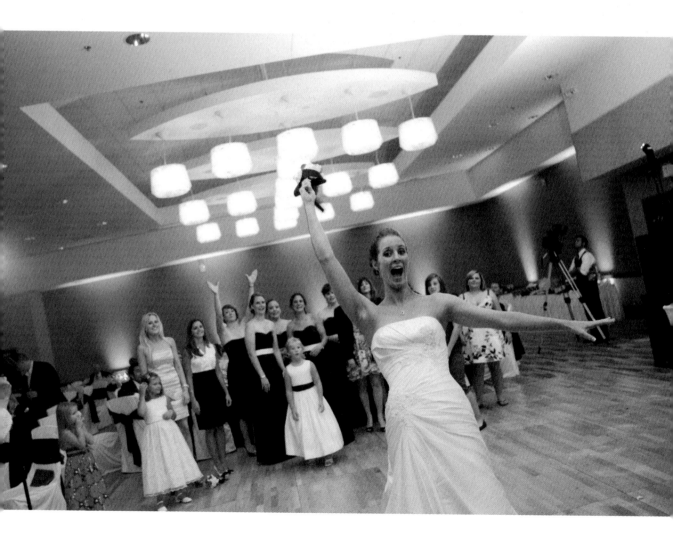

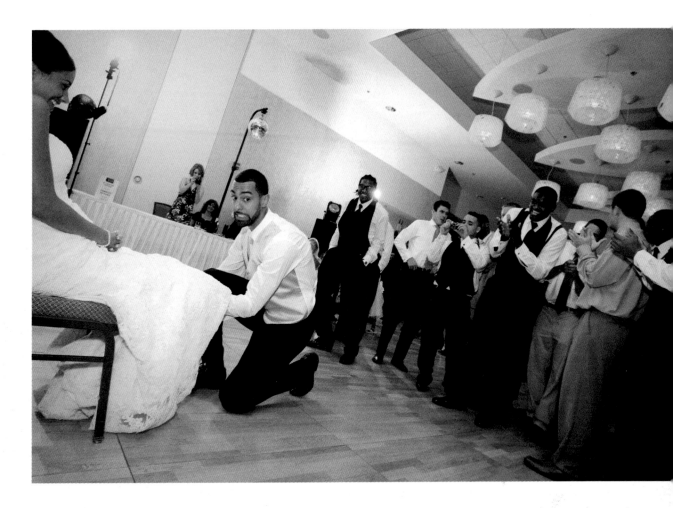

These tosses are notorious for mishaps. Because the garter is really light, a common pitfall happens when the garter falls far short of the group of guys, even when tossed by the strongest groom. Frilly lace garments just don't travel very far. Ceilings, or even worse, a ceiling fan can get in the way of a bride tossing the bouquet to waiting single ladies. Making sure the distance between the person tossing the item and the group isn't too great, and look for locations with high ceilings. Hopefully this will stop the garter from falling flat on the ground and the bouquet from being hit like a baseball. The bride and groom will appreciate your assistance in helping avoid these mishaps. ❖

CAKE **CUTTING**

The cake cutting and the more intimate feeding of the cake is another one of the must-capture moments of any wedding reception. Since I have already photographed the cake earlier, the cake cutting is more about the interaction between the couple than anything else. Some things to keep in mind when shooting the cake cutting:

Be in position. You want to make sure the bride and groom are the center of attention and you are not at the back of the crowd. Try to avoid standing in front of the cake with the bride and groom behind it because the cake may block the couple.

Bounce / diffuse the light. Direct light can cause harsh shadows and when the bride and groom raise their hands to feed cake to their partner, it can cause the shadow to fall across their face.

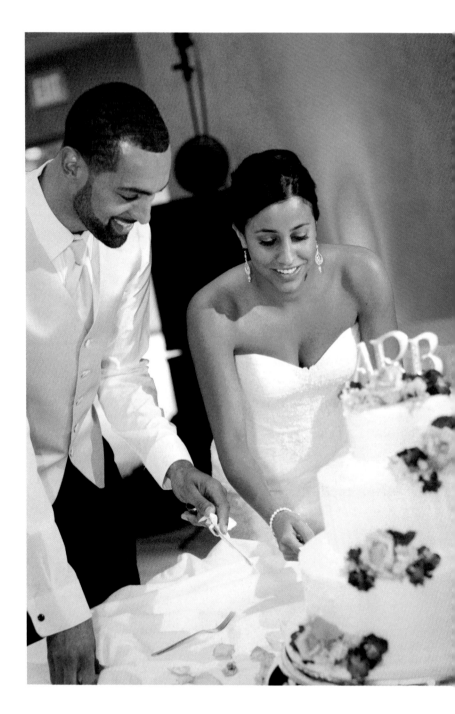

Control the depth of field. To get the cake and the couple in sharp focus you will need to use a deeper depth of field such as 4.0-5.6. This can also cause the background to come into sharp focus so be careful that the background is something you want in the photograph. Sometimes you might decide you rather have just the couple be the center of focus while everything else is blurred out. You can use a shallow depth of field such as 1.8-2.8 (depending on your lens capability) to remedy this situation. ✻

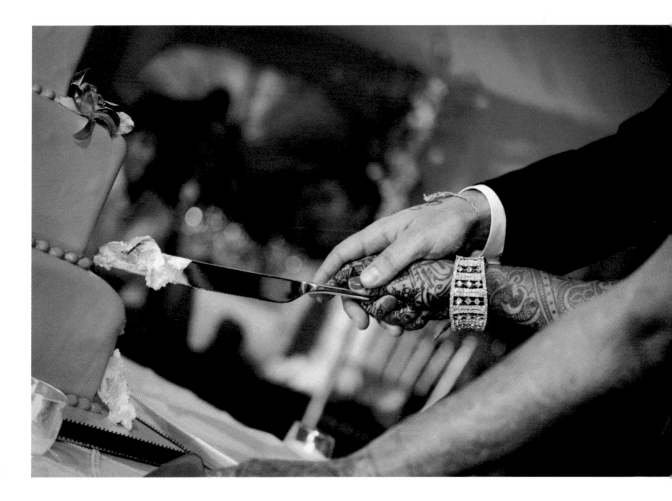

Remove the clutter. The only thing on the cake table should be the cake and decorations. Make sure there are no extra glasses or plates in the photo.

DANCING

The reception is essentially a party and if you ask me one of the best things about a party is the dancing. When it comes to weddings there are some dances more important than others, including the previously discussed first dance of the new husband and wife. Other important dances are the Father/Daughter and Mother/Son dances. There are also some traditional wedding dances like the Hora at Jewish weddings. Make sure you know when these dances are going to take place so you can be ready to shoot when they start.

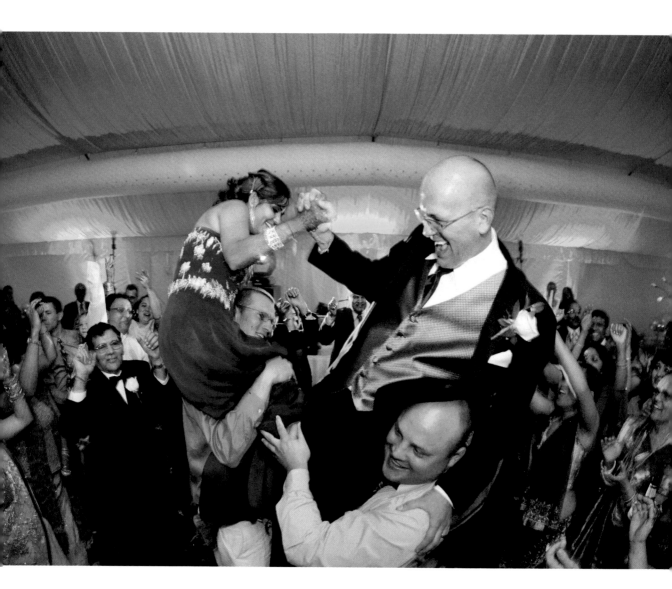

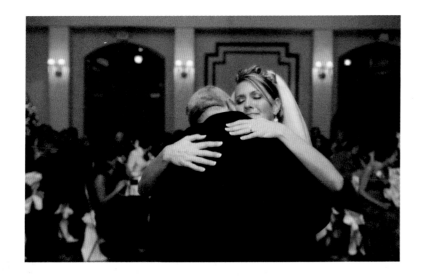

When the Father/Daughter and Mother/Son dances begin, it is best to start with a long lens so as not to distract from the moment. As people start to join in, you can switch to wider and wider angle lenses and physically move in closer to the action without being a distraction. ❋

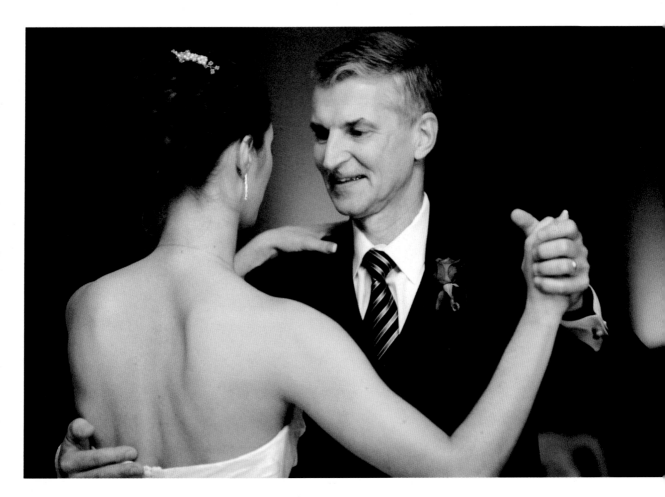

INFORMAL **PORTRAITS**

At the reception, be sure to get informal portrait shots of the bride and groom with their guests. Talk with the couple before hand so you know who they want photos with, and work out a plan for when the couple will take a few minutes for some relaxed portraits and group shots.

One great way to make sure you get all the guests in the wedding photos is to shoot the tables with the guests around them. If possible, take pictures of the bride and groom as they make the rounds to greet everyone at the reception, allowing you to capture them interacting with their guests. The best time to capture these photos is usually right after the guests are seated, but before the food is served. If you shoot before food is served, the tables will look their best and there won't be half-eaten food on dirty plates to ruin your shots. If it's impossible to do it before the meal, then ask the guests to move to one side of the table and have the newlyweds pose with them.

Think of these groups of people when discussing the informal portraits:

❄ Work friends

❄ School friends

❄ Childhood friends

❄ Family friends

❄ Teammates

❄ Different family groups

Another great time for informal and group shots is after the meal and toasts but before the cake cutting and garter/bouquet toss. This presents a great time to get those special groups together, like the college friends or the guys on the softball team or work friends. Have a spot in mind for the informal portraits so when the opportunity comes up, you can shoot a few frames and move on. ❄

CANDIDS

The candid shots you take throughout the day will really tell the story about the wedding, and the reception offers many moments for great photos. In fact, this is where you get to shine and these photos often end up as the couple's favorites. Be sure to capture conversations between the couple and their guests, and watch for guests' reactions during events such as toasts, cake cutting, first dance, and the slideshow.

The most important lesson here is to stay alert to what is going on during the reception. During one reception I shot, as the party went on and music played loudly, we suddenly heard something "pop." One of the music speakers blew out and caught on fire. The guests translated it to mean they were partying too hard and began cheering. One girl walked up to the speaker and put the fire out by splashing it with cup of water. I suspected she was going to do something along that line, so I followed her closely and captured that moment. ❊

SLIDESHOW **PRESENTATION**

Some wedding receptions have a slideshow of images of the couple through the
years. These slideshows can be fun, moving, sad, happy and as with the toasts,
the reaction of the guests and married couple is often the more important and
more meaningful image. Since the room will usually be quite dark during this
time you will need a lens that can capture more light. Anything that ranges from
1.2-2.8 should do the trick. You can also use an on-camera flash to brighten
your subject. As mentioned before, avoid using direct flash to light your subject.
Bounce the light or use the white reflector card to create soft diffused light. ❊

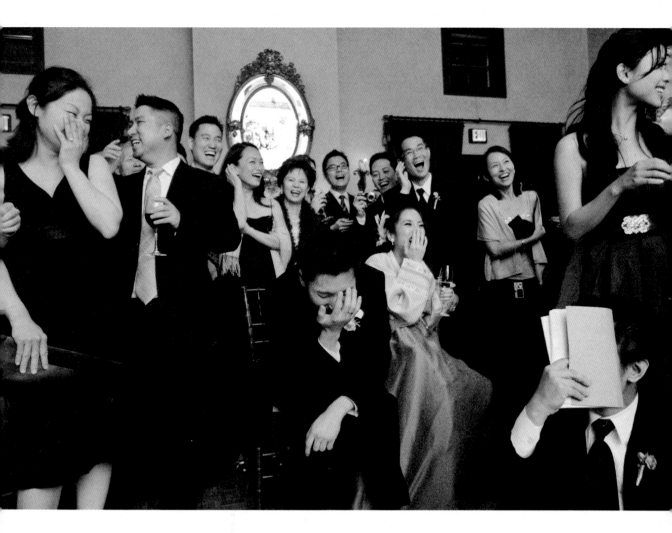

NETWORKING

As a wedding photographer, your primary job is to photograph the wedding. However, you also have a secondary job to network and potentially land future jobs. There are two different groups of people you need to network with at the wedding: the guests and the vendors. At the end of the reception program, instead of leaving, it is a good idea to stick around and casually talk to the guests as well as the other vendors. Many guests at weddings are interested and have questions about photography. Take time to answer their questions and talk to them about how you do your business. Building these relationships can lead you to other weddings in the future. Also exchange business cards with vendors. Follow-up with them after the wedding by sharing some of the images you captured of them, which they can use to promote their business. Sharing can go a long way and may lead to an inquiry in the future. ❧

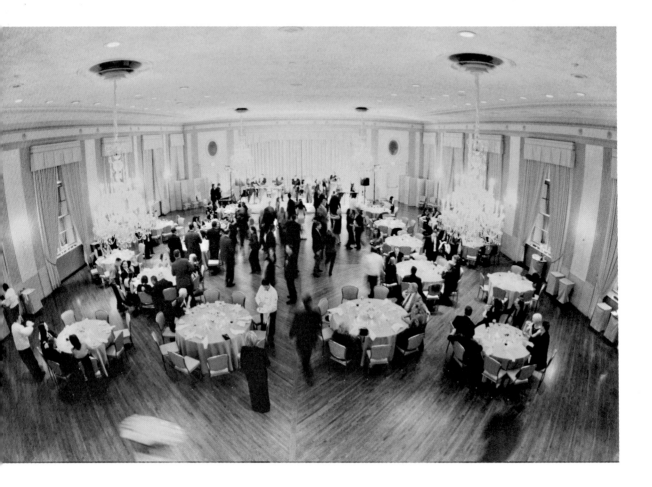

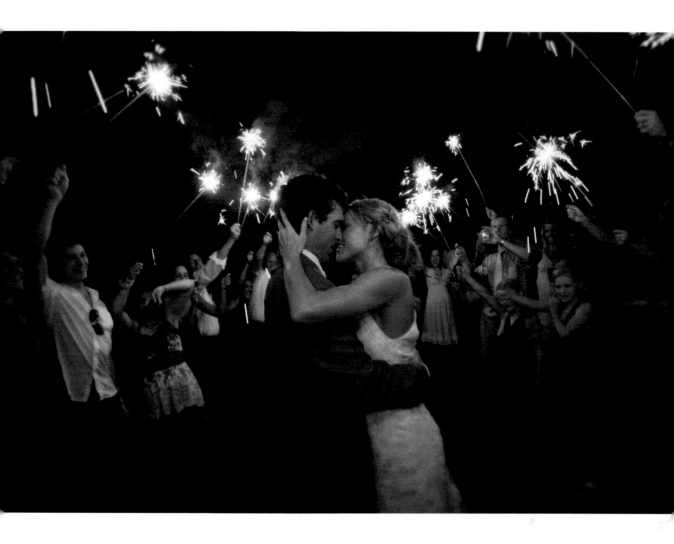

LEAVING **THE PARTY**

The last "must-get" shot of the reception is the bride and groom leaving.
Sometimes this shot is captured when they leave the church after the ceremony,
or it may be planned for after the reception. It's key to know when this will
happen so you can be in the best position. Usually, you'll want to be outside
shooting the couple as they exit the building. Capture the bride being helped into
the car by her new husband and any decorations on the vehicle. It's best to use
a wide-angle (such as 16-35mm) to capture them exiting. You can capture the
reaction of the guests as they cheer for the bride and groom one last time. ❀

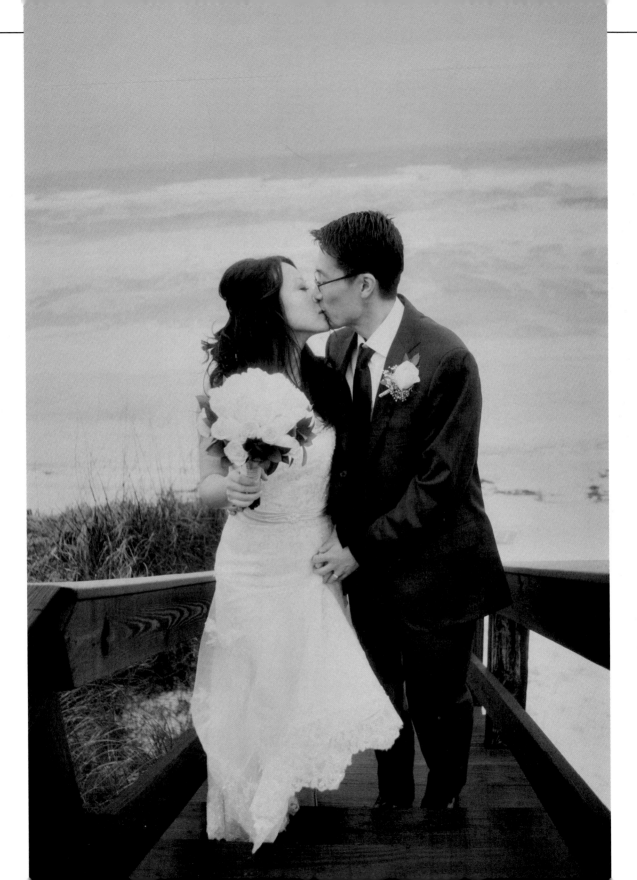

Reception shot checklist:

* The inside of the reception without the guests
* The exterior of the reception noting any special features
* Bride and groom arriving
* First dance
* Mother/Son dance
* Father/Daughter dance
* Garter toss
* Bouquet toss
* Toasts
* Cake
* Cake cutting
* Dancing

* Leaving the party
* Place setting
* Special food or drinks
* Guest arriving
* Guest signing the guest book
* Place cards
* Decorations
* Table settings
* Guest favors
* Special décor touches
* Parents, grandparents, family dancing
* Musicians/DJ
* Couple leaving

SUMMARY

The reception is a great place to really capture the essence of the day. Get both still life images of reception details and the shots of the bride and groom and all the guests. Be creative and have fun; everyone will be more relaxed and is celebrating the beginning of the couple's new life together. Your images will really tell the story. ❈

Post production

Years ago, when wedding photographers used film, all they had
to do after the wedding was send the rolls of film to a lab to get
processed. With digital photography, however, the process is a little
more complicated. The days of looking at your photographs as
negatives, contact sheets or as slides on a light table are long gone.
Now photographers view and edit their images on their computers,
then post them online for their clients to see and order prints and
other products. While there are many benefits to the digital age, it
does require today's wedding photographer to have knowledge about
more than just their cameras and other photography equipment.
Today's photographers must also have good working knowledge of
computers, software and digital workflow options.

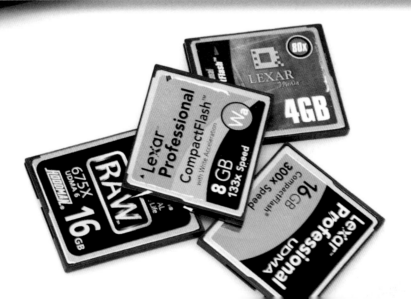

DIGITAL **WORKFLOW**

The first step in the digital workflow is downloading images from the camera to the computer, and there are many ways to do this. Many cameras come with software allowing the photographer to download the images directly from the camera to their computer. There are also specialized card readers that allow you to download the images while the card is not in the camera, freeing up the camera for use and saving the camera's battery.

I use Photo Mechanic™ software by Camera Bits to download and sort the images from my memory cards. When using Photo Mechanic, I transfer the images from my memory cards to my laptop, sometimes even starting before the wedding reception is over. As the files are downloaded, I rename them as they import to make it much easier to keep track of which images are from which wedding. I can also add information about the shoot directly into the file. I use the IPTC (International Press Telecommunications Council) stationary pad to add captions, keywords, photographer information, location and any special instructions. Having this information inserted directly into the file makes it much easier later to find images from a specific wedding or images taken at a specific location. This information is also helpful when you share your images with publications and vendors to identify the owner of the images. ✳

Information to add to the images:

❊ Photographer (either my name or the name of the secondary shooters) and contact information

❊ Location

❊ Date of event

❊ Client's name and contact information

❊ Copyright information

SELECTING **IMAGES**

Once the images are imported, I use the contact sheet mode in Photo Mechanic to cull the images down and create a group only of the ones I want to edit. This is where the real work begins. One of the most important parts of the digital workflow is looking at your images and realizing which should and shouldn't be used. When I was starting out, this quote by Joe Buissink really spoke to me. "There are no perfect photographs, only perfect moments." I still find it is more important to capture the emotion than to make sure the technical qualities of the image are perfect. Images that lack emotion will have very little impact on the viewers, and since weddings are very emotional times, the images need to convey that.

The next step is to make sure the image is flattering to subjects; no one wants to see an unflattering image of their wedding day. Then I look at the technical aspects of the photograph. Is the exposure correct? Are the eyes in sharp focus? Are there any distracting elements in the background? If everything looks good, then the photo makes the cut. Keep in mind, however, that sometimes the technical qualities can be fixed during the editing process.

Every photograph you allow to be seen represents your work. Make sure you only show the good images. It is as simple as that. ❋

Tips for selecting images:

❋ Look for shots that capture emotion

❋ Choose images flattering to the subjects

❋ Consider technical aspects of the image
 • focus
 • exposure
 • distracting elements
 • distracting backgrounds
 • distracting foregrounds

❋ Make sure you have covered all the important people

❋ Make sure you covered all the important events

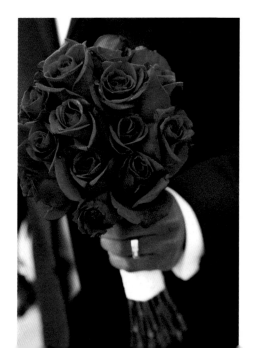

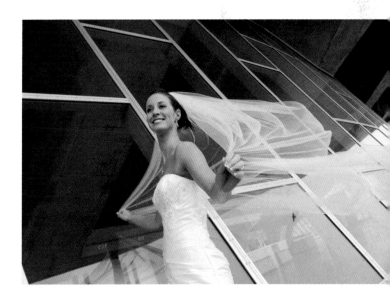

EDITING **IMAGES**

It's wonderful to think that every image is perfect right out of the camera, but we all know that just isn't true. Even the best shot sometimes needs a helping hand. There are a number of software options for editing your images to create the best possible photographs for your clients, including Aperture by Apple, Adobe® Photoshop® and Adobe® Photoshop® Lightroom®. Read more about these in Appendix 4.

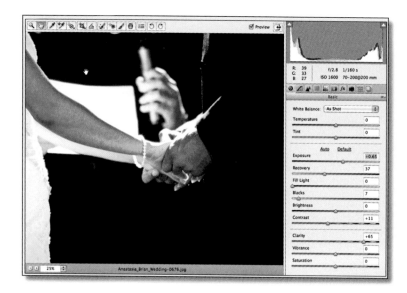

The most common and easy-to-make corrections involve adjusting the exposure. Many software packages have an exposure slide, which can increase or decrease the overall exposure of your image without doing any real damage to the image itself. Many software programs also allow you to crop the images to remove extra area surrounding the subject. You can also convert images from color to black and white and even remove unwanted objects in the image. Be sure to invest time learning the software package you choose for editing so you can efficiently get the results you want.

Once the wedding images have been selected and edited, I am ready to show off my work and let the clients preview images and order prints. Today's technology makes this quick and easy. Read about several ways to deliver images to clients in the chapter 13. ❈

Outsourcing image editing

Editing images takes a lot of time, and I have found outsourcing this aspect of my workflow to be a good investment. Once I have selected the group of images to edit, I make a copy of those images to an external hard drive and ship the drive to Photographers Edit (www.photographersedit.com), a company specializing in editing photography. They do all the editing and send the drive back to me with all the images as high resolution JPG files as well as the original files and the whole collection as an Adobe Lightroom Gallery. (See Appendix 4 for more on Adobe Lightroom.) When I receive the images back, I make sure they look the way I want before uploading them to a Web site for the clients to see.

Because I have worked with the people at Photographers Edit for a long time, they know how to edit my images in my style. Rarely do I need to spend much time editing images, and outsourcing this task frees me to spend more time marketing, photographing or getting new clients. This might be a good solution if you are a self-employed photographer trying to juggle the entire studio by yourself. A good rule of thumb is to consider outsourcing aspects that can be outsourced to allow more time to focus on the main source of your business.

ARCHIVING

There are many different ways to store your images after the wedding is over, from keeping them on the computer's hard drive to copying and storing the photos on DVD discs. Since computer hard drives are mechanical devices, they will fail over time and DVD technology is continually changing. The real solution for archiving is to stay current with the new technology and adapt. It probably goes without saying that having backup copies of your files is critical. I currently use the Drobo system by Data Robotics, Inc.™ for keeping my files backed up. The system can grow as I need it to and offers a method of keeping the data safe, even if a drive fails. I also copy files to DVD discs, which I store off-site in case of a catastrophe.

My current archiving workflow is as follows:

✳ Download the images without erasing the memory cards

✳ Make a copy of the images on an external drive system (Drobo system)

✳ Edit the files

✳ Copy the edited JPG files to the Drobo

✳ Archive each wedding to DVD discs and store off site in case of flood, fire or other problems

✳ Reformat the memory cards for use on the next wedding only after all backups are made

Keeping images well archived is important. One way I provide good customer service is make sure I can get images to clients at any time, even if it is years later. If a client loses their photographs in a natural disaster or for some other reason needs to get their hands on an image, I can help them recover what they need. ✳

SUMMARY

Today's wedding photographers must develop an organized workflow that extends beyond the capture of high quality images. The post-production process is critical, but it can also be time-consuming. Determine how to best use your time and look for efficient ways to showcase your work and make viewing and ordering easy for your clients. ✳

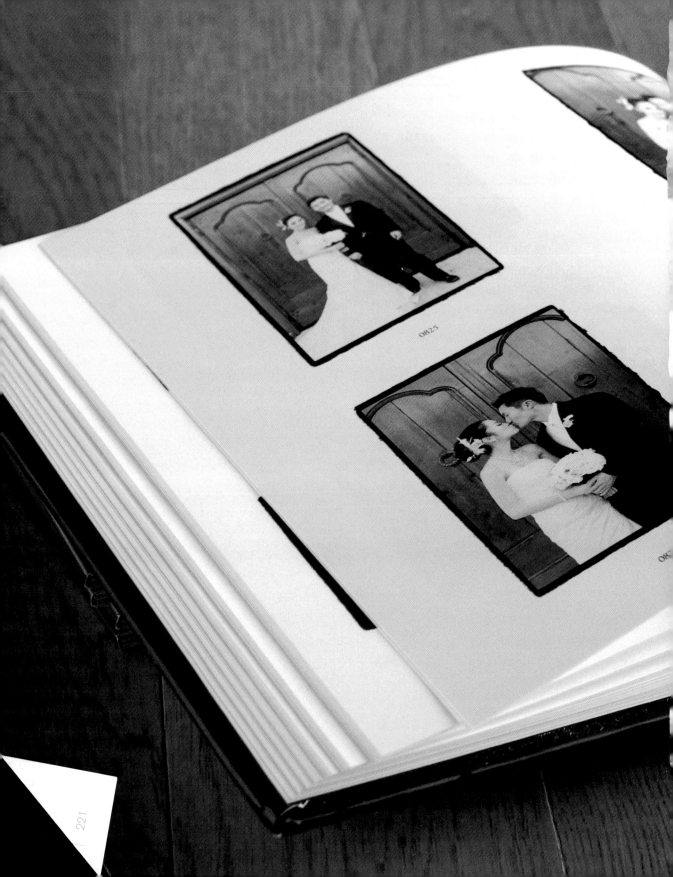

Delivery of memories to the couple

Other than the honeymoon and in some cases opening the wedding gifts, most couples anticipate no other wedding activity as much as they anticipate seeing their wedding photos. These images let the couple relive their special day over and over again. In fact, many times as a couple looks through their images, they will see moments they missed on their actual wedding day or those that passed by so quickly they didn't get to enjoy them. Thanks to today's technology, couples can view and share their special memories through a variety of mediums.

PROOF **BOOKS**

Many people in this digital world still want to see their images in a printed form. Printing proof books allows the couple to share the wedding images with folks who don't have a computer, access to the Internet, or just want to see the images in a traditional manner. I offer a single hardbound proof book as an addition to my wedding packages, which keeps life simple for both the couple and for me.

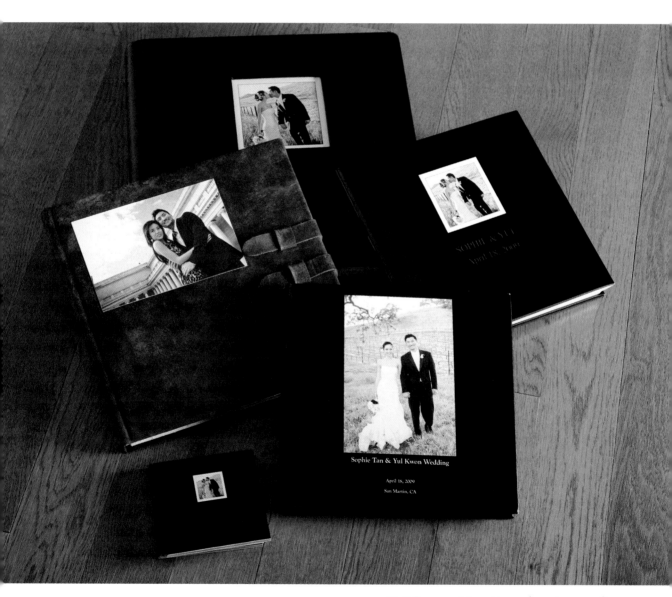

Matt Savage of AveryHouse (averyhouse.net)

TIPS FOR CHOOSING AND **DESIGNING A PROOF BOOK**

Keep it simple: Let the photos speak for themselves; don't add too many extras that can detract from the images.

Quality counts: Remember that the proof book is a representation of you and your work and should leave a positive impression.

Shop around: There are many different companies that offer proof books and you should look for one that matches your style.

Update when necessary: As you grow as a photographer update the look and feel of your proof books to better showcase your work.

Organize the proof book to tell as story: When the couple sees the book, the images should follow a logical progression, making it easier for them to relive the day.

The proof book I use is printed through Pictage (www.pictage.com). It is a high-quality product that represents my work well. Since the proof book photographs are only 2" x 2", I don't need to add a watermark, which might detract from the images. The clients can then order the prints through the Web gallery making the process as easy and painless for the couple as possible. ❖

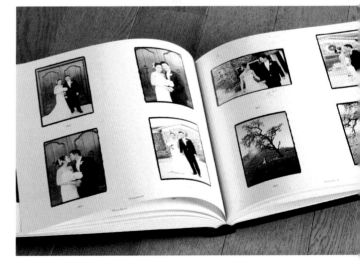

Matt Savage of AveryHouse (averyhouse.net)

WEB **GALLERIES**

The most common way wedding images are seen and shared today
is on the Internet. Having a Web gallery of the photos for your clients
is an absolute necessity, but there is no reason to spend a lot of time
and energy building a Web site for clients when there are great pre-
packaged solutions available.

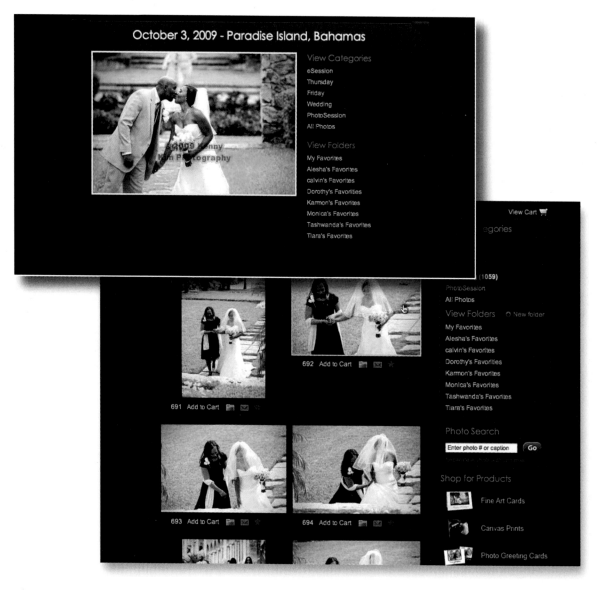

TIPS FOR SELECTING A **WEB GALLERY SOLUTION**

Ease of use for the photographer: Is it easy to upload the images? Does the hosting company allow for easy customization?

Ease of use for the clients: Can the clients find the images easily and share the gallery with friends and family?

Look and feel: Can the gallery look and feel be changed to match your Web site?

Ordering options: Is it possible to order prints and other products directly from the Web site, and if so, what is the cost?

Copyright safeguards: Are the photos protected by either a watermark or other protection scheme that stops unauthorized downloads?

I use Pictage service to host the Web galleries for my clients. Because I don't have to program or design a new gallery every time I photograph a wedding, it is easier to get the Web gallery to the clients in a timely manner. In fact, I am usually able to set up a gallery of images and get them to the newlyweds within a two to three week period following the wedding. In most cases, this is ideal timing, as it gives them something to look at very shortly after they return from their honeymoon.

Pictage offers a photographer a lot of control over the Web galleries as they are created, which is a big benefit. I can control the look and feel, including adding my studio logo to the pages, how long the galleries are available, and who can see the images. Because it's just too easy for people to borrow images from the Internet, I make sure the images on the Web gallery have my watermark on them, ensuring the images can't easily be used without my permission. �֍

PRINTS

One aspect of the entire wedding photography process that hasn't changed with the digital revolution is the creation of prints. You can go into nearly any married couple's house and find a wedding photograph, usually framed nicely and displayed prominently. The parents of the newlyweds also often display printed photographs from the wedding in their homes or places of work, and prints are also often given to other family members and friends.

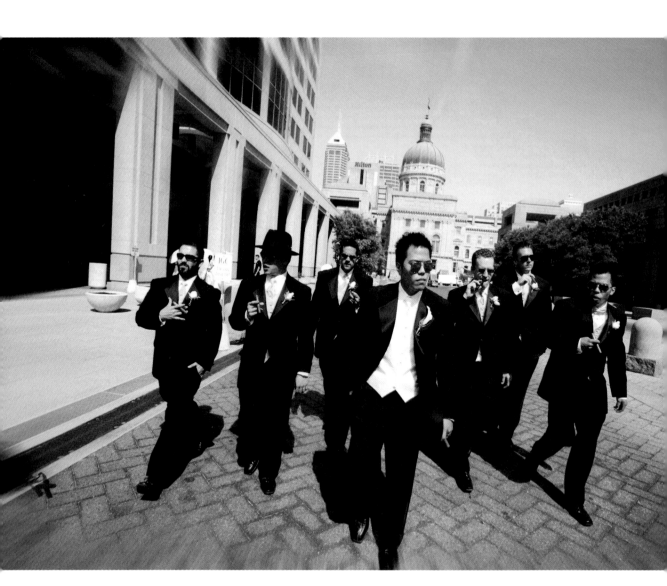

TIPS FOR CHOOSING A **COMPANY TO SUPPLY PRINTS**

Quality counts: Even though you are not doing the actual printing yourself, the prints you supply or companies you recommend reflect back on you.

Convenience: Make it easy for the clients, their family or friends to order prints. The easier it is, the more likely they will order the print.

Variety: Some folks like big prints; others want a smaller shot for the office desk or nightstand. Make sure the printer offers all sizes.

Reputation: Check the reputation of the printer. Their product is a representation of you. Make sure they have the same high regard for their customers as you have for yours.

Since prints can now be ordered directly from the Web gallery, individual print packages are no longer necessary offerings. This not only saves time, but also allows the couple to only order the prints they want and need. Pictage offers prints in a wide variety of sizes and finishes but if the customer wants something special, I will work with them to get the prints through another printing company. Because the couple can allow others to view and order prints, it also takes away the stress of trying to make sure everyone gets the right prints. It is important to remember, however, that even though the wedding is over and the photographs have all been taken, the customer support you show your clients through the delivery of the prints will help you gain the reputation you want. This also will help when it comes to networking and gaining new business. ❖

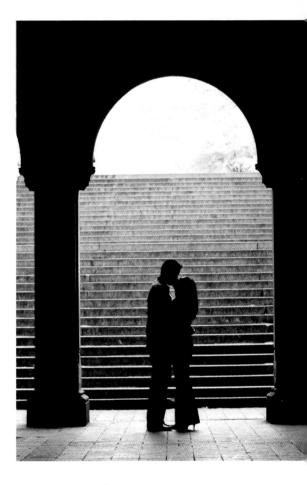

WEDDING **BOOKS**

Wedding albums or wedding books are the final culmination of the wedding photographer's job. There are many options when it comes to wedding books, including options through Pictage that clients can order directly from the Web gallery. These wedding books are a standard design and thus creativity is limited. Since the wedding book should be special and tell each couple's individual wedding story, I offer many more options and even work with a graphic designer who will help the couple get exactly what they want. This personal service is another way I market myself above other wedding photographers, and it provides a client service that online sources cannot match.

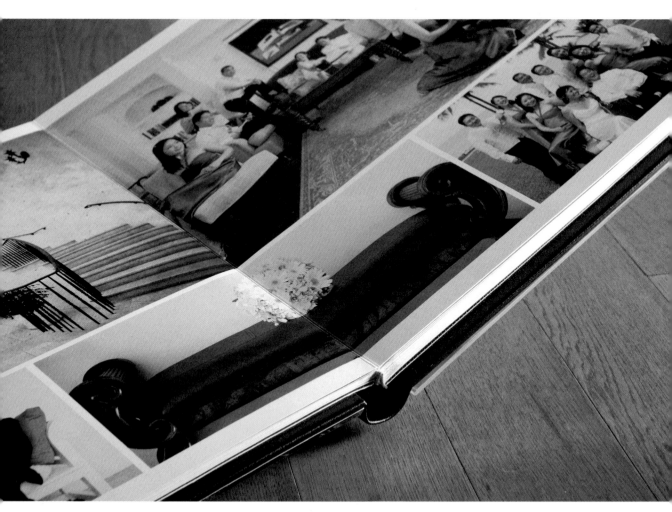

Matt Savage of AveryHouse (averyhouse.net)

TIPS FOR PICKING A **WEDDING BOOK SUPPLIER**

Quality first: This is the book that will get shown around and represents your work. Use the best.

Customization: Can the book be modified to match the theme of the wedding or more importantly the style of the clients?

Ease of use: Is it easy to upload and layout the book yourself or do you need a designer to help at an extra cost? Can the clients work directly with the book company or do you need to be involved?

Reputation: Since the wedding book will be something the clients have to remember the wedding and is one of your most important marketing devices, does their customer service and reputation match yours?

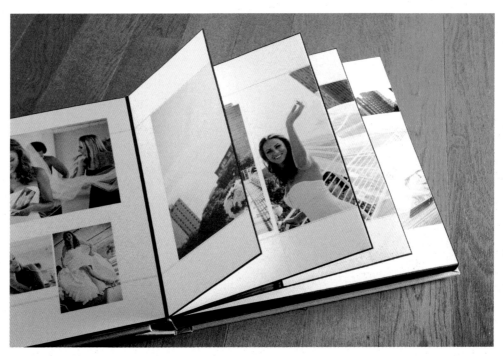

Matt Savage of AveryHouse (averyhouse.net)

Two of the companies I currently use to create wedding books are GraphiStudio (www.graphistudio.com) and La-vie Album (www.la-viealbum.com.) Both companies offer high-end wedding books of unparalleled beauty and quality. If the couple orders a wedding album through me, I also provide them with a disc of high-resolution image files at the end. When couples don't order an album, there is an additional fee for the high resolution files after the online gallery expires. ✻

CANVAS **PRINTS**

Another popular way to capture your memory is to print them onto a canvas, which can be displayed on the wall as artwork. Unlike the "cheesy" art-like quality prints of the past, today's advanced technology creates high-quality print canvases in any shape and size. There are several companies that provide this service, including Pixel2Canvas (www.pixel2canvas.com), Simply Canvas (www.simplycanvas.com), and Mpix (www.mpix.com).

Right now I use Pixel2Canvas because I find they provide high quality artwork that is meant to last a lifetime using the best material and technology available. They also have a history of supporting photographers and worthwhile causes. I also appreciate their use of green products to keep the impact on the environment to a minimum and the fact that they do not use optical brighteners in their prints. That does not mean I will not look at other companies from time to time to see what they might be offering. It's always a good idea to shop around so you know when another company begins offering a superior product. ❧

TIPS FOR SELECTING A **CANVAS PRINTER**

Quality: Each print you supply or recommend will reflect back on you, so make sure the quality is top notch.

Ease of ordering: Time is money. Make sure the company has a good ordering system in place for you or the clients so you aren't spending all your time dealing with a single print.

Product size and selection: Make sure that the company has all the sizes and products you want before placing an order.

Establish a relationship. If the printer knows you and knows your work, you may be able to negotiate a better price or ask for special pricing, but don't be afraid to shop around for the best deal.

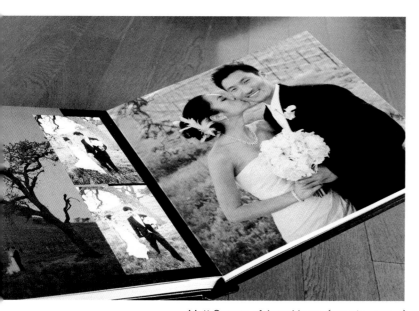

Matt Savage of AveryHouse (averyhouse.net)

SUMMARY

Delivery of the final product to clients is highly anticipated, and today's technology allows for much more flexibility and speed. Set up a good system for clients to view, order, and receive their images. You will appreciate the time you save, and your clients will appreciate the ability to cherish their memories more quickly. ❈

Appendix 1 - Advice for photographers

So far, in this book we have covered which photos to take, what to expect during different parts of the ceremony, and even the post-production workflow and presentation of images. But it wouldn't be complete if I didn't share the path that led me to where I am today. On my journey into wedding photography, I have made plenty of mistakes. I have also learned first hand what works and what doesn't.

Of all the advice I can give, not just to wedding but all photographers, two things come to mind. The first is to be willing to give before you receive. Life works in a cycle: whatever you invest in, will come back to you ten fold. Many people are willing to give IF they receive, but sometimes it takes sacrifice to reach out first. We may not get the results we expect, but often, good things will surprise us in return. The second is to treat each client and each shoot as the most important one ever. It makes no difference if the subject isn't a rich and famous celebrity. Treat them as if they are and pour your heart and soul into their event. They'll be happy, and you'll get better images and develop a good reputation. I have developed my business based solely on relationships. The clients I meet today are my friends tomorrow. They are my biggest advocates and fans of my work. As your list of clients grows, so will your network and relationships. �

PHILOSOPHY OF **WEDDING PHOTOGRAPHY**

My wedding photography philosophy is very simple; I bring who I am as a person to the wedding, to my photography and to the way I relate to the couple. I used to regret not starting as a photographer earlier. Then it occurred to me that the images I produce today come from the way I look at life and the experiences I have had.

The truth is photographing weddings isn't the right fit for everyone. It takes a certain personality type and a lot of really HARD WORK. Anyone who wants to be a wedding photographer needs to be honest with himself or herself whether wedding photography suits his or her style and work ethic. It requires being good with people, being open and friendly, and certainly not being afraid of hard work and long hours. The bottom line: to be a wedding photographer you need to trust in yourself and be passionate pursuing your vision. ❈

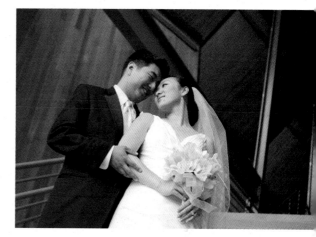

IMPORTANCE OF **NETWORKING**

Networking is fundamental to growing any type of business. This is especially true of wedding photography. To be successful, you need to network and connect with as many people as possible. Building relationships today can lead to long lasting friendships and potential clients or referrals down the road. ❈

When it comes to networking with other photographers, I believe wedding photography is a collaborative job. People working together can produce better results than one can alone. There are many times when I work with a second or third shooter at my clients' weddings. Likewise, I have been the second or third shooter at other photographers' wedding shoots. In both cases, I often work with the same photographers. I have learned to trust them, and they have learned to trust me. See Appendix 2 for more on working with assistants and second photographers.

Also attending tradeshows, workshops, conventions, and various local meetings will help you grow your network as a photographer. But don't just attend — find ways to get involved and become active in this community. You will share ideas, goals and visions and help sharpen each other into better photographers. ❁

LEARNING FROM **YOUR PAST**

Everything you are as a person influences who you are as a photographer. Don't be afraid to bring your influences and life experiences into your work. It will help define your style and make your photography unique. For example, my first interest in this profession came from my love of sports. While living in Champaign, Illinois, I worked part-time with the college tennis team. One day, the head coach asked me to photograph some of their matches. I had no clue about photography, but thoroughly enjoyed sitting near the court where I was close to the players and action.

As I learned more, I realized I could use my developing skills to photograph other sports like basketball. I contacted the basketball team's media coordinator who granted me a pass to shoot some of the games.

Not only did I get out of the crummy nosebleed seats, but I learned that the better I understood the game, the better I became as a photographer. It was all about anticipating the right moments and positioning myself to be at the right place with the right gear, which definitely translates into wedding photography.

Even now, outside sources inspire my wedding style of photography. There is no longer the dichotomy between my personal life and work life; my hobby has become my

job, and I love what I do. I travel, get involved in my local community and activities to become a better photographer. For example, I organize workshop called a Kenny Kim PhotoVenture where a group of photographers travels to different countries to experience life outside of their own country. Something about being in another environment, learning about different cultures and lifestyles helps me see things from a different perspective. I try to translate this experience into my business and hope the other attendees do the same.

I also volunteer my time and services to worthy causes. Recently I took a trip with a couple of videographers to Tanzania Africa to help document the conditions of that country and their need for clean drinking water. It changed my life and perspective about what to be thankful for. I use this when photographing weddings to try capture the details and emotions that are really important. Even if a trip to Africa is not in your future, there are many worthy causes in your own backyard that can offer great inspiration. ✻

INVESTING IN **EQUIPMENT AND EDUCATION**

When deciding where to invest in your business, choose areas that can truly help you grow. I believe investing in equipment and education is wise, because these two parallel tracks can really help improve your photography. In my opinion, equipment and education are combined and can't really be separated. It is no good to get the best camera, lenses and accessories and not know how to use them. At the same time, it doesn't pay to get the knowledge and not have the tools to put that knowledge to use.

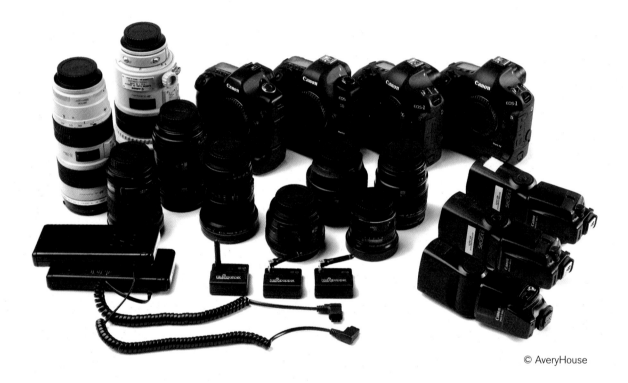

© AveryHouse

Keep in mind when investing in camera gear that camera manufacturers introduce new and improved models every year. Camera manufacturers continually increase the ISO sensitivity of their camera's sensors and at the same time reduce the amount of noise. While it's probably not necessary to buy the newest camera every year, it is important to keep up with the advances in the technology and upgrade when applicable. Lenses, however, are a different story. Good lenses can last a lifetime, especially if cared for properly. Since it is the lens that controls and focuses the light, always purchase the best lens you can afford.

We talk about the different education choices in Appendix 3, and you will see there are many places where you can spend your hard-earned money. Be sure when selecting classes or workshops to match the skill level of the education with what you need to know. Start with the introductory classes or online training and work toward travel seminars and longer classes. Remember too, that today's digital age requires photographers to be savvy in areas beyond just capturing images. Understanding computers and getting training in various types of software and the digital workflow can increase the speed in which you get the work done. ❖

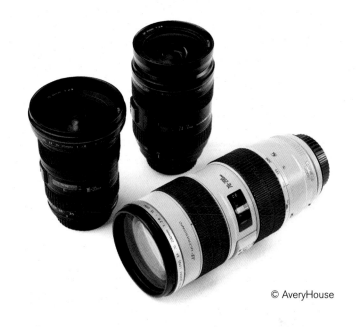

© AveryHouse

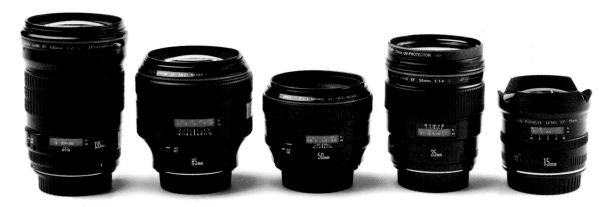

© AveryHouse

Appendix 2 - Working with an assistant / 2nd shooter

Weddings are busy, fast-paced, and can be very difficult for one photographer to cover alone. For that reason, I offer my clients the option of having a second or even a third

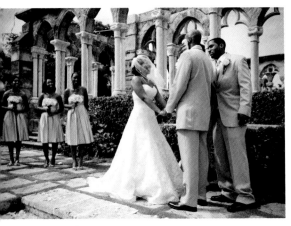

© Bob Davis

photographer at the event. While having another shooter helps make sure all aspects of the wedding are covered, it's important to remember that an assistant or a second shooter acts as an extension of you. All their actions and behaviors are your responsibility and a direct representation of you. Choose who you want to represent you carefully, and make sure they are as friendly and courteous as you yourself would be.

DEFINING THE **ROLES AND EXPECTATIONS**

When working with other photographers it is imperative that you discuss roles and expectations before the event. A second shooter should know in detail what they are supposed to do and clearly understand what you expect from them. For example, one thing I always ask of the photographers working with me is to be mindful of where we are positioned so that we do not get in each other's photographs. When there is more than one photographer covering an event, it is nearly impossible to avoid capturing the other photographer in at least a few shots. By letting them know my preferences, we can minimize the number of times this happens.

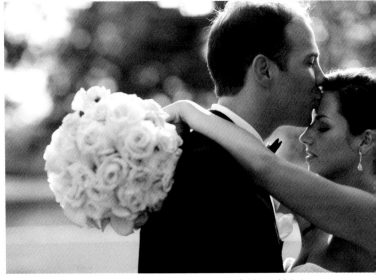

© Kenny Nakai

ASSISTANTS

Some photographers use an assistant whose main role is not to photograph, but to help with other various tasks during the wedding day. This includes hauling gear, setting up lights, anticipating the photographer's needs, organizing memory cards, lenses, cameras and basically trying to make the photographer's life as easy as possible. Many times the assistant will help get people ready for the portraits as well as take care of anything else that comes up.

© Tomas Flint

Being an assistant is not the most glamorous job in the world, and most aren't paid for their role. Their compensation consists of the experience and guidance they receive during the shoot. When an assistant works with me, I share with them how I shoot a wedding, set up the portraits and interact with the clients. They need to be professional in both attitude and presentation. Even though the assistance isn't paid, I still make sure his or her incidental expenses like travel, lodging and meals are covered. The job is supposed to be a learning experience, not something that will cost the assistant any out of pocket expenses.

Even though it is not their main role to take photographs, it's a good idea for an assistant to carry a camera during the wedding. Shooting a few images represents a great educational experience. Just remember that if you give your assistant a special assignment or something to cover during a wedding, and it does not get done properly, you cannot blame anything on him or her. In the end, as the hired photographer, the responsibility lies entirely on you to get the job done. ❧

SECOND OR **THIRD SHOOTERS**

Second or third shooters help cover the event by shooting at the same time as I do. I work with photographers I know and trust. As I mentioned in Chapter 12, most times these second or third photographers are other wedding shooters who also use me as a second shooter at their weddings. I know how they work and they know what I expect.

I like to give the second shooters I work with the freedom to shoot the wedding as they see fit. I choose to work with them because I like the way they work and the images they capture

from their own perspectives. At the same time, I do make sure the second shooter is aware of my expectations and I occasionally ask the second shooter to cover specific events during the wedding.

• When the bride and groom are getting ready at the same time but in different locations, I usually spend the time with the bride while the second shooter is off shooting the groom. If time permits, we will switch and take turns covering both the bride and groom.

• When the bride is walking down the aisle, I am the one shooting the bride's face and her reaction and the second shooter concentrates on the groom. Since it is practically impossible to catch both reactions, it's important to know ahead of time who will take responsibility for capturing each response. A third shooter will sometimes be positioned behind the bride as she walks in to capture the angle from another perspective while making sure not to get in the shots of the lead photographer.

• During the ceremony I ask the second shooter to concentrate on the crowd and the wider shots of the church while I am focused on the wedding party.

• When there are toasts, I usually concentrate on the person making the toast and the bride and groom and the second shooter captures other guests' reactions. Or he or she focuses on the person making the toast and I focus on the couple.

The goal of the second shooter is to complement me as the primary shooter and cover what I can't. For example, if I am shooting with the wide angle lens, then I want the second shooter to be shooting with the telephoto. He or she needs to be covering my blind side and act as the eyes in the back of my head. ❧

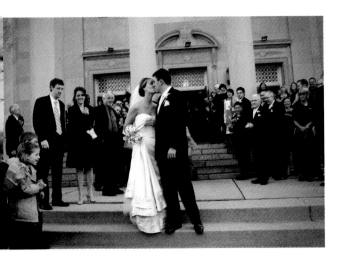
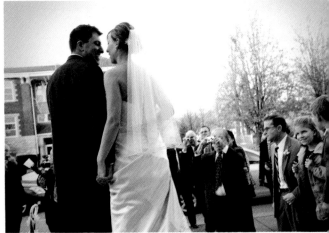

© Matt Savage

CONTRACTS AND **AGREEMENTS**

Even if you are working with photographers you trust or like their style, it is a good idea to have a general agreement established before the shoot so there are no misconceptions. It's a good business practice to draw up a second shooter's agreement and have an attorney review it. This will save lot of headaches in the long run.

I enter into a contract with the other photographers who work with me either as assistants or as extra shooters to establish and confirm expectations right from the start. The contract spells out the hours they are expected to work along with when I expect to receive their images and in what form. The contract also spells out what they will be paid and when.

One of the most important parts of the contract stipulates how images taken by the assistant and other shooters can and can't be used. The actual photographer always holds the copyright, but I control the rights and usage of the images. Images usage stipulations include:

- Can be used in the photographer's online portfolio to promote their work
- Can use the images in their blog AFTER it has been blogged by the lead photographer and the blog must mention that it was photographed for another lead photographer
- Not to be entered in competitions unless it was a shot the photographer setup and created instead of the shots he or she photographed while the main photographer was setting up the shot
- Not to be submitted for publication or feature editorial
- Not to be sold to clients or vendors separately
- Images photographed by the second shooter will remain copyrighted under the main photographer's business
- Cannot create their own Facebook or other online gallery and request friends or "tag" them (a system to notify the guests of their images being published online)
- Do not establish and or initiate contact with the client/vendor for business reasons during and after the wedding. In the event the client/vendor contacts them, the second shooter will refer them back to the main photographer
- Agrees to represent the main photographer's business on the day of the wedding and not promote their own business. If a client or vendors requests a business card, that of the main photographer will get handed out
- Agrees to turn over all digital files/images after the event, preferably at the event or as soon as possible after the event
- Agrees to keep a backup copy of all their images until I confirm I have backed up all their files ❖

Appendix 3 - Marketing your business

As wedding photographers, our work does not end when we finish shooting the wedding. There is another aspect to this business that constantly needs attention in order to be successful: marketing. In an ideal world, we would get a couple referrals after each wedding, but the reality is we need to market ourselves to our target audience and always think a few steps ahead to stay in the game.

FIRST **IMPRESSIONS**

You can never take back your first impression. I know this seems so simple, yet many people don't take it seriously. Every time you meet with a prospective customer you need to make sure you look your best. Every time you work at a wedding or any event, you need to look and act your best. Everything you present, from how your shoes look to how your Web site looks, affects how people view you, so it is important to make a good impression.

As a general rule of thumb, when shooting a wedding, I dress in a similar fashion as the guests. This helps me fit in and makes everyone feel more comfortable with my presence. For formal events, I wear a suit. I actually custom designed a suit last year because none of the suits I purchased fit me well and I got tired of wearing things that didn't make me feel comfortable. The investment was worth it and now every time I wear the suit, I get compliments. Not only does that make me feel good, it makes the bride feel good knowing she invested in a great photographer with good taste. The bottom line is I make sure I always look my best when I am working in order to make a positive impression.

Likewise, your Web site and other marketing tools need to show your best images, those that will make a lasting first impression. This means you need to constantly make sure your Web site, blog and marketing materials are up to date and portraying the latest and greatest work. �ло

CREATING A **BRAND IDENTITY**

Part of marketing your business is creating a brand identity. This includes creating a name, logo and all types of marketing materials that are consistent and reflect who you are as a photographer. Often, it is a good idea to work with a professional designer who has the skills to help you develop what you need.

Some things to consider:

• Personality: Does your company's name and identity match your personality? When a prospective client looks at your logo, Web site or other marketing materials can they get a sense of who you are?

• Style: Does your identity match your style? If you are a casual, relaxed photographer who shoots in a more photojournalistic style, then having a classic look to your marketing materials would be misleading.

• Client: Make sure you create an identity and marketing materials that will speak to people looking for wedding photographers. There is no need to include sports or landscapes photos in your portfolio since it would send mixed messages to potential clients.

• Consistency: Your logo, business card, Web site, letterhead and other marketing materials need to have a consistent look and feel. If you are having difficulty coming up with one that works, consult a professional graphic designer to help. It is worth the investment. ❊

NETWORKING

Just because you have talent and a business, doesn't mean customers are going to beat a path to your door. Networking is by far the best way to get more jobs and perhaps the number one reason for my success in this industry. Even though it might seem counterintuitive, some of the best people to network with are other photographers because: 1) by establishing good relationships with them, they can refer weddings to you that they cannot shoot because they are already commissioned for the same date; 2) you can build a network of photographers who can serve as your second shooters and vice versa; and 3) often we get job requests for things outside our specialty, and we can refer those jobs to others.

Take advantage of meeting other photographers at workshops and other educational gatherings. There are local groups of community photographers meeting everywhere these days. If you can't find one, why not create your own? It doesn't require an elaborate meeting. A simple coffee talk or lunch appointment should do the trick.

Here are some tips on networking:

- Introduce yourself: Every event, class, and workshop you attend is an opportunity to meet other photographers who have the same general interests as you. Make sure to introduce yourself to everyone and remember that first impressions count.

- Use social media, forums to be proactive: With the proliferation of social media, from Facebook to Twitter, it is easier to find and contact people who are going to the same events as you. Get in contact with other attendees and set up meetings or just make contact. See if the event has a forum and introduce yourself there before the event even starts making it easier to connect at the event.

- Don't eat alone: Sitting down to a casual meal with some new acquaintances is a great way to make new friends. Keep in mind you can extend your network in the off hours just as much as during the working hours.

- Diversify: Just because I shoot weddings and my main focus is on wedding photography, doesn't mean I don't have other types of photographers in my network. Diversify so you will have contacts into different types of work and different shooting styles. You never know when you will be offered a job that needs a different touch or second photographer with a certain style. Likewise you never know when someone in your network will need a photographer like you. Don't limit your network.

- Keep in touch / follow up: This is the most important part of networking.

© Roberto Valenzuela

Meeting other photographers is good; staying in touch with them is better. All the work you put into meeting and finding people to share your network is wasted if you don't keep in constant contact with them. Exchanging business card is not the end of networking; it is just the beginning. If you do not follow up, chances are you will be forgotten within few days. This can be as simple as a quick email stating how nice it was to meet them and letting them know you are looking forward to speaking with them again. People will remember your follow up conversations more than what you talked about during your meeting. Twitter or Facebook has made it even easier to keep in touch. Nothing beats face-to-face networking, but these online social media tools are a great way to stay connected. Leaving comments on another's blog is also great. Not only does it make the other person feel good, it provides a link for their visitors to reference back to your site giving you more exposure. ❁

EDUCATION

I cannot stress how important continuing education is. Most photographers (including myself) did not have formal training in photography, and with technology continually improving and changing, we need to always be sharpening our skills and mastering our craft. Going to workshops, classes, seminars and other photography training is essential not only to improve your images, but to help you network and grow your business. It can be costly to attend many of them so choose carefully and think of them as an investment for your future. I have gained incredible knowledge and a great network of friends from these events.

There are many great workshops and resources available. Do some research and talk to people who have attended them in the past to find out what they got out of it and if it's what you are looking to improve in your business. In my opinion, here are some of the best places to learn both in person and on the Internet.

Workshops:

- Bob & Dawn Davis (www.davisworkshops.com) My good friend and mentor, Bob and his wife are not only great photographers, but great people.

- Yervant (www.yervant.info) - These workshops and seminars are packed with down-to-earth, doable and up-to-date information to take your skills and business to higher levels.

- Joe Buissink (www.joebuissink.com) - Learn from the wedding photographer to the stars how to push beyond your comfort zone.

- Jim Garner (www.jgarnerphoto.com) – Jim teaches many workshops, designed to make you a better photographer and business owner.

- David Jay (www.davidjay.com) - Named one of the top 15 wedding photographers in the world by Wedding Photojournalist Association.

- Mike Colón (www.mikecolon.net) - Mike regularly teaches a workshop called "The 7 Most Important Topics in Wedding Photography."

- Kenny Kim & Ray Santana (www.portfolioplusworkshop.com) - Shameless plug for our workshop teaching the basics of wedding photography and helping you build your portfolio. We also invite other great photographers to teach us about their specialties.

Online Resources:

• Digital Wedding Forum (www.digitalweddingforum.com) - A great place for a wealth of information regarding wedding and portrait business.

• [b] School (www.thebschool.com) - An online community started by [b]ecker who used to teach Party of [5] workshops before he expanded his education to a broader audience. It allows photographers to share their images and network, and offers great tutorials.

• Kelby Training (www.kelbytraining.com) - A site full of training videos by some of the top photographers in the world. Learn at your own pace with subjects ranging from small flashes to wedding portraits.

• Kevin Kubota Training (www.kubotaimagetools.com) - Kevin offers a wide range of workshops all over the world. From Italy to Oregon, the workshops are great learning experiences taught by one of the greats.

• The I.C.E. Society (www.theicesociety.com) - This was started by Jerry Ghionis, one of my favorite wedding photographers in the world to Inspire, Challenge & Educate fellow photographers from all over the world.

Conventions:

The following conventions offer a variety of classes and instruction for just about anything you want to learn about the wedding photography industry. Each also has a tradeshow going on at the same time, where many vendors display their latest products.

• Wedding & Portrait Photographers International (WPPI) - www.wppionline.com: Usually held in March in Las Vegas, WPPI is probably the single most important event for wedding photographers to attend.

• Imaging USA (www.imagingusa.org) - The longest running national photographic convention, expo, and image exhibition in the United States, Imaging USA draws thousands of professionals from around the world. It is usually held in January. Digital Wedding Forum Convention (www.digitalweddingforum.com) is usually held at the same time and in the same city.

• Skip's Summer School (www.mei500.com) - Held in August, this provides solid teaching by some of the best in the business at a smaller and more intimate setting. Great for someone starting out or who wants to take their business to the next level.

Sitting and learning is great, but remember shooting is better. Get out and practice. I am always humbled by one of my mentors, Bob Davis. He has so many years of photography experience under his belt, yet he is always practicing and encourages others to do the same. Try new techniques, and remember to be creative. The more you learn, the better you'll become, and your business will begin to market itself. ❄

Appendix 4 - Digital darkroom

There are many different software programs available for digital photographers. I have already discussed Photo Mechanic (www.camerabits.com) in my Digital workflow, but there are three additional programs on the market that are very popular: Adobe® Photoshop®, Adobe® Lightroom® and Apple Aperture®. Many people don't understand the difference between the three, and while it is possible to think of them as image editors, that is not strictly true. Photoshop actually changes the image on a pixel level, while Lightroom and Aperture keep a list of the changes you want to make but don't actually do anything to the image file until it is output for use. This functionality allows you to always go back to the original file as it came from the camera.

ADOBE PHOTOSHOP **LIGHTROOM**

Adobe is the leading manufacturer of software for digital photographers with the industry standard Photoshop. In early 2007, Adobe released Photoshop Lightroom, a product aimed at professional photographers to help streamline digital photography workflow. This powerful program allows photographers to import, sort, edit and output images easily and quickly. I highly recommend reading Nathaniel Coalson's book *Adobe Photoshop Lightroom 2: Streamlining Your Digital Photography Process* to learn more about how to effectively use Lightroom.

The program is divided into five separate modules: Library, Develop, Slideshow, Print and Web, plus an image importer. Since I use Photo Mechanic to import my images and I do not do any of my own printing or Web gallery creation, I am mainly concerned with the first three modules, Library, Develop and Slideshow when I use Lightroom. The first module, Library is where I do all my sorting and where I make the decisions on what will stay and what will go.

Sorting

The goal is to find the best photos from the shoot. Lightroom offers three different ways to rate your images: a five star rating system, a color label system, and a flag system. You can use one rating system or a combination of all three to sort your images.

- The Five Star system allows you to rank your images from 0 starts to 5 stars, with your best being 5 stars and the worst are 0 or 1 star.

- A color label in Red, Yellow, Green, Blue or Purple can be applied to each image.

- The flag system allows you to either flag an image as a Pick or as Rejected. Of course, you also have the option to not flag the images at all.

I often use all three of these methods in conjunction with each other. For example I give an image a star rating, give it a red label and flag it as a pick. Then I can also sort by any or all of the rating methods to organize my images and look at them in a variety of sorting orders.

Editing

All the editing done in Adobe Photoshop Lightroom is non-destructive editing. When a file is cropped or converted to black and white, the image is actually unchanged until it is exported. Lightroom actually creates a set of instructions on how to display the image inside of Lightroom and writes those instructions into the file if using the DNG file format or into a sidecar XML if you are using camera raw, JPEG or TIFF formats. While this sounds very complicated, in practice it is pretty simple and convenient. It means you can edit the same image in a variety of ways and see what you like best without ever actually changing any of the image information.

Lightroom uses a file structure based on Catalogs. Each catalog can have one shoot or hundreds of shoots in them. I have chosen to have a catalog for each wedding I shoot. This catalog contains all the photos from that wedding—mine and any from the second shooter, all in the same catalog. ❖

APPLE **APERTURE**

With the recent release of version 3.0, Aperture has made leaps and bounds with their software. Version 3 includes over 200 new features and improvements including a new and improved import module, non-destructive adjustment brushes, improved histograms and adjustment presets. The new non-destructive brushes allow you to paint an effect selectively onto parts of your image.

Two features unique to Apple and their image editors are Faces and Places. These two started as features in the consumer iPhoto software, but now have been integrated into Aperture. Faces uses facial recognition software to automatically detect people in your images, while Places allows GPS-enabled cameras to place the location of the image on a map without having to do much work.

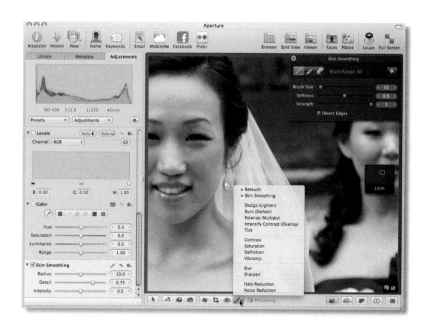

Apple has also improved the slideshow functions of Aperture making it possible to create full multi-media presentations combining still images, audio and video into a single presentation. It is also possible to add titles, borders, and special effects to create a full slideshow presentation from a single program. Aperture also allows you to sort, tag and rate your images like you can in Adobe Photoshop Lightroom

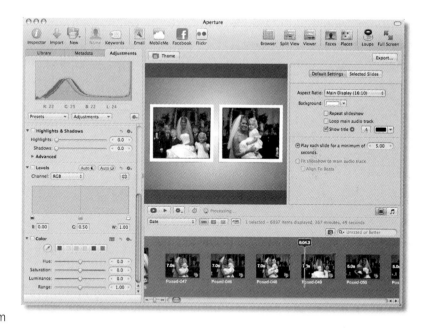

One nice thing about using Aperture is that it works well in conjunction with rest of the Apple software collection. My friend Joseph Linaschke (www.apertureexpert.com) is actually an Apple Aperture expert and has written a great eBook about Getting Started with Aperture. Register on his Web site to gain access to this book and other great resources. ❧

ADOBE **PHOTOSHOP**

If you want to edit digital photographs, Adobe Photoshop is the leader. There is no possible way to cover all of Photoshop in this appendix and there is no need to with the amount of Photoshop books in the market place. I just wanted to share a couple ways I use Photoshop. Often I use it to create black and white images from color shots. I also frequently use the touchup tools including the healing brush and the Liquify filter coupled with some of my favorite preset actions.

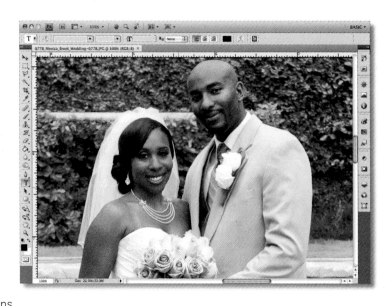

Black & White

Black and white photographs have a very classic look to them, especially when it comes to weddings. The bride dressed in a white dress with the groom dressed in a black tuxedo naturally lends itself to black and white photography. There are many different methods to create black and white photos in Photoshop including the built-in Black & White filter. When I started using Photoshop, I used a set of purchased

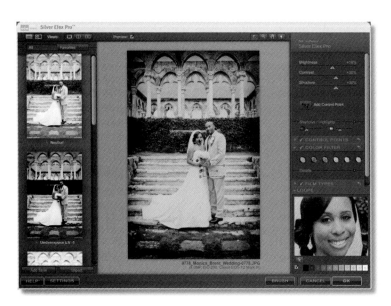

actions, which are preset commands that can be used over and over again to convert the selected images to Black & White. One of the more popular Black & White conversion methods is with Nik Software's Silver Efex Pro, a plug-in that allows you to control all aspects of the black & white conversion and save the setting so they can be used over and over again to give your images consistency.

Touchups

Photoshop is powerful enough to change just about everything in an image and make it look real. However, just because it can be done, doesn't mean it should be done. My personal belief is to try to make the image look as good as possible, but when it comes to making cosmetic changes, I only change what I believe will not be there in a few weeks. That might mean doing a little Photoshop blemish removal, but not major Photoshop plastic surgery.

For example, there are times, when no matter what you wish, things don't go perfectly to plan. This is very true when it comes to skin. I know every bride and groom would like to have perfect blemish-free skin on their important day, but sometimes that doesn't happen. The Photoshop healing brush can help with those little imperfections by allowing you to select an area of skin that is unblemished and use it to paint over the blemished area. This will remove the blemished area and replace it with the unblemished skin.

The Liquify filter allows me to make other minor changes when needed. Maybe there is an out of place bulge or bump that needs to be slightly reduced. By nudging it slightly, I can make it not as noticeable. The idea is not to change the image but to slightly enhance it. I would never want a bride or groom to look at the images and wonder what I did with Photoshop to make them look so different.

A final note about the actions — as a photographer, you want to capture everything on camera as much as possible. So knowing the camera settings and the right combination of shutter speed, ISO, aperture and white balance can help you achieve the effect you want. Using software should just enhance your images, not recover or recreate what was not there. Get in the habit of getting things right on camera first. ❀

Wedding shot list

ENGAGEMENT **SHOOT**

Location Ideas

* Wedding ceremony site
* Reception site
* Fancy hotel
* Local park
* Engagement site
* First date site
* First meeting place
* The beach
* The lake
* Their home
* Downtown
* Scenic neighborhood
* Industrial area
* Local store (e.g. record store for music lovers)
* Vineyard
* Local landmark
* School campus
* Museum grounds

Pose Suggestions

* Looking at each other
* Holding hands
* On bended knee
* Stagger the couple
* Couple really laughing
* Back to back
* Sitting with bride-to-be in front of groom-to-be
* Kissing

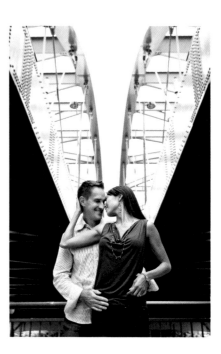

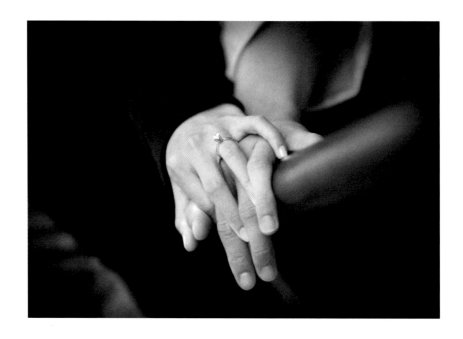

LOCATIONS TO
SCOUT BEFORE WEDDING

* Bride dressing area
* Groom dressing area
* Relaxed pre ceremony portrait location
* Ceremony site
* Relaxed pre reception portrait location
* Reception area
* License signing area
* Toast location
* Cake cutting area
* Dance floor

REHEARSAL

* Bride and groom arriving
* Bride practicing her walk down the aisle with her father
* Wedding party in position
* Bride and groom at alter
* Officiate
* Ring bearer and flower girl
* Bride and groom practicing the vows
* Bride and groom practicing the kiss
* Organist or other musicians, and soloist
* Informal group portrait
* Bride and groom with parents
* Bride with maid or matron of honor
* Groom with best man
* Family group portraits

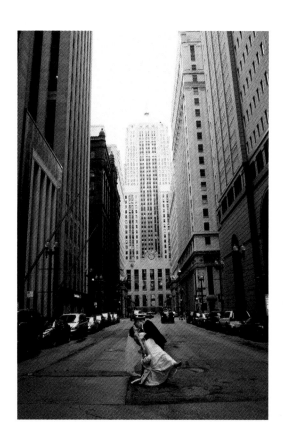

REHEARSAL **DINNER**

* The restaurant exterior
* The restaurant interior
* Party welcome sign
* The wedding party
* Informal groupings
* People chatting
* Tables
* A plate of food
* The buffet
* Father of the groom's toast
* Groom's toast
* Other toasts

WEDDING DAY – **BEFORE THE CEREMONY**

Bride getting ready:

* Bride getting her makeup and hair done
* Wedding dress
* Wedding dress detail (lace, buttons, bows, etc.)
* Dress shoes
* Something Old
* Something New
* Something Borrowed
* Something Blue
* Any special jewelry
* The bouquet
* Bridesmaid dresses
* Bridesmaid flowers

* Candid shots of bride getting ready
* Candid shots of bridesmaids getting ready
* Flower girls getting ready
* Mother helping the bride get ready
* Mother helping with one last detail (veil)
* Maid of honor helping bride get ready
* Bride with bridesmaids around her
* Bride with each member of her entourage
* Full length shot of bride in dress
* 3/4 Length shot of bride in dress
* Bride and bridesmaids toasting
* Bride and her family

Groom getting ready:

* Putting on the tux or suit jacket
* Help with the tie
* Help with the boutonnière
* Help with the cufflinks
* Straightening the jacket
* Dusting imaginary lint off the shoulder
* Groom with parents
* Groom with siblings
* Groom with groomsmen
* Groom's mother helping with the boutonnière
* Groomsmen putting on their boutonnières
* Groom and groomsmen straightening their ties
* Groom relaxed waiting
* Groom with ring bearer
* The rings
* Tux or suit details
* Groom with his entourage
* Groom ready to get married
* Groom and groomsmen waiting for the ceremony to start

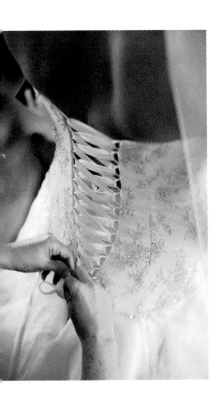

The groom with:

❊ Whole family

❊ Parents, grandparents, siblings, nephews, nieces, children

❊ Parents, grandparents, siblings, nephews, nieces, children plus bride

❊ Grandfather, father and sons (Male side of family)

❊ Grandparents and parents

❊ Grandparents and parents plus bride

❊ Grandparents

❊ Parents, siblings and children

❊ Parents and children

❊ Parents and children plus bride

❊ Parents

❊ Both sets of the parents plus the bride

❊ Parents plus bride

❊ Children

❊ Children plus bride

❊ Special relative

Wedding party:

❊ Bride and groom with whole wedding party

❊ Bride and the groomsmen

❊ Groom and bridesmaids

❊ Bride and groom with flower girls and ring bearer

❊ Bride and groom with maid of honor and best man

The bride with:

❊ Whole family

❊ Parents, grandparents, siblings, Nephews, nieces, children

❊ Parents, grandparents, siblings, nephews, nieces, children plus groom

❊ Grandmother, mother and daughter (Female side of family)

❊ Grandparents and parents

❊ Grandparents and parents plus groom

❊ Grandparents

❊ Parents, siblings and children

❊ Parents and children

❊ Parents and children plus groom

❊ Parents

❊ Both sets of the parents plus the groom

❊ Parents plus groom

❊ Children

❊ Children plus groom

❊ Special relative

WEDDING DAY - **DURING THE CEREMONY**

* The exterior of the venue
* The interior of the venue without any people
* Guests walking into the ceremony
* Any musicians playing during the processional and wedding
* Guests being seated
* Officiate waiting
* Groom walking down the aisle with mother/parents
* Groomsmen walking family down the aisle
* Parents being seated
* Grandparents being seated
* Groom waiting for bride

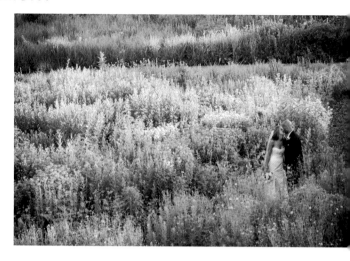

* Important family members being seated
* Bridal party walking down aisle
* Maid/Matron of Honor walking down the aisle
* Ring bearer walking the aisle
* Flower girl walking down the aisle
* Bride with her escort
* Bride walking down aisle
* Bride's expression as she sees groom
* Groom's expression when he sees bride (2nd shooter?)
* Father of the bride giving her away
* Bride and groom at alter/Chupah
* Parents watching the ceremony
* View of ceremony from guest's point of view
* Close ups of the bride's and groom's faces
* Wedding party close ups during the ceremony
* Exchange of vows close up and wide angle

* Ring exchange both close up and wide angle
* The kiss
* Any blessings
* Any readings
* Any special moments like candle lighting or glass breaking
* Bride and groom walking down the aisle after ceremony
* Hugs and congratulations
* Receiving line

WEDDING DAY - **AFTER THE CEREMONY**

* Whole family (both bride's and groom's families)
* Groom's parents, grandparents, siblings, nephews, nieces, children
* Bride's parents, grandparents, siblings, nephews, nieces, children
* Groom's grandparents and parents
* Bride's grandparents and parents
* Groom's grandparents
* Bride's grandparents
* All grandparents
* Groom's parents, siblings and children
* Bride's parents, siblings and children
* Groom's parents and children
* Bride's parents and children
* All parents and children
* Groom's parents
* Bride's parents
* All parents
* Children
* Special relative
* Officiate and witness for signing of the marriage certificate

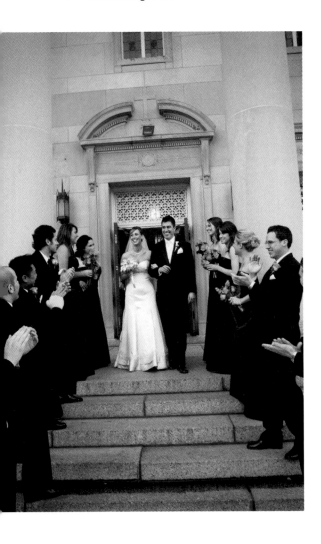

RECEPTION **DETAILS**

- ❋ Place setting
- ❋ Flowers
- ❋ Cake
- ❋ Cake table
- ❋ Cake details
- ❋ Guest book
- ❋ Seating cards
- ❋ Seating plan
- ❋ Room details
- ❋ Toast glasses
- ❋ Wedding favors
- ❋ DJ or Band
- ❋ Decorations
- ❋ Table settings
- ❋ Building details

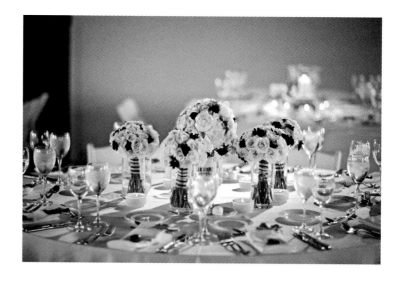

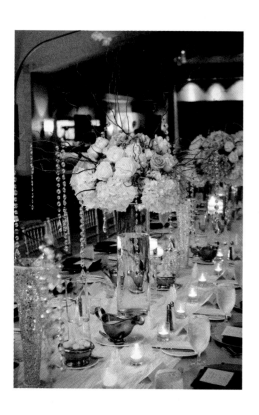

RECEPTION

- ❋ Bride and groom arriving
- ❋ First dance
- ❋ Mother/Son dance
- ❋ Father/Daughter dance
- ❋ Garter toss
- ❋ Bouquet toss
- ❋ Toasts
- ❋ Cake cutting
- ❋ Dancing
- ❋ Leaving the party
- ❋ Special food or drinks
- ❋ Guest arriving
- ❋ Guest signing the guest book
- ❋ Parents, grandparents, family dancing
- ❋ Musicians/DJ
- ❋ Couple leaving

INDEX